SYMBOL
& MAGIC
IN
EGYPTIAN
ART

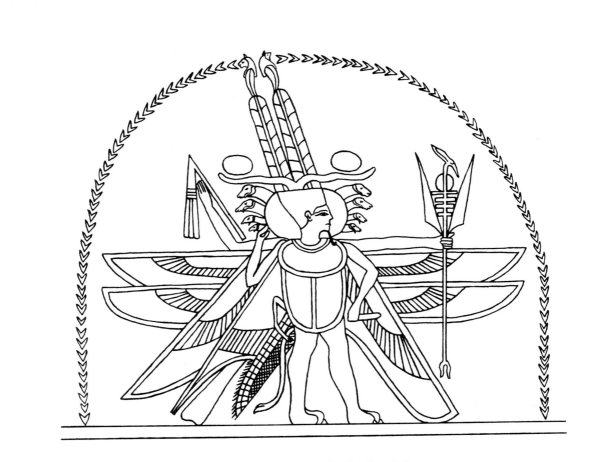

*The "god who comprehends all gods," a
composite form of the sun god
incorporating the attributes and symbols
of many deities. From a Late Period
magical stela.*

RICHARD H. WILKINSON

SYMBOL & MAGIC IN EGYPTIAN ART

With 160 illustrations
10 in color

THAMES AND HUDSON

© 1994 Thames and Hudson Ltd,
London

First published in the United
States of America in 1994 by
Thames and Hudson Inc.,
500 Fifth Avenue,
New York, New York 10110

Library of Congress Catalog Card
Number 93-60424

ISBN 0-500-23663-1

Printed and bound in Slovenia

Contents

Through Egyptian Eyes:
The Symbolism of
Form

Measure and Meaning:
The Symbolism of
Size

Position and Placement:
The Symbolism of
Location

Acknowledgments

I am grateful to several colleagues who offered comments on sections of the text of this book: Professors Lanny Bell, Earl Ertman, John Foster, James Hoffmeier, Susan Hollis, Arielle Kozloff, and Gay Robins. A number of scholars also kindly assisted in other ways, among them, Doctors Peter Der Manuelian, Rita Freed, Catharine Roehrig, Otto Schaden, and Emily Teeter.

The hieroglyphs appearing in the text were produced by Carl Shelley with CompuGlyph software, and Troy Sagrillo is to be thanked for his care in producing the line drawings which accompany the text.

As always, I would like to thank my wife Anna for her encouragement and help during the production of this book – without her, the following chapters might not have seen completion.

Photographic credits

British Museum, London: ill. 79; Cleveland Museum of Art: ill. 81; Griffith Institute, Oxford: ill. 22; Harer Collection, San Bernardino: ills. 62, 74; Hirmer Verlag, Munich: ill. 23; Louvre, Paris: ill. 94; Museum of Fine Arts, Boston: ill. 152.
All other photographs by author.

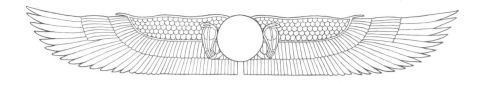

Introduction

A NCIENT EGYPTIAN paintings and sculptures have an extraordinary emotive power. Often highly sophisticated for their time, and in their finest examples for any time, they continue to haunt us thousands of years after they were created. But few of them can be classified as "art for art's sake." Most were conceived within a matrix of symbolism and magic. Thus, while an understanding of the principles of Egyptian art and of art historical development can begin to help us appreciate the surviving masterpieces, we cannot truly comprehend them without some knowledge of the underlying magic and symbolism intrinsic in their composition. What follows is an attempt to provide just such a key.

By definition, symbols represent something other than what they actually depict, and in ancient Egypt that deeper meaning was invariably linked with the very nature of existence itself. The Egyptian concept of magic was also based on an idea of the implicit nature of things – the belief in a universal supernatural force that was the prerogative of the gods but available to humans through sympathetic means. Thus the Egyptians believed that by acting out or depicting a situation – either the destruction or thwarting of evil, or the encouragement of good – the desired result would be accomplished. In this respect the purpose of Egyptian magic does not essentially differ from that of religion itself, with both sharing the common goal of what anthropologists have called "transformation of state" – the changing of existent reality to a more desirable situation.[1] It is against this background that the pictorial symbolism of Egyptian art is to be understood.

Egyptian painting and sculpture were symbolically oriented to a degree rarely equaled by other cultures, for it was mainly through symbols that the Egyptians sought to represent many of their ideas and beliefs about the nature of life and death. Yet this was hardly a result of primitive naïveté. Symbolism has been described as a primary form of ancient Egyptian thought, and when this fact is grasped we realize that it represents a system in which a very real human dilemma – the existence of conflicting facts – was often

successfully resolved. Symbols themselves are often ambivalent. They frequently have several meanings and may openly contradict themselves in their expression, yet therein lay their value for the ancient Egyptian.[2] The crocodile, for example, could symbolize not only death and destruction but also solar-oriented life and regeneration, as both appear to be true aspects of the creature's existence – for despite its fearsome nature, this animal faces the morning sun as though in adoration and hunts the fish which were the mythological enemies of the sun god. This same polarity is seen in the Egyptian perception of many other creatures and in the character of many of the Egyptian gods themselves.

Egyptian symbols could be used both to reveal and to conceal: to reveal by evoking important aspects of reality, and to conceal by limiting the audience who would understand their message.[3] Such contradictory aspects were inherent in symbolic expression and were fundamental to Egyptian religion as well. The two cannot be divorced from one another, for the symbolism inherent in a given work is usually an expression of underlying religious beliefs which gave the work life, meaning, and power.

To understand the symbolic dimensions of Egyptian art, then, we must learn to see it as the Egyptians did. We may never be in a position fully to comprehend or replicate that experience, but with practice we can come to recognize many of the symbols found in Egyptian painting, sculpture, and other works, and the manner in which the ancient artists utilized them.[4]

Types of Symbols in Egyptian Art

Symbolism may be manifested in many ways in Egyptian art. In this book, we examine nine of the more important and frequently encountered aspects, ranging from the basic form or shape of an object, its size, the materials from which it is constructed, its color, number, and hieroglyphic symbolism, to the actions and gestures performed by the figures in a composition. As an example of the manner in which all these symbolic aspects might be brought together in a single work, let us consider the Twelfth Dynasty funerary stela of Sa-Inheret (ill. 1) from his tomb at Naga ed-Der in Upper Egypt.

The scene represented is a common one: servants or relatives present offerings to the deceased and his wife for their afterlife sustenance and enjoyment. But a whole range of symbolic details enriches the composition, and provides important non-verbal statements about the status of the key individuals and their assurance of

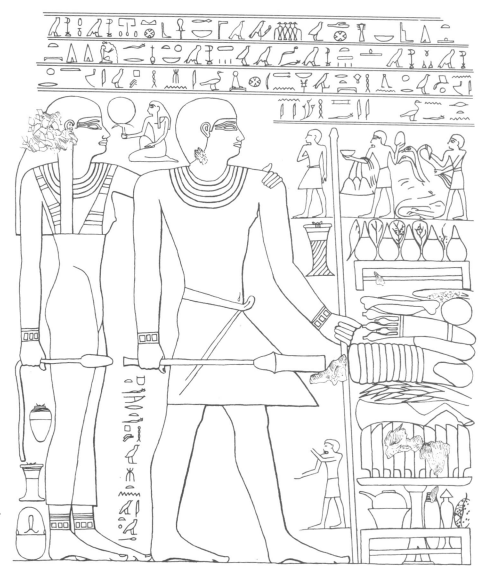

1 *Stela of Sa-Inheret,
Dynasty 12 (Museum of
Fine Arts, Boston).*[5]

afterlife existence and sustenance. Some of these details can be
briefly outlined in the order of the chapters in this book:

Form The lotus bud held by Sa-Inheret's wife, Hepu, stands
unnaturally rigid in front of the woman's hand. The natural limpness
of the lotus stem may be seen in that part of the flower's stem hanging
behind her hand and in the depiction of the flowers of the same
species draped over the arm of the small offering bearer before the
couple. But the stiffened lotus bud held by Hepu is probably meant to

Introduction 9

mirror the scepter carried by her husband, and thus to impart a measure of symbolic authority and prestige to her.

Size The relative sizes of the tomb owner and his wife compared to the servants, who are depicted on a much smaller scale, are clearly symbolic of relative status within the composition. More subtly, in some cases there may be symbolic significance in the representations of couples in which the wife is made exactly the same height as her husband (i.e. isocephalic equality), though this is more often simply the result of artistic convention.

Location Apart from the placement of the stela itself within the tomb in a position to elicit and magically supply offerings to the tomb owners, the manner in which the bread loaves on the offering table are depicted is symbolic of the afterlife location (as will be seen below under **Hieroglyph**).

Material Although the white limestone from which this stela was made was probably chosen for purely practical reasons, various stones and other materials can connote symbolic associations. The metal hand mirrors depicted in the composition were certainly symbolic of the sun (and therefore of rebirth) because of their bright reflective surfaces.

Color As in most Egyptian art, the man was originally painted in darker red tones while his wife was depicted in a much paler, yellow-white color – a form of gender differentiation symbolic to at least some degree of the traditional outdoor/indoor roles of the male and female in Egyptian society.

Number The hieroglyphic inscription which appears above the offering scene includes the standard wish for "a thousand offerings" of various types, symbolically supplying a rich and unfailing source of sustenance in the afterlife.

Hieroglyph Not only is Sa-Inheret shown in a pose reflecting the hieroglyph 𓀀 , which connotes a measure of status, but also the bread loaves on the offering table before the couple are drawn like reed leaves in the hieroglyphic sign for "field" 𓇋𓇋𓇋 and thus symbolize the idea of a "field of reeds" or "field of offerings," one of the names of the afterlife location of the deceased.

Actions The presentation of offerings was a symbolic action in itself, but also the small figure of a female servant in front of Hepu holds a mirror (in Egyptian, *ankh*) before her mistress in what may be a symbolic offering of life (also *ankh*) parallel to those scenes in which the king is offered an *ankh* sign by the gods. A bouquet of flowers (also called *ankh*) brought before the deceased could also function in the same way.

Gestures Although the small figure standing before Sa-Inheret's left

leg is not fully preserved, we can see by the position of his arm that he makes a gesture which was symbolic of respect or reverence, and which was often made by servants before their masters.

This example is not meant to imply that all, or any, of these aspects are to be found in every Egyptian painting or sculpture, but rather to show that in a given work a good many symbolic dimensions may be present. Different aspects may be stressed in different works. While form symbolism is one of the most commonly encountered aspects, for example, it is not always present; and sometimes the number of aspects used might be limited to just one, such as color or size.

The Interpretation of Symbols

Interpreting these symbols – discovering what they meant for the Egyptians themselves – is a fascinating challenge, and not always a simple matter, for Egyptian symbolism is a vast subject and may be approached from a number of viewpoints. It is important to stress, therefore, that the present book is written from a purely Egyptological perspective and does not attempt to deal with the psychological aspects, or to use the comparative theoretical approaches of the art historian. Rather, we attempt simply to explore some of the ways in which symbolism was manifested in Egyptian art. Even here there are difficulties. How can we be sure that a symbolic meaning, identified by us, held significance for the ancient Egyptians? The Egyptologist Barry Kemp has drawn attention to this issue in relation to assumptions sometimes made regarding the architectural plan of the small uninscribed temple that stands before the great Sphinx at Giza. Because this structure has cult niches on the eastern and western sides of a center court containing twenty-four columns, it has been suggested that the niches played a part in rituals dedicated to the rising and setting sun, and that the twenty-four pillars represent the twenty-four hours of each day. As Kemp remarks: "If we suppose, for a moment, that we could make direct contact with the ancient builders and ask them if this [interpretation] is correct, we might obtain a yes or no answer. But we might also find them answering: 'We hadn't thought of that before, but it's true none the less. . . .'"[6]

Thanks to the fluidity of Egyptian theology, which allowed and encouraged free association of ideas, the Egyptians could well have answered in the manner Kemp suggests. The scope for misinterpretation, therefore, in ancient times as well as the present, can be considerable. The classical author Plutarch (c. AD 46–120) tells us, for example, that the cat was regarded by the Egyptians as a symbol of

the moon on account of its activity in the night, the "fact" that it brings forth increasing numbers of young till a total of 28 is reached – corresponding to the daily increase in the moon's light – and especially because the pupils of cats' eyes expand and contract again to narrow slits like the full and crescent moon.[7] Yet how much, if any, of this was true for the ancient Egyptians' original association of the cat with the moon is difficult to ascertain. Symbols can in any case seem almost to have lives of their own. Their meanings may change over time, and it does not always follow that the symbolic significance of a given element in one composition will be identical in another work of earlier or later date.

Symbols in Egyptian art may also exhibit different meanings in different contexts in the same period of time. The feather, for example, may be found either as a symbol of air and the air god Shu, or of the goddess Maat and the concepts of truth, order, and justice. In funerary contexts, however, feathers may be symbolic of the wings of certain protective goddesses, or of the bird-like *ba* or human soul. Textual evidence suggests even more possibilities, as a passage from the Pyramid Texts indicates: "Wherewith can the king be made to fly up [to heaven]? ... You shall fly up and alight on account of the plumes of your father Geb."[8] Here plumes are related to the earth god Geb who is often symbolized by a goose. Other passages from the same texts associate or identify the deceased with a hawk, a swallow, or some other avian species, sometimes at the same time: "The king soars as a divine falcon, the king flies heavenward like a heron, the king flies up as a goose ..."[9] so that in certain cases where context does not render a clear choice we may wonder what the specific significance of such a symbol might be – or if there could be some kind of generic symbolism meant to embrace any or all of these possible ideas. The Egyptians themselves were certainly conscious of the ambiguity in their own symbolism, and even seem to have encouraged it. At one point the Book of the Dead states, "I have put my twin plumes on my head," and goes on to explain this enigmatic statement as follows: "What is that? As for 'his twin plumes on his head,' Isis and Nephthys went and put themselves on his head, being present as hawks ..." while the same text gives other meanings such as "the twin plumes on his head are his eyes," and "they are the two large stately cobras that are on the brow of ... Atum."[10]

Examples such as these show us that there is often a range of possible meanings for a given symbol. While we may select a specific interpretation that seems best to fit the context, other symbolic associations may also be involved. This is not to say that Egyptian symbolism is either inchoate or inconsistent, simply that a flexible

approach must be maintained in attempting to understand its workings. The student of Egyptian culture who is willing to follow these basic principles – to avoid unfounded speculation on the one hand, yet to attempt to develop the intellectual flexibility which the Egyptians themselves displayed – will be richly rewarded in discovering many of the fascinating levels which lie beneath the surface of Egyptian art.

An Overview of Egyptian History and Art

In the third century BC, using earlier king lists and other records at his disposal, the learned priest Manetho of Heliopolis divided the history of Egypt into thirty successive royal dynasties. These thirty dynasties, plus a thirty-first which was subsequently added, run from the putative beginnings of Egyptian history (often referred to as the unification of the "Two Lands" of Upper and Lower Egypt) to the Grecianized Ptolemaic dynasty of Manetho's own day. Although modern scholars debate the history of some of these dynasties (a few kings were probably contemporaneous), by and large they are clearly based on historical fact; and the same chronological system is still in use today. The dynasties are now grouped into larger periods, however, corresponding to eras of centralized power and cultural achievement, the three major pharaonic periods being: the Old Kingdom (2649–2150 BC), Middle Kingdom (2040–1640 BC), and New Kingdom (1550–1070 BC). These three eras all eventually ended in periods of decline known respectively as the First, Second, and Third Intermediate Periods, as may be seen in the accompanying table.

New styles in Egyptian art may often be seen to have developed with the arrival of new dynasties and historical eras. In some cases there are especially distinct periods and styles such as those of the Amarna Period of the mid-Eighteenth Dynasty and the Ramesside Period of Dynasties Nineteen and Twenty. There are also periods of marked external influence in Egyptian culture and art. At the very beginning of Egyptian history, for example, the art of the Early Dynastic Period shows apparent Mesopotamian contact in a number of its motifs, and some three thousand years later pharaonic Egyptian history likewise closes with strong external influence from the Greco-Roman world. In all periods of Egyptian history, however, a characteristic proclivity for magical and symbolic expression may be clearly seen.

Chronological Table°

The names of monarchs mentioned in this book appear in parentheses.

Late Predynastic Period (*c*.3000 BC)°°

(Narmer)

Early Dynastic Period (2920–2649)

Dynasty 1	2920–2770	
Dynasty 2	2770–2649	

Old Kingdom (2649–2150)°°°

Dynasty 3	2649–2575	(Djoser)
Dynasty 4	2575–2465	(Cheops, Chephren, Mycerinus)
Dynasty 5	2465–2323	(Sahure, Unis)
Dynasty 6	2323–2150	(Pepi I, Pepi II)

First Intermediate Period (2150–2040)

Dynasty 7	2150–2134
Dynasty 8	2150–2134
Dynasty 9	2134–2040
Dynasty 10	2134–2040

Middle Kingdom (2040–1640)

Dynasty 11	2040–1991	(Mentuhotep II)
Dynasty 12	1991–1783	(Sesostris I)
Dynasty 13	1783–1640	

Second Intermediate Period (1640–1550)

Dynasty 14–17	1640–1550

° The dates in this chronological table are based primarily on those given by Professor John Baines and Dr. Jaromír Málek in their *Atlas of Ancient Egypt* (Oxford, 1980; New York, 1984).

°° The final century or so of the Predynastic Period actually seems to have seen the rise of kingship in Egypt, and some scholars therefore refer to this period as "Dynasty 0."

°°° The Old Kingdom is sometimes viewed as beginning with Dynasty 3, as here, and by some authors as beginning with Dynasty 4.

New Kingdom (1550–1070)

Dynasty 18	1550–1307	(Thutmose III, Hatshepsut, Thutmose IV, Amenhotep III, Akhenaten, Tutankhamun, Ay, Horemheb)
Dynasty 19	1307–1196	(Ramesses I, Seti I, Ramesses II)
Dynasty 20	1196–1070	(Ramesses III, Ramesses IV, Ramesses VI, Ramesses XI)

Third Intermediate Period (1070–712)

Dynasty 21	1070–945	(Psusennes I)
Dynasty 22	945–712	
Dynasty 23	828–712	
Dynasty 24	724–712	

Late Period (712–332)

Dynasty 25 (Kushite)	712–657	(Taharqa)
Dynasty 26 (Saite)	664–525	
Dynasty 27 (Persian)	525–404	
Dynasty 28	404–399	
Dynasty 29	399–380	
Dynasty 30	380–343	
Dynasty 31 (Persian)	343–332	

Greco-Roman Period (332 BC–AD 395)

Macedonian Dynasty	332–304	(Philip Arrhidaeus)
Ptolemaic Dynasty	304–30	(Ptolemy VIII/Euergetes II)
Roman Emperors	30 BC–AD 395	

THROUGH EGYPTIAN EYES
the symbolism of
FORM

"A spell for being transformed into any shape one may wish to take ..."
Book of the Dead, Chapter 76

A LITTLE KNOWN but fascinating inscription made at the command of the pharaoh Thutmose IV (1401–1391 BC) records the discovery by the king of a stone. The significance of this celebrated stone lay not in its being of rare material or appearance, the inscription tells us, but because "his majesty found this stone in the shape of a divine hawk."[1] That an Egyptian king should place so much importance on a mere rock simply because of its shape is instructive, for it shows how alert the ancient Egyptian was to the shapes of objects, and to the symbolic importance which the dimension of form could hold.

The relationship of form, symbolism, and magical function may be seen in almost every class of object found in Egyptian culture – from some of the smallest items of personal adornment to the architectural programs of massive temple complexes. The basic principle by which an object or representation suggests the form of something of symbolic significance is found in hundreds of different contexts across this spectrum. In fact, form follows function in only the most general manner in much of Egyptian art, and the specific details of shape and form are often dictated by symbolic rather than by practical concerns.

Primary and Secondary Association

Symbolism of form may be expressed at "primary" and "secondary" levels of association (see Chapter 7 on hieroglyphs). In *primary*, or direct, association, the form of an object suggests concepts, ideas, or identities with which the object is directly related. So in many works,

an object associated with a specific deity thus suggests that god or goddess – or by extension, a concept connected with that deity.

This is the level at which most amuletic charms function symbolically. For example, among the amulets meant to magically protect or assist the ancient Egyptian in life and death was the *djed* pillar ⚱ , directly associated with the netherworld deity Osiris; this amulet is often drawn with the eyes, arms, and various attributes of the god (ill. 8). Although the *djed* may have had a different origin, it was regarded as a representation of the backbone of Osiris, and amulets made in this form could also signify the concept of support and stability. The *djed* thus appears not only as an amulet used on the mummy of the deceased, but also painted along the inside backs of coffins and depicted on pillars and other architectural features within tombs (ill. 7) – all with the dual significance of support and Osirian symbolism. A drawing of a real or imagined mirror in a Ramesside private tomb at Thebes has the handle of the mirror shaped like a *djed* pillar with two anthropomorphic arms which help support the mirror's disk which is a symbol of the sun (ill. 9). Here again, both the magical powers of stability which support the sun and the god Osiris from whom the sun rises as it leaves the netherworld are symbolized. The depiction of the *djed* is thus a primary one in all these cases, and the relation of the object to its symbolic meanings is direct.

In *secondary*, or indirect, association, the form of an object suggests another, different, form which has its own symbolic significance. This kind of symbolic association is also found in the forms of a number of amulets. The cowrie shell (ill. 10), for example, appears as an amulet and in Egyptian jewelry from a very early date. Both natural shells and ones manufactured from various materials were worn, and the Twelfth Dynasty girdle of Princess Sat-Hathor-Yunet in the Metropolitan Museum of Art consists of large cowries made of burnished gold interspersed with spacing beads of gold, carnelian, and feldspar. The reason for this use of the cowrie shell's form was as much symbolic as decorative. Because the shape of this shell is reminiscent of female genitalia, it was a potent amulet in its own right, and endured as a symbol of sexuality and fertility throughout Egyptian history. In a similar manner, the amulet depicting a clenched hand (ill. 11) could also represent the female sexual principle; and the chief priestess of the cult of Amun, who represented the god's consort, was actually given the title of "The God's Hand," along with that of "God's Wife" and "God's Adoress."

Amulets made in the form of a cluster of grapes (ill. 13) may likewise represent the human heart, due to their shape (and perhaps also their color). There is literary evidence to support this in the work

known as the "Tale of Two Brothers," in which the heart of the protagonist is described as *iarret*: "a bunch of grapes."[2] This form may thus indirectly suggest the heart and through this connection, the concepts of life and rebirth associated with the heart.

Because the Egyptians delighted in these kinds of visual relationships, since for them they transcended the purely coincidental and took on symbolic meaning and importance, the forms of many objects of domestic, funerary, and cultic use were adapted to symbolic shapes. For example, the outstretched wings of flying vulture pendants and winged sun disks are sometimes formed with downpointing wing tips in the shape of the sky hieroglyph ⌦ .[3] Kohl or eye-paint tubes were frequently made in the form of a hollow reed – sometimes with the base shaped like the mouthpiece of a reed made into a musical pipe (ill. 12). This form suggested a connection with the goddess Hathor who was associated with both the papyrus reed and with music. In a similar manner, a famous bronze lamp from the Eighteenth Dynasty tomb of Kha at Thebes, now in the Cairo Museum, is constructed in the shape of the bulti fish, which because of its rotund form and reddish coloration was used as an implicit symbol of the solar orb.[4] The idea of a symbol of the sun being used as a lamp had obvious appeal for the Egyptians, but as a solar image, the bulti fish had important connotations of rebirth which are doubtless also present in the lamp placed in Kha's tomb.

The Interaction of Forms: Different Forms with Similar Meanings

Often different symbolic forms exist with identical significance, as is the case with frequent depictions of the Egyptian king as a bull, falcon, sphinx, or other creature.

But form symbolism can go much deeper than the simple equation of an object's basic shape with another form of some significance. Often, this kind of symbolism involves not just the overall shape of an object but the forms of its individual parts or of what might at first appear to be simply decorative additions. The subtlety of this symbolism may be clearly seen in a number of small, handled objects for use in private and cultic settings – such as the hand mirror and so-called "cosmetic spoon" which often exhibit different decorative forms with similar meanings.

The polished metal hand mirrors used by the Egyptians for personal grooming and adornment were also used in religious rituals and were frequently given symbolically meaningful forms. Reliefs on

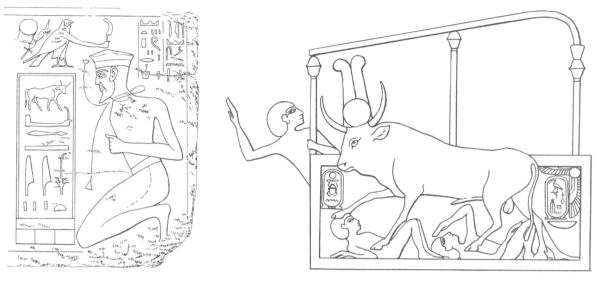

2, 3
Different forms with identical function – the king destroys enemies as a falcon and as a bull.

the walls of Ptolemaic temples show that some goddesses, especially Hathor and Mut, were presented with two mirrors, one of gold and one of silver, signifying the sun and moon as offerings in the service of their cults. Because the disk of the mirror was evocative of the sun – both in its brightness, and in its shape – Egyptian mirrors often exhibit decoration which enhances this symbolic association from the time of the Middle Kingdom. Something of this significance has been seen in the *djed*-handled mirror already discussed, where the mirror's form alludes to the eternal stability and magical support of the sun in the cosmic scheme of things. But the solar significance of the mirror disk may find expression in dozens of ways through the different forms or details added to the mirror's basic shape. For example, a mirror handle found in the tomb of Tutankhamun (1333–1323 BC) was inscribed so that the beetle which pushes the sun disk before it in the hieroglyphic writing of the king's name is directly below the mirror disk which could have functioned symbolically as an enlarged *re* or sun disk.[5]

Other mirrors illustrate how a similar symbolic meaning may be achieved in a different manner. In some examples, additional elements suggest solar significance, for instance when the mirror disk is flanked by two falcons – sacred symbols of the sun. Occasionally, a totally different form may be used to suggest the same significance. A bronze mirror in the British Museum is made in the shape of a lotus leaf, with the leaf's slender stalk forming its handle, and the reverse of the mirror being decorated with the pattern of veins seen on actual

The Symbolism of Form 19

leaves (ill. 16). Here, the mirror disk evokes the sun in a unique way, for not only is the lotus leaf round like the sun, but the lotus was also the symbolic solar plant par excellence, since the flower retreats beneath the water at night and rises again each day with the sun.

The use of the mirror as an instrument of beauty and as a symbol of the sun is the reason for its association with the goddess Hathor. Not only was Hathor a goddess of love, joy, and fertility, but according to myth she was also the wife of the sun god Re. Mirrors frequently spell out this symbolic association with the goddess through the shape of their handles made in the form of the stem and umbel of the papyrus – which was one of her attributes, or symbols. In many examples the connection with Hathor is made even more explicit by the face of the cow-eared goddess herself being incorporated as a central element in the design (ill. 15). The handle of a mirror might also be constructed in the form of a shapely young woman, as in ill. 14 which is typical of a form popular throughout the New Kingdom in which the young girl probably represents one of the *khener* dancers, entertainers who performed for the deceased in his outer tomb and who were associated with Hathor. Even the figure of Bes, the dwarf god associated with protection and childbirth, which appears on the handles of many mirrors is also connected with Hathor. Thus most if not all of the many decorative forms found on Egyptian mirrors may carry a similar symbolic significance – an association with the sun god and with Hathor, his consort.[6]

A similar situation occurs in the case of the forms given by Egyptian craftsmen to a class of utensils still not fully understood – the so-called unguent dishes and "spoons," which may have been made to hold rejuvenating oils, ointments, or unguents. The bowls of such spoons may be circular, oval, rectangular, or in the shape of a specific object. Often the bowls are incised with wave-like lines signifying water in order to suggest that the bowl is a pool. Sometimes the bowl may also be decorated with depictions of ducks, fish, frogs, or other aquatic creatures. Here the symbolism has often been thought to be of a double nature. At one level, water and water creatures simply suggest the visual metaphor of pool for the spoon which holds liquid. At another level the images have been seen to be at least to some degree associated on a sexual and a rebirth level. Water itself was used as a female sexual symbol; and ducks, fish, and frogs may all have connotations of sexuality and fecundity in Egyptian art (see Actions). In a number of examples the circular disk of the dish certainly may be symbolic of the sun rising above the papyrus marsh, a potent symbol of creation and rebirth; and many are *ankh*-shaped, symbolizing – like mirrors – life, rejuvenation, and rebirth. The

rejuvenating powers of the unguent that the spoon held would thus be magically enhanced by the symbolism of the container's form.

This same duality is seen in the handles of the spoons which were utilized as a field for decoration and often carved into the shape of a human figure who "carries" the bowl of the spoon in the form of a large pitcher or vase. Some of these figures are Asiatic servants, but other spoons depict attractive girls – naked except for minor ornaments. Often the handle depicts such a girl holding papyrus fronds or ducklings, and in several cases she is shown standing on a small duck-headed skiff while playing a stringed instrument. Another common type of handle depicts the girl extended in the attitude of a swimmer and supporting on her outstretched arms the spoon's bowl in the form of a duck, goose, fish, or even a gazelle (ill. 17). Once again the use of these varied motifs is open to different interpretations. At a very basic level many handles simply reinforce the "pool" symbolism associated with the bowls of the spoons. At a more subtle level, however, some type of sexual or rebirth symbolism seems to be implied. Many of the motifs used in the decoration of these spoons certainly seem to relate directly to the goddess Hathor and have already been noted in our discussion of the form symbolism of mirrors. The female *khener* dancers, the dwarf Bes figures, Asiatics, animals such as the gazelle, oryx, and ibex, and even the forms of objects such as mirrors, sistra, and wine jars that appear on these spoons are all directly associated with Hathor.

But the great variety of recurrent motifs in these spoons suggests an underlying symbolism which might tie these puzzling objects together. Recently, Arielle Kozloff completed research which may well supply the symbolic clue.[7] Beginning with a study of the swimming girl type spoons, this scholar noticed that the bird which forms the bowl of these objects is frequently a goose rather than a duck. Knowing that the goose is often a symbol of the earth god Geb, Kozloff realized that the figure of the nude girl might represent the god's wife, Nut, the mother goddess of the heavens who is frequently depicted as a youthful, naked woman stretched out over the earth (and who appears in the night sky as the Milky Way).[8] The swimming pose would thus be understandable as that of the goddess swimming in the heavens – which the Egyptians regarded as a cosmic sea over which the sun god sailed each day in his barque.[9] Textual sources examined by Kozloff seem to parallel this visual image in the way in which they refer to the goddess Nut presenting or "lifting up" her son or heir Osiris. Because the swimming girls sometimes bear on their hands a duck (the Egyptian name of which is *sa*, which is also the word for son) or an infant gazelle (the word for which is *iua*, which is

also the word for "heir"), a direct connection seems to exist which suggests a relationship between the goddess and the deceased who was associated with Osiris in Egyptian funerary beliefs.

As the mother of the sun god Re as well as Osiris, Nut may also "lift up" before her solar symbols such as the bulti fish or the lotus flower which form the bowl of many swimming girl spoons, or bowls in the shape of the oval cartouche or circular *shen* which symbolize the circuit of the sun. A coherent symbolism of what might appear to be totally unrelated types of these spoons may thus be revealed. Even a type of spoon which has its handle in the form of a running (or swimming?) dog holding a bulti fish or clamshell in its mouth (ill. 18) may be understandable, since Kozloff has shown that the dog may symbolically represent the fingers of the goddess who holds the sun.[10]

Through their association with the goddesses Nut and Hathor, the spoons may reflect a consistent symbolic stress on solar and cosmic rebirth, and of renewed life for the deceased through one or another of these great mother goddesses. These objects thus provide a clear example of the interactive nature of different images, whereby many different forms may be used in expressing the same symbolic range of meaning. The principle has important ramifications in various areas of Egyptian art, and has been recognized, for example, in cases where private funerary art utilizes images such as a floral bouquet or a mirror (both known by the word *ankh* in Egyptian) in symbolic imitation of the sacred *ankh* sign ☥ held by Egyptian gods and kings. In this instance there is an added linguistic connection between the objects; but the underlying principle remains the same.

The Modification of Forms: Similar Forms with Different Meanings

If a wide range of different symbolic forms may suggest a common meaning, so small variations in the same form may sometimes hold different symbolic connotations. Just as the private use of forms such as the *ankh* bouquet and *ankh* mirror could be used to suggest a symbol associated with royalty or divinity, more rarely, the modification of form was accomplished for the opposite purpose, and motifs used in the funerary art of commoners were adjusted for royal use. This may be seen in an interesting variant of the *menet* bird motif of Egyptian mythology.

The *menet* was a swallow, martin, or swift of the family *Hirundinidae* or was perhaps modeled generically on all these

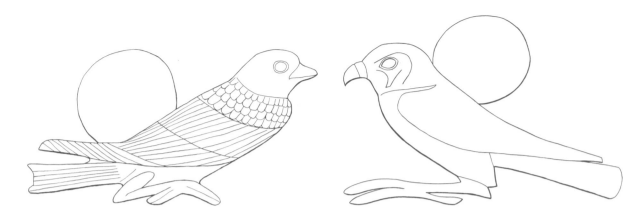

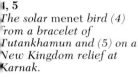
birds.[11] It is known that swallows were identified with the transfigured souls of the dead, and representations of the barque of the sun god Re frequently show the bird sitting on the boat's prow as the sun passes through the underworld. In these instances the swallow seems to represent not the soul of the deceased, but a kind of "day greeting" bird which announced the dawn and the sun's approach. Both these concepts may have found their origin in the fact that some species of these birds build their nests in holes in the cliffs bordering the Nile, from which they emerge at dawn and to which they return at sunset – in the same way that the souls of the dead were believed to emerge from their tombs with the sunrise and to return as the sun set.[12]

The swallow thus appears as a symbol of the soul and of solar renewal in both private and royal art from at least the end of the Middle Kingdom. Frequently the bird is depicted with a solar disk set upon its back to enforce this association, and a bracelet from the tomb of Tutankhamun shows a swallow bearing a sun disk in exactly this way (ill. 4). This is the canonical representation which was utilized in a number of contexts by royalty and non-royalty alike. On an early New Kingdom royal relief at Karnak, however, the motif is subtly adjusted.[13]

The swallow with sun disk motif appears on the relief as an ornament worn on the kilt of the king, but the head and tail of a falcon have been substituted for those of the swallow as if to identify the motif directly with the king through the use of the standard royal avian symbol. Here, a symbolic form – which may even have been originally associated with the person of the king and later appropriated by the population at large – seems to have been adjusted to strengthen or personalize its royal associations.

This aspect of form symbolism can be seen especially clearly in the multiple meanings associated with various poses given to the human

The Symbolism of Form　23

form. In sculpture, for example, static, seated, or standing poses are usually the rule, though most of the basic types display a fairly wide range of form symbolism. The so-called "block" or "cube" statues which show their subjects seated on the ground with knees drawn up before them (ill. 19) commonly resemble at least in their general form the pose of the hieroglyph for "god;" and the use of such statues to portray the revered deceased may well be based on this similarity. However, details of other statues of the same general type seem to show their subjects as simply seated, perhaps piously within the temple, or even as though being seated on a carrying chair.

Representations of the enthroned Egyptian king may likewise reveal small differences aimed at the modification of their symbolism. Many statues and paintings depict the emblematic motif connoting unification of the Two Lands on the sides of the throne (*sema-tawy*), so that the seated king symbolically presides over his unified kingdom (ill. 20). A number of Old Kingdom examples also depict a small figure of the divine falcon perched on the top of the throne and spreading its wings around the back of the king's head – as in the famous statue of Chephren (2520–2494 BC) in the Cairo Museum – and in these works it is evident that the king is symbolically protected by the powerful sky god and patron of kingship. Later seated statues of kings which do not incorporate the protective falcon motif may sometimes be intended to be viewed in a different manner. Because the Egyptian word for throne was *set* and this word seems to form the core of the name of the goddess Isis (*aset*), it is possible that some statues showing the king seated upon the throne are intended to evoke the idea of the king – as Horus, the son of Isis – seated upon the lap of his divine mother: a motif which may find concrete expression in the Brooklyn Museum statuette of Pepi II (2246–2152 BC) as a tiny adult in his mother's lap.[14] Alternatively, the royal seat may sometimes symbolize the king's "father" Osiris, as in the statement, "The king makes his seat like Osiris," in which the expression "makes his seat" (*iri set-ef*) contains elements of the god's name.[15]

In royal standing statuary, similar differences in symbolic meaning also seem to be produced by minor variations in form. Certainly, the association of the king with Osiris in mummiform statues showing the god's attributes is clear, while those statues exhibiting the "striding pose" may be associated with the god in a different way. The striding pose (ill. 21) seems to denote action, or potential action, and was often utilized in tomb statues where it appears to show the deceased king or private person coming forth to receive offerings. Because striding legs were used ideographically in the hieroglyphic script in words indicating movement, and because such statues were often placed in

false doorways within the tomb, a meaning alluding to the ability of the deceased to come and go between this world and the netherworld seems quite sure. Sometimes, such a form may also have been chosen to represent the god Osiris in his role as the god of the southern constellation Orion, referred to in the Pyramid Texts as "long of leg and lengthy of stride."[16] This is especially true in cases where other symbolic aspects such as location, color, or attributes also suggest an Osiride identity.

As in every area of Egyptian symbolism, care must be taken to consider all aspects of the iconography of a work of art. A magnificent and perfectly preserved standing statue of Amenhotep III (1391–1353 BC) – as a statue on a sledge – which was unearthed in the court of Luxor Temple in 1989 provides an excellent example of this (see ill. 63). The statue was carved from purple-red quartzite (the color having definite solar connotations and connection with the Heliopolitan sun god Re) and not only depicts the king with the double crown (sometimes associated with the Heliopolitan god Atum), but also displays a feathered patterning (associated with falconiform gods such as Horus, Re, and Re-Horakhty) on the king's kilt. Because the image depicts a statue, however, thus associating the king with deceased rulers, and exhibits the striding pose also associated with Osiris, it is possible that this single statue equates the king with that god as well as with the Heliopolitan sun gods[17] – a combination which is especially interesting, since Osiris and Re came to be considered as representing the body and soul, respectively, of a single great god.

Just as varying details of a given form may produce different symbolic expressions, some forms may take on new meanings with the progression of time. When this occurs old meanings may be retained to some degree or they may be superseded. This process can be seen in many areas of Egyptian art, but the development of the Egyptian coffin provides a clear example. Coffins of all periods are subject to complex typologies with many variants, but in purely symbolic terms four major types may be differentiated from the earliest times to the end of pharaonic history.[18]

Although it may have originated simply as a protective container for the body of the deceased, the Egyptian coffin soon took on symbolic aspects related to its form. Many early coffins functioned as a symbolic tomb and "house" for the deceased (the Egyptian word for "house" and "tomb" is the same), so that they were frequently decorated to resemble the recessed paneling found on the walls of tombs and houses. The so-called "false door" of the Old Kingdom tomb – through which the spirit of the deceased was supposed to pass to receive offerings – was also incorporated into the design of the

coffin itself in the Sixth Dynasty. By the Middle Kingdom, however, an anthropoid coffin shape appeared which copied the appearance of the mummy and symbolically provided an alternative "body" for the deceased's spirit. Afterlife beliefs were so influenced by the worship of the god Osiris in this period that the significance of the form of the coffin and its decoration soon began to change, however, and as time progressed the anthropoid, or mummiform, shape of the coffin took on new significance.

In the New Kingdom the figures of Isis, Nephthys, the four sons of Horus, and other deities connected with Osiris were routinely added to the decoration of the coffin walls in order to provide a ring of protection around the deceased "Osiris;" and many of the attributes of the god – e.g. his curved beard, tripartite "divine" wig, or hands crossed on the breast – were added to the coffin's form. Occasionally we find regional differences in the expression of this kind of form symbolism. Usually, figures of Osiris from Upper Egypt show the arms crossed over each other, while in Middle Egypt they are held at the same level. Another adaptation of the coffin's form to symbolic concerns may be seen in the relationship of the deceased with the goddess Nut. Just as Nut was the mother of Osiris, the goddess could be regarded as the mother of the deceased; and for this reason the coffin began to be seen as symbolic of the body of Nut. Old Kingdom texts often refer to the funerary chest as *mut* or "mother," in fact, and from New Kingdom times for royalty, and later – by the Twenty-second Dynasty – for commoners, the aspect of Nut as goddess of the heavens is represented on the floor or lid of the coffin embracing the deceased – just as Nut stretched herself over the earth and received the spirit of the deceased to become one of the stars.

Yet another type of anthropoid coffin, which developed in the Theban area during the Second Intermediate Period, is the so-called *rishi* coffin. The name is taken from the Arabic word for "feather," as these coffins are recognized by the patterning which covers much of their lids in the form of two great wings wrapped around the body from the shoulders to the feet. The symbolic significance of this feather patterning is not entirely understood. Many Egyptologists have seen the decoration as representing the enfolding arms of a winged goddess – such as Isis or Nephthys, the sky goddess Nut, or the vulture goddess Nekhbet, though other possibilities exist. It has sometimes been suggested that the feathers may in fact associate the coffin with an avian entity such as the *ba* – the bird-like "soul" of the deceased himself.[19] The coffin was eventually completely sheathed in the *rishi* pattern, with the shoulders and torso being covered with rows of small scale-like "body" feathers and the legs being sheathed

in longer "wing" feathers. Whatever its symbolism, this coffin type continued to be used for royal and private burials during much of the Eighteenth Dynasty and is seen, for example, in the coffins and some of the mummiform figures of Tutankhamun which combine the symbolism of the basic anthropoid form with that of both the Osiride and *rishi* types (ill. 22).

The Programmatic Use of Forms: New Kingdom Temple Architecture

Form follows concept in all types of monumental Egyptian architecture, but nowhere is this principle more clearly seen than in the design and decoration of the developed Egyptian temple. The temple functioned as both the residence of the gods who dwelt within its enclosure, and from at least New Kingdom times also provided a symbolic model of the universe.[20] This symbolic model was not just a representation of reality, however, but also constituted a working model which formalized and strengthened through its functioning the actual running of the cosmos.

The developed, axial temple consisted of an encircling *temenos* or precinct wall of mud brick, within which was situated the temple proper, of stone (ill. 23). This consisted of multiple pylons or gateways which opened into one or more open courtyards and eventually into a pillared hall, and the dimly lit inner sanctum of the god. The temple roof was the sky of this miniature world, and as such was usually decorated with stars and flying birds which represented protective deities. The floor, correspondingly, was regarded as the great marsh from which the primeval world arose; and the great columns of the pillared courts and halls were thus made to represent palm, lotus, or papyrus plants, with their intricately worked capitals depicting the leaves or flowers of these species (ill. 24). The lower sections of the temple walls were also often decorated with representations of marsh plants, and the whole effect was considerably heightened in a number of temples where the outer courts and pillared hall were actually flooded in the annual inundation of the Nile. In the same way, the wall which surrounded the temple complex was sometimes built on an alternating concave and convex foundation bed to represent the waves of the watery environment of the First Time. Erik Hornung has pointed out that excavation for the temple foundation also symbolically found a connection with the primeval flood (Nun) in digging down to the level of the naturally occurring ground water.[21]

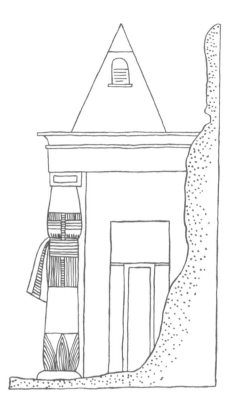

6 *The persistence of forms: the ancient form of the pyramid continues to occur in many New Kingdom tombs and on shrines and other objects of even the latest periods. Detail from a New Kingdom tomb painting.*

The marsh-like environment provided the surroundings for the raised inner sanctuary which symbolized the primeval earth mound that rose from the waters at the world's beginning, and the first appearance of the gods themselves. The elevated position of the temple's innermost area also symbolized the relation of the structure to *maat* – the underlying "order" upon which the world rested. For although the fact has rarely been considered, the ramps and stairways leading up to the temple's entrance and its inner sections formed visual reminders of the ramps or plinths upon which statues of the gods were placed – and which were made in the form of the hieroglyph ⊂⊃ used to write the word *maat* itself.

Just as these elements of structural design seem to have symbolized the original creation of the world, other aspects of temple design represented the ongoing functioning of the cosmos. The entrance pylons were built to mirror the form of the hieroglyph for the "horizon," on which the sun rose each day (see Hieroglyphs), as a stela of Amenhotep III commemorating the construction of his great mortuary temple on the west bank of Thebes shows: "It resembles the horizon of heaven when Re rises in it;"[22] and in a later inscription

carved at the entrance to the Ptolemaic temple of Edfu, the pylons are specifically called "Isis and Nephthys who raise up the sun god who shines on the horizon."[23] The long processional path of the temple thus replicates the course of the sun in its daily journey across the world, rising above the pylons in the east, moving across the columned halls and courts where its image appears under the lintels and architraves, and setting finally in the west, where the darkened inner shrine was situated (see Location).

Other forms associated with the Egyptian temple also echo these same symbolic meanings. The pairs of obelisks which were placed on each side of the entrance pylons were certainly solar-symbolic and were sometimes dedicated to the morning and evening manifestations of the sun god, but they may also have functioned to some degree as a form of the two mountains of the horizon upon which the pylons themselves were modeled. This added meaning is perhaps seen in an inscription of Hatshepsut who boasted of the obelisks which she erected that ". . . their rays flood the Two Lands when the sun disk dawns between them. . . ."[24]

The architectural program utilized in the developed Egyptian temples thus incorporated virtually every structural feature found within these great monuments. It was symbolism which dictated many of the forms of the various features – roofs, walls, columns, and doors – and which integrated them and provided a coherent meaning to the whole. It was symbolism, too, which allowed the temple to function in its role as a model of the cosmos itself. All this was accomplished primarily through the programmatic use of form symbolism, which was also employed in the construction of Egyptian palaces and tombs, and in several non-architectural contexts such as the design of many of the amulets placed on the mummy of the deceased. Yet even so, form was only one of the symbolic dimensions which the ancient Egyptians utilized in expressing and establishing order in their world, and is usually found with other symbolic aspects which support and enhance its basic significance.

Primary and Secondary Association of Forms

7–9 *(7)* Djed *pillar. Tomb of Nefertari (pillared hall), Valley of the Queens, Thebes, Dynasty 19. (8)* Djed *pillar with attributes of Osiris. Tomb of Seti I, Valley of the Kings, Thebes, Dynasty 19. (9) Mirror with djedform handle. Tomb 217, Thebes, Dynasty 19.*

Egyptian art utilizes form symbolism at two levels, which we may refer to as *primary* and *secondary* levels of association. At the primary level, the symbolism is direct and objects are shown in the forms they are meant to represent. Thus, the *djed* pillar ⚱ , an ancient symbol associated with the god Osiris and sometimes said to represent the backbone of the god, symbolized both the deity and the concept of support and duration. In the tomb of Nefertari the *djed* pillars painted on some of the tomb's columns (left) not only act as symbolic supporting pillars, but also symbolize Osiris, the god of the underworld. This latter meaning is made plain in depictions of the *djed* with the eyes, arms, crowns, and other insignia of the god (below left). The New Kingdom representation of a mirror (below right), made in the form of a *djed* pillar holding aloft a solar disk, suggests the same support and stability but may also allude to Osiris in the netherworld and Re rising into the heavens. Despite modifications and additions to the image, the form of the *djed* is directly recognizable in all these depictions.

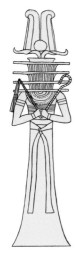

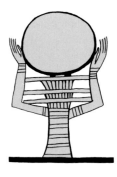

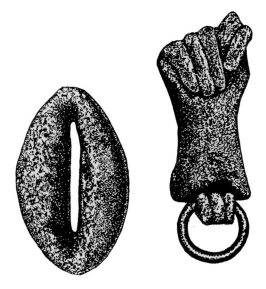

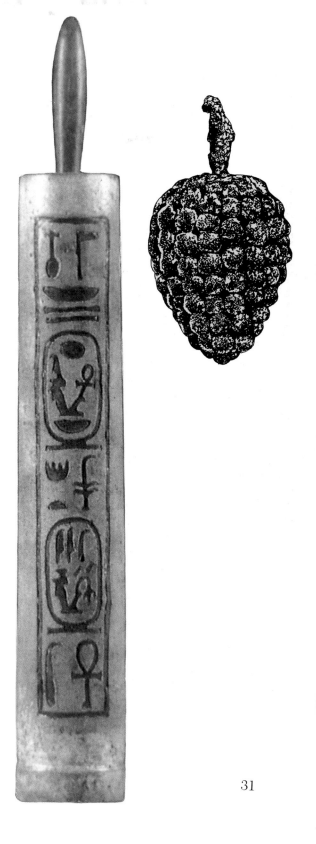

10–13 *Faience amulets in the shape of (10) a cowrie shell, (11) a clenched hand, and (13) a bunch of grapes. Greco-Roman Period. Harer Collection, San Bernardino, California. (12) Eye-paint tube of Tiy, wife of Amenhotep III. Dynasty 18, Egyptian Museum, Turin.*

Secondary symbolic association occurs where significant forms are represented indirectly in Egyptian art. Here, forms are used which suggest the shape of something else which has symbolic meaning. This level of association is especially common in amulets such as the cowrie shell (10) – which was used as a symbol of sexuality, because it resembled the female genitalia – or the clenched hand (11), which was also a symbol of the female principle or of sexual union. In a similar manner, amulets depicting a bunch of grapes (13) are known to have been symbolic of the heart, and thus life itself, because of their essential similarity in shape (as well as their color and the blood-like juice of the grape). The eye-paint tube (12) also utilized the same kind of secondary symbolic association because it is made in the shape of a hollow papyrus stem, shaped at the base into a mouthpiece so that it could be played as a pipe-like instrument. This form associates the object with Hathor, the goddess of love and beauty, since this goddess was also associated with music and with the papyrus, which was one of her symbols.

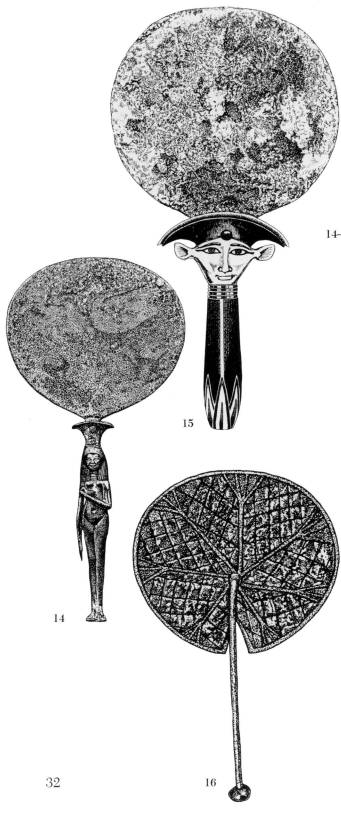

The Interaction of Forms

14–16 *Bronze mirrors: (14) New Kingdom. The Louvre, Paris. (15) New Kingdom. Egyptian Museum, Cairo. (16) Old/Middle Kingdom. British Museum, London.*

Mirrors held great symbolic significance, especially as symbols of the sun – on account of the shape and brightness of their polished metal disks – and were used in a number of ritual contexts. While the decorative forms associated with mirrors are quite numerous, most of these relate in some way to the underlying solar significance of the objects. Many show a direct connection with the goddess Hathor, who was not only the patron deity of beauty and love (an association clearly relevant to the function of the mirror), but also the consort of the sun god Re and hence connected with solar symbolism. Hathoric forms frequently used on mirrors include the portrayal of the cow-eared goddess' face and the papyrus umbel which was one of her more important symbols – both seen in example 15. The forms of young, usually unclothed, girls which are commonly depicted on mirror handles are also connected with Hathor (14, which has a papyrus umbel beneath the mirror disk), as are images of the god Bes, and certain other symbols. Other mirrors show their solar symbolism more directly, for instance when they are decorated with falcons which suggest the falcon-headed sun gods, Re, Horus, and Re-Horakhty; or, as in the case of 16, as the leaf of the lotus or water lily which functioned as an important solar symbol because of the fact that the plant retreats beneath the water at night and rises again with the first light of day.

15

14

16

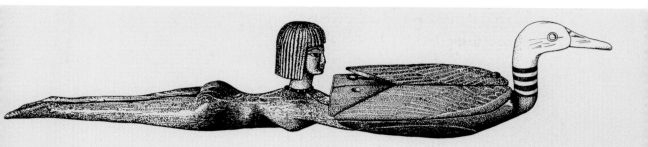

17, 18 Cosmetic spoons: (17) Goddess with goose and (18) dog with clamshell. Dynasty 18. The Louvre, Paris.

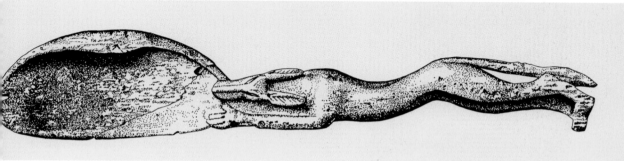

The so-called cosmetic spoons used by the Egyptians represent another class of small object commonly decorated with a large number of representational motifs and apparently used in certain ritual contexts with symbolic intent. While the decorative forms utilized for these utensils are often similar to those found on mirrors – Hathoric symbols such as the papyrus, cow, young girls, and so on – another group of quite diverse forms also seems to relate to a very different symbolic theme. This second group includes the "swimming girl" type spoons showing an outstretched young woman supporting a duck, goose, or one of several other creatures (17). These spoons all appear to symbolize the great mother-sky goddess and the sun which she bore (or her husband or son depending on the symbol used) in accordance with Egyptian mythological beliefs. Decorative motifs which seem widely disparate may thus actually relate to this same underlying theme, and it has been shown, for example, that spoons made in the form of a running or swimming dog with a bulti fish or clamshell in its mouth (18) relate to exactly the same concept, with the dog symbolically representing the fingers of the goddess holding the sun.

The Modification of Forms

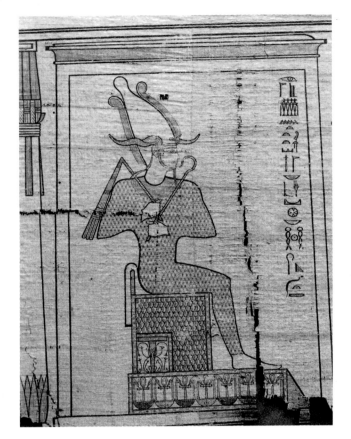

20 *Seated Osiris. Ptolemaic Period papyrus. Egyptian Museum, Cairo.*

19 *Block statue of Yamu-Nedjeh. Dynasty 18. Luxor Museum.*

Small variations in a given form may sometimes convey different symbolic meanings, especially in representations of the human figure. The Egyptian "block" statue, for example, occurs with several variations which suggest a different significance in each case. Many examples simply depict their subjects as though seated within the temples where many of the statues were sited. Others seem to represent the person in a carrying chair, doubtless implying a level of status, or depict the figure in a form similar to the "seated god" hieroglyph, suggesting the divine nature of the deceased person.

Representations of seated kings may likewise reveal a number of symbolic variations in meaning. While several Old Kingdom monarchs were portrayed with the small figure of the divine Horus falcon behind them – symbolic of divine protection and their own role as the manifestation of the god – other representations stress the king's rule over Egypt through the physical act of sitting upon the heraldic emblem for "unification" inscribed upon the sides of the throne. Sometimes the royal seat may perhaps represent the goddess Isis (whose name means "throne"), suggesting the symbolism of the king seated in his divine mother's lap.

21 *(Right) Striding statue of Ramesses II. Luxor Temple, Dynasty 19.*

Statues of individuals with one leg advanced as though striding forward were often placed in temples and false doorways of tombs and probably symbolized the deceased person emerging from the underworld to receive offerings and thus to experience afterlife existence. Some royal statues in this striding form may also suggest the king's symbolic association with the god Osiris – with whom he was believed to fuse at death. This symbolism is especially clear in representations of the striding king depicted as Osiris in his role of the god of the southern constellation Orion who was called "long of leg and lengthy of stride."

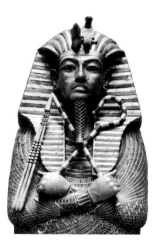

22 *(Above) Second coffin of Tutankhamun. Valley of the Kings, Thebes, Dynasty 18. Egyptian Museum, Cairo.*

The representation of the human form in Egyptian coffins and sarcophagi also shows the same symbolic variation. The basic anthropoid shape provided an alternative "body" for the spirit of the deceased, and the "rishi" feather patterning which was added to this form during the early New Kingdom suggested the embracing wings of protective goddesses or the bird-like *ba* of the deceased himself. The curved beard, crossed arms, and crook and flail added to some royal coffins associated the dead king with Osiris. All of these details of form are found on this coffin of Tutankhamun.

The Programmatic
Use of Forms:
the Egyptian Temple

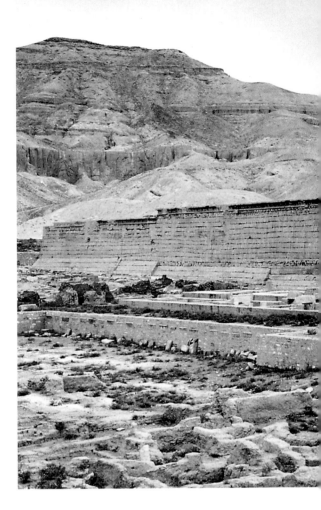

23 *Mortuary temple of Ramesses III. Medinet Habu, Thebes, Dynasty 20.*

Nowhere is the principle of "form follows concept" more clearly seen than in the design and decoration of the developed Egyptian temple. From the time of the New Kingdom, Egyptian temple design consciously reflects the unique nature of the Egyptian view of the cosmos, as well as the nature of the king and his all-important role in that view of the universe. Details of the temple's decoration also show a programmatic approach to the representation of the pharaoh. On the entrance pylon and outer walls of the temple the Egyptian king is often depicted as a colossal figure, representing the gods to humankind by defeating enemies and controlling the powers of chaos which might threaten the divine dwelling. In the inner parts of the temple, however, the king is shown on a much smaller scale, as the representative of humankind who carefully attends the needs of the gods and who receives their blessings and promises of support.

24 *Schematic view of a developed Egyptian temple.*

Each temple was constructed as a cosmos in itself. The roof was the sky of this miniature world, and was usually decorated with stars and flying birds which represented protective deities. The floor, correspondingly, was regarded as the great marsh from which the primeval world arose. Thus, the lower sections of the temple walls were often decorated with representations of papyrus and other plants, and the great columns of the pillared courts and halls were usually made to depict palm, lotus, or papyrus plants – represented in this illustration by the hieroglyphic sign for a papyrus stem 𓇅 .

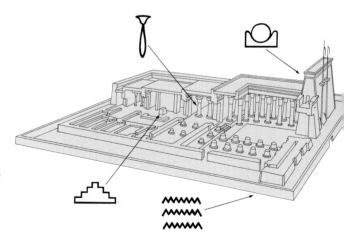

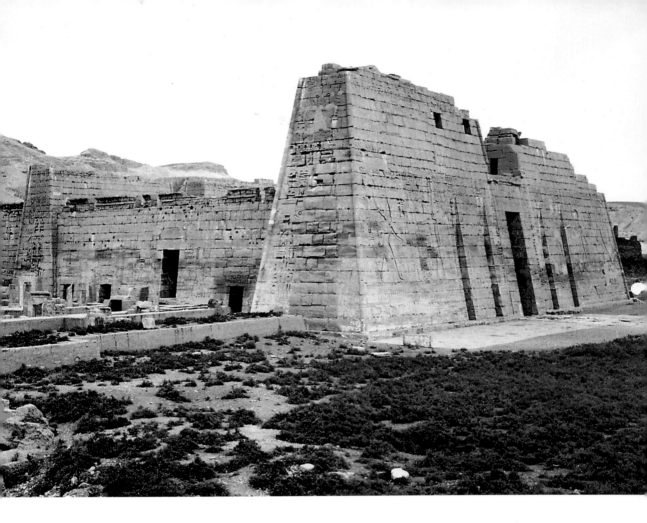

This marsh-like environment provided the approach to the raised inner sanctuary which symbolized the primeval earth mound that rose from the waters at the world's beginning (represented by the staircase-like sign for this mound ⛰).

In the same way, the *temenos* wall which surrounded the temple complex was sometimes built on an alternating concave and convex foundation bed to represent the waves of the watery environment of the First Time – here shown as the sign for a body of water ≈ .

Just as these elements of the temple's structural design symbolized the original creation of the world, other aspects represented the cyclic, ongoing nature of the creation. Because the Egyptian temple was theoretically aligned on an east–west axis (though the actual alignment was usually based on the Nile River – even when it curved in its course), the two pylon towers of the temple's entrance symbolized the two mountains of the horizon between which the sun rose each day. The pylons form the shape of the hieroglyph for "horizon" ☉ , and in an inscription carved at the entrance to the temple of Edfu the pylons are specifically called "Isis and Nephthys who raise up the sun god who shines on the horizon."

MEASURE AND MEANING
the symbolism of
SIZE

"I know that Field of Reeds which belongs to Re ... the height of
the barley is five cubits, its ear is two cubits and its stalk is three
cubits ... They are spirits, each nine cubits tall, who reap it ..."
Book of the Dead, Chapter 109

WHILE the relative size of objects is rarely of symbolic significance in modern works of art using visual perspective, in ancient Egyptian art the opposite is true. In Egyptian sculpture and two-dimensional works, differences of scale rarely reflect visual reality. As in many other ancient cultures, the size of objects and figures is more often a result of the principle of relative importance, and hierarchic scaling – showing gods and kings depicted larger than lesser beings – was used from the earliest dynastic period. This practice undoubtedly arose at a time when physical size was directly equated with physical strength, but the principle was almost immediately developed to the point where the king is not simply a bigger man than his subjects – but a being on an altogether different plane. The principle then becomes symbolic of power and importance rather than indicative of strength alone. This is seen in the fact that early Egyptian art often exhibits not a simple dichotomy of king and subjects, but a gradation of the sizes of king, vizier, and servants (ill. 28). Beginning in the Old Kingdom, the same relative scaling was employed in the funerary representations of private individuals and their families, so that differences of size within a composition are usually – though by no means always – meant to represent differences of relative importance. Yet basic as this principle may be, it has a number of subtle and interesting ramifications which directly affect our understanding of the symbolism of Egyptian art.

The Massive

The enlargement of certain subjects in representational works may be the result of a number of different factors, as noted by Heinrich Schäfer in his masterly study of Egyptian art: "In sophisticated art like the Egyptian there are two sides to the emphasizing of figures. On the one hand it is a factual statement of importance without aesthetic meaning . . . [and on the other hand] . . . Egyptian artists of all periods were well able to appreciate the great advantage for construction and composition of exaggerating the size of certain figures."[1] Sometimes, as Schäfer states, the enlargement of certain objects within a scene appears merely the result of artistic license, or whim, as when a marshland butterfly is drawn almost the same size as a duck, a man as big as a nearby house, or a coffin twice as big as the tomb meant to receive it. Yet in many of these instances the enlargement may be based upon the relative importance in the artist's mind of the objects portrayed.

In some cases there may be mythological reasons for the depiction of certain objects or figures at large scale. According to Egyptian beliefs, for example, not only were the dimensions of the underworld of huge proportions, but many of the inhabitants and other aspects of the afterlife were also massive – a phenomenon described in spells 109 and 149 of the Book of the Dead. In the tomb of Sennedjem at Thebes, the deceased and his wife Iyneferti are thus shown in the eternal fields – harvesting grain as tall as they are (ill. 29).

The use of larger than life-size representational works was also stressed at different times, and massive works of sculpture and relief were produced not only when economic conditions allowed, but also when the symbolic statement made by the massive was especially important from a political standpoint. Dimensions larger than those of nature first appear regularly in the art of the Fourth Dynasty, and continued to be used throughout much of Egyptian history, usually for the benefit of the king. This is not always the case, however, for in some periods of decline when the power of the Egyptian pharaoh reached a low ebb, there is an increase in the size of the statues of provincial rulers, whose sometimes colossal representations make pointed political statements.[2]

Under the later monarchs of the Eighteenth and Nineteenth Dynasties the New Kingdom tendency toward the massive in art and architecture reached its apex. The trend begins with the construction of Hatshepsut's mortuary temple and continues for several hundred years, with the works of Amenhotep III and Ramesses II (1290–1224 BC) being unsurpassed in number and size. The penchant of these

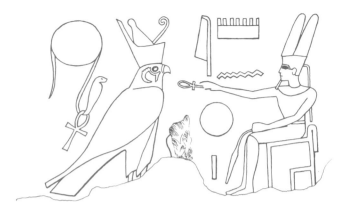

25 *Enlargement commensurate with status: the king as a great falcon before Amun.*

two kings for the colossal in sculptural and architectural forms must be experienced to be truly appreciated. It was the former – Nebmaatra Amenhotep – who first made the colossal statue a hallmark of royal sculpture. Among his representations are the two seated giants known as the Colossi of Memnon which front the area of the king's long-vanished mortuary temple at Thebes (ill. 30). Ravaged by time, the images still impress by size alone and even without their fallen crowns these statues stand over sixty feet high.

Originally even larger, and the largest of a number of freestanding colossi sculpted during the reign of Ramesses II, was the great seated figure which now lies, toppled and fragmentary, in the court of that king's mortuary temple in the same area of western Thebes. This titanic figure of Ramesses – originally weighing over a thousand tons and standing at least 66 feet high – was the subject of Shelley's poem "Ozymandias." The colossus was given a special name, had its own attendant priesthood, and was venerated as a god in its own right – or at least as an intermediary between humans and the gods, for this massive figure, like many somewhat smaller ones, functioned as a manifestation of the spirits of the divine kings of Egypt protecting the temples of the gods in which they were placed. But the superhuman size of these statues cannot be seen as entirely the result of this association with divinity, and other factors, quite probably of a propagandistic nature, were surely involved in the choice of their dimensions. The gigantic statues of Ramesses II which project from his rock-cut temple at Abu Simbel on Egypt's southern frontier probably served such a purpose, with a clear message of pharaonic might directed toward Egypt's southern neighbors.[3]

It has frequently been noted that the representational program for Egyptian temple reliefs places scenes of warfare, the delivery of captives to the deity, smiting of captives, and hunting of wild animals on the outer walls of a given structure for apotropaic reasons, to ward

off evil (see Location). It may also be an important aspect of this same program that the figures of gods and the king are usually drawn much larger in these depictions than those within the temples. This size is of course made possible by the larger outer walls, but the larger scale does seem to have been used consciously, for these walls could just as easily have been divided into more registers with their figures drawn at the same scale as those within the temple. The massive size of some of these outer figures certainly could have had a symbolic basis – both in terms of increasing the apotropaic power of the representations, and also in impressing the human viewer, for they appear in precisely the areas to which the Egyptian population – and foreign visitors – had access. As Amenhotep III is reported to have said of his additions to the Luxor temple: "Its pylons reach to the sky, its flagpoles to the stars. When the people see it they give praise to his majesty."[4] In spite of the hyperbole, we see in this statement that the temple entrance was a most suitable location for propagandizing representations of both a religious and national – and perhaps even dynastic – nature; and that the desire to awe may certainly have been an important factor in the minds of the kings who created these huge structures.[5]

The proportions of later temples seem to have held specific symbolic significance, and at Edfu, for example, inscriptions on the temple walls record many of the measurements of the structure, explaining the dimensions through mythological references. Without textual or inscriptional clues, however, it is hard to judge whether such concerns attended the dimensions of earlier structures and especially the great pyramids of the Old Kingdom – the largest structures ever created in the ancient world. Much has been written of a mystical nature on their size and proportions (see Number) – especially about the Great Pyramid of Cheops (2551–2528 BC). But more important by far than such things as the units of measurement involved in the design of the pyramids is the sheer size of the structures themselves – a factor which visually impresses and suggests symbolic significance well enough without reference to the mysterious or the arcane.

A final aspect of the Egyptians' use of the massive is seen in what Erik Hornung has termed "extension of the existing," by which Egyptian kings constantly attempted to expand upon the works of their predecessors. Throughout the New Kingdom, the courts and pylons of temples were added to and made ever larger, and the rock-cut tombs of the pharaohs were also constantly enlarged in their dimensions,[6] until in Ramesside times the number of chambers and passages was sometimes double that found in earlier tombs.

Eventually, of course, limits were met, but the production of massive works of art and architecture remained a symbolic indicator of the Egyptian king's power and his desire to maintain and exceed the established traditions of greatness.

The Minuscule

Although the massive and larger-than-life works created by the Egyptians may command our attention and suggest great significance through their size, it is nevertheless true that the smallest objects may be just as endowed with symbolic importance. There are as many minuscule representations of Egypt's kings as there are huge colossi. It is ironic but perhaps equally instructive, for example, that the only representation that has survived of Cheops, the builder of the largest structure of the ancient world, is a tiny ivory statuette just 7.5 centimeters (3 inches) tall. Although this statuette was perhaps produced much later than the time of the king himself,[7] small-scale figures of many other Egyptian kings are known, and it must be remembered that because such figures are far more easily lost or destroyed than larger ones, probably a good many more were made. These small figures were evidently viewed as important in the context of their own use for commemorative ritual and mythical purposes. Thus, certain small figures of the god Amun-Re depicted behind royal shrines seem to indicate symbolically the function of the king as intermediary for the god.[8]

This is not to imply that all small-scale figures or objects are symbolically significant in some way. In three-dimensional works of art diminutive size may be purely a matter of artistic experimentation or a display of skill. The Egyptians delighted in intricately formed jewelry, for example, sometimes produced at the very smallest scale. A cache of tiny glass beads found on an excavation in which the present writer took part consisted of beads so small – about two millimeters (just over one-sixteenth of an inch) across – that they could only be threaded on a hair-thin wire.[9] Such fine items of jewelry were sometimes worn in life, but in other instances, diminutive models used in funerary contexts functioned as magical replacements for full-scale objects. Thus, tiny implements were buried as symbolic foundation deposits when work commenced on the construction of some New Kingdom royal tombs; and many small models of servants, offerings, and various domestic items such as storage jars made in the shape of model granaries, or as imitation sacks, and even detailed model houses and farms were included in the funerary furniture deposited in Egyptian tombs. All of these items substituted for the

objects they depicted and provided magically potent assistance for the deceased's afterlife.

In two-dimensional works, reduction of size may occur for various reasons. The practice sometimes appears as a kind of compositional aid whereby the ancient artist manipulated images in order to better fit them into a scene. This kind of reduction is seen in representations showing men with offerings including diminutive cattle – depicted the same size as ducks and geese and seeming ludicrously small from the viewpoint of visual perspective (ill. 31). For the Egyptian, however, such reduction of size allowed the artist to fit elements neatly into a composition which would otherwise completely fill or not fit within the available space, or which would only allow the depiction of one such object when many were intended. The practice also sometimes achieves a perfectly logical expression of the relative importance of the elements of the composition – in this instance saving the human from appearing less significant than the animal, the giver than the gift. In this sense, although compositional reasons predominate, the reduction of size may certainly be seen as having symbolic significance to at least some degree.

Reduction also allows manipulation of images in other ways which are sometimes, yet not always, symbolic. In some representations in private tombs, where the tomb owner, drawn large, sits before multiple registers containing smaller figures bringing offerings, a scribe holding a statement or list of the offerings being presented may be placed at the front of the register closest to the tomb owner's face. Here, the diminution of the scale of the minor figures allows the document to be placed in a position where it is symbolically "readable" for the master or mistress of the tomb.[10]

Occasionally, different scales may be used to portray the same individual at the same time. In the coronation scene from the sanctuary of Philip Arrhidaeus (323–316 BC) at Karnak, for example, the final, culminating scene of this representation shows the adult king kneeling before the god Amun-Re and receiving his approval, while directly behind the figure of the god the consort of Amun, the goddess Amaunet, is shown nursing the tiny infant king at her breast. The temporal illogic involved in depicting a person twice – at very different ages – in the same scene was of little concern to the Egyptians. For them the dual images were purely symbolic and represented an effective way of stressing the king's predestined role as well as his status as a child of the gods. Similarly, in the tomb of Ra-kha-ef-ankh at Giza, the tomb owner is shown full-scale before a number of registers in which the much smaller figures of workmen are represented engaged in various agricultural tasks, and he is also

26 *Scene from the tomb of*
Ii-nefret at Giza.

shown as a small but otherwise identical figure standing among the
workmen in the midst of one of the registers – evidently overseeing
the work being done.

Most often, reduction is merely a matter of hierarchical status, as
in the many Old Kingdom depictions of a tomb owner whose son –
shown as though only inches tall – clutches the base of his father's
staff (ill. 38). Another generic scene found in many private tomb
paintings, that of a family shown boating together in the marshlands,
often utilizes the same principle carried to an extreme degree of
application. In the Sixth Dynasty tomb of Ii-nefret at Giza (ill. 26), the
tomb owner is shown (as to a slightly lesser degree is his wife) at the
same scale as the background elements of papyrus and wildfowl
while the boatmen who propel their skiff are far smaller. But among
the boatmen the scale is also varied. The important men who stand at
the boat's prow and stern to assist in the steering are shown at a larger
scale, while the numerous rowers are drawn at about half their size.
The various species of wildlife depicted in the scene also receive the
same hierarchic scaling, and the hippopotamus and crocodile in the
lower right foreground are shown on a far smaller scale than the
compositionally more important wildfowl which are the main objects
of the painting's theme.

But hostile creatures such as the crocodile and hippopotamus are
also sometimes represented at very small scale in order to diminish
their magical influence. The hippopotami which represent the god

Seth on the wall reliefs of the Ptolemaic Temple of Edfu are thus shown as tiny, relatively helpless-looking animals easily overpowered by the figures of the king and the gods who assail them. The New Kingdom depiction of captive enemies at an extremely diminutive scale beneath the royal throne, on footstools, and in other locations may also have carried this same symbolic connotation of weakness and defeat.

Symbolic significance may sometimes also be achieved through the inclusion in a composition of a subject which is naturally small. To a certain extent, this is true of statues and other representations of dwarfs since dwarfism could carry a level of prestige in ancient Egypt. Dwarfs played a specific role in some funerals, and it was one of the functions of some dwarfs, like Pygmies, to "rejoice the heart" of the king by dancing before him. Statues of a number of high-ranking dwarfs have been found in their tombs in a special cemetery close to the Great Pyramid at Giza. Because people were almost universally depicted in their funerary statues as perfect physical specimens, we can only assume that the portrayal of dwarfs in their natural state was a positive statement indicating the prestige that society accorded them.

The interrelationship of status and smallness of size becomes even more apparent in the case of the relationships of adults with high-ranking children. In the series of pair statues which have survived showing Hatshepsut's (1473–1458 BC) chief minister Senenmut with his young ward, Princess Neferrure, Senenmut and the princess are shown in a variety of poses, all of which imply a degree of affection of the older man for the child. Yet it has been pointed out that a close examination of these statues reveals a message of a very different kind. In none of the best preserved statues do the steward and child actually look directly at each other, and in several it is evident that the princess is actually being held in the manner of a small shrine or perhaps a staff or other badge of office, depending upon the composition. The statement made by these works is in fact, "less one of affection than a proclamation of Senenmut's economic and political prestige ... a 'boast' of his status."[11] It must not be forgotten, however, that such a situation is only possible as a result and a direct function of the princess' youth and small size. If she had been older, or represented as larger, the steward could not have been shown in such intimate spatial relationship with the child, nor could her representation have been manipulated as a "badge of office" in the ways described. These statues provide, then, examples of how the Egyptian artist might use a subject of diminutive size for symbolic – and in this case propagandistic – purposes.

Equality of Size

Less obvious than the two extremes of enlargement and reduction, yet frequently of a very real symbolic significance, is the concept of equality of size. Actually, two aspects must be considered under this heading – isocephaly and equality of scale.

Isocephaly (from two Greek roots indicating heads drawn on the same line) denotes equality between subjects, or maintains a hierarchical difference by placing the heads of two or more figures at the same level so that a figure of lesser importance does not look down upon a more important figure. Isocephalic representation is thus commonly employed in scenes involving the Egyptian king and the gods. A fine example of its application is found on the rear wall of the upper pillared hall in the tomb of Seti I (ill. 34). In this scene Seti (1306–1290 BC), accompanied by the falcon-headed Horus, is introduced to the enthroned Osiris and the goddess Hathor in her guise as goddess of the west. The king and the god Horus are shown at essentially the same height – as is usual in the representation of kings and deities together, because the two are shown as essentially near equals – but the principle has been carefully maintained throughout the composition. Although seated, the great god Osiris is elevated upon a platform to the extent that his head is level with those of the figures before him, and the figure of the goddess Hathor has been depicted on a much smaller scale so that she too should conform to the same level of height.

Isocephaly is seen again in many representations where a king confronts the statue of a deity. In these instances the figure of the god is often portrayed at a slightly smaller scale than that of the king so that the two appear to be of equal height when the statue is placed upon its plinth. It is as though having the king looking down upon the image would diminish the deity just as the greater height of the god would undermine the theological position of equality held by the king.

In private representations, isocephaly is used in a similar manner. In instances where a man and wife stand or are seated side by side, the height of the two figures is often identical. Although some couples undoubtedly were of the same height, it is unlikely that this fact accounts entirely for equal size in certain paintings and statues. Frequently, the equality of size is simply the result of the figures being constructed on the same artistic grid with the same canon of proportions though, as Gay Robins points out, "... some periods, like the first half of the Eighteenth Dynasty, favour couples of the same height, while others, like the second half of the Eighteenth Dynasty,

more often reduce the size of the woman's figure."[12] Isocephalic manipulation of reality is also clear in instances such as group statues where a chief wife is shown at the same size as her husband while lesser wives are depicted on a smaller scale – sometimes between that of the chief wife and children. The application of this principle is also seen in the celebrated Old Kingdom statue of the dwarf Seneb and his wife, where it actually occurs in reverse. The couple is shown seated together, with the diminutive figures of their son and daughter before the dwarf, who sits with his legs drawn up beneath him and in such a way as to present his head at the exact level of that of his wife (ill. 36). It has often been observed that the positioning of the two children where the man's legs would normally be visually completes the composition and also serves to increase the apparent stature of the dwarf. The work is thus completely successful in stressing, through isocephaly, the importance and dignity of Seneb.

The principle of equality of scale functions in a similar manner to that of isocephaly, and is expressed in the manner in which more important figures are never shown smaller than figures of lesser importance. Sometimes, however, equality of scale is a result of representational concerns and has no real symbolic significance. If, for example, two figures are depicted in the same register of a composition, the one standing and the other seated or squatting, the height of the latter may be compensated for and the two figures represented as being the same height. Sometimes, of course, the seated person may be more important and thus the equality of size reflects the higher status of the seated individual. On the other hand, in many examples this is not the case. Where, for example, a row of figures ascending a staircase is depicted so that the top of each figure is at the same height, this clearly cannot be symbolic.

Another situation exists in which equality of size is not really symbolic. In works from the earliest dynastic period the Egyptian king is depicted despatching enemies in the classic "smiting scene" (see Actions). In these scenes, the king and one or more of the enemy are the main figures in the composition and may therefore be shown as being the same size. In the temple reliefs of the later New Kingdom the king is frequently shown in the midst of battle grasping an enemy who is drawn at the same scale while other enemy figures shown on the same ground line are much smaller. Thus, in a depiction of Ramesses II attacking an Asiatic city, the king grasps the head of an enemy which protrudes from the top of the enemy fortress (ill. 37). The enemy's head and upper body are impossibly large for their setting but provide realism of scale in relation to the king for the key central area of the representation. In scenes such as this the enemy

figure shown at the same scale as the Egyptian king is a type figure representing the enemy as a whole.[13] Hierarchical dominance is maintained, however, in that the heads of the king and his foe are never shown at the same level – equality of scale is employed, but not isocephaly.

Relative Proportions

Beyond the symbolism associated with the relative size of different figures or objects, the relative proportions of the parts of a single figure must also be considered when attempting to understand the symbolism of size. Proportion was not something left to caprice in Egyptian art, and in sculpture at least, it may often be based on the accurate portrayal of individual appearance. Although relatively little work has been done in this area a start has recently been made. In studying the proportions of several Eighteenth Dynasty monarchs, Betsy Bryan found that sculptures of Hatshepsut (1473–1458 BC) and Thutmose III (1479–1425 BC) (often said to be depicted as virtually identical in build) showed specific differences in their relative proportions particularly through their upper body widths and thicknesses – proportional changes which are distinctive enough that they must have been intentional. Bryan found, for example, that Hatshepsut was quite consistently depicted as being relatively narrow from waist to neck while Thutmose III was portrayed as broader shouldered though slim waisted with an hourglass-like figure. Many statues of Amenhotep III likewise showed an average shoulder width but greater breadth at the breast and waist.[14]

Some proportional differences were undoubtedly based on the actual physiques of the individuals depicted, though others must reflect the result of idealizing tendencies and stylistic considerations which changed through time.[15] It is also true that the physiques, just as the features, of the Egyptian kings were often echoed in those of private persons, and the bodily proportions of both royal and non-royal persons may thus sometimes bear little resemblance to reality. Sometimes, however, the relative proportions assigned to an individual do take on an added symbolic significance.

The wealthy Egyptian, from relatively early times, was often portrayed in two very different manners in his tomb representations: as a young man, enjoying the physique and strength of youth; and as a much older, often rather corpulent man, enjoying the rewards of a successful career. In the latter case, the proportions of the body are usually changed only in the area of the torso where rolls of fat are evident around the midriff and the breasts are often heavy and

drooping. Far from being a caricature, this portrayal of the mature man is nevertheless not entirely based on reality and is primarily a symbolic statement of a kind of generic corpulence associated with age and social status. A fine example of this may be seen in a scene from the Old Kingdom tomb of Ra-kha-ef-ankh already mentioned (ill. 38) where, on opposite sides of the false door of his mastaba, the tomb owner is shown as a young man and as an older, more portly individual. The juxtaposition of the two images in cases such as this shows very well their symbolic nature and intent.

Exaggerated or adjusted as they may be, such examples are based to at least some degree on real differences of proportion relative to age. Even more interesting and surely no less symbolic is the radically disproportionate sizing of specific body parts which is found in a number of contexts throughout Egyptian art. A seated statue of the Fourth Dynasty king Mycerinus (2490–2472 BC) in the Boston Museum of Fine Arts[16] depicts the king with a head which is relatively small compared with the massive torso on which it is placed. While the many other statues of this king show him with naturally proportioned head and body, it can only be assumed that the head of this particular work was intended to heighten the effect of the massive body, and thus to underscore symbolically the king's physical strength and might.

Similarly, a statue of Mentuhotep II (2061–2010 BC) in New York's Metropolitan Museum of Art shows the king as Osiris with the curled beard and crossed arms of the god, standing in a mummy-like pose on a tall rectangular base which is part of the same block of stone. The extraordinary thing about this portrait, and the similar seated statue of the king in the Cairo Museum[17] (ill. 39) – both from the courtyard of the king's funerary temple at Thebes – is the disproportionate heaviness of the lower limbs which gives a feeling of power and massiveness. While it has been suggested that the legs and feet of the standing statue were purposely rendered as large as they were in order to enable the statue to stand without support, the parallel seated statue in Cairo which exhibits the same trait shows that the effect was undoubtedly for visual and not practical purposes. The result is the conscious portrayal of a heavy and almost barbaric forcefulness which may have had its origins in the monarchical ideology of its time. If this is the case, then the disproportion must be viewed as a variant of the kind seen in the Mycerinus statue, and of a similar symbolic intent. If this supposition is correct, then the exaggerated proportions displayed in certain other Egyptian works, such as the unrealistically large ears shown on statues of several Middle Kingdom monarchs, may also be symbolic – possibly

27 *Adjusted proportions:*
personified wedjat *eye,*
from a Book of the Dead
vignette.

signifying the king's ability or willingness to hear the prayers of the people. The ears of a well-known statue of Amenemhet III (1844–1797 BC) in Cairo, for example, are almost half the length of the face to the headdress and can hardly be realistic.

Such representational manipulation for symbolic reasons is found in the later New Kingdom depictions of Amenhotep III. This monarch ruled Egypt for some 38 years during which time he apparently grew quite corpulent as may be seen from a number of representations which have survived from the latter half of his reign. In his thirtieth year Amenhotep celebrated a *sed* festival or renewal jubilee (his first of three) in which he declared himself divine. It was at this point that the aging Amenhotep seems to have adopted a "juvenilizing" style showing himself in a much younger, leaner fashion.[18] This style was clearly a symbolic reflection of the profound rejuvenation which was believed to occur in the *sed* festival, and which was surely heightened by Amenhotep's assumption of divinity. During this same final period of his life, Amenhotep continued to allow himself to be portrayed with a more realistic obesity – possibly as an expression of divine fecundity, or simply in naturalistic portrayal – but the symbolic juvenilizing style was also used to a considerable degree.

The art of Akhenaten (1353–1335 BC), heir and successor of Amenhotep III, is even more remarkable in its use of bodily proportion. Because Akhenaten was frequently portrayed with short legs and spindly arms, but a long neck, protruding belly, heavy buttocks and thighs (ill. 40), it was long assumed that these proportions were the result of some physical abnormality or disease. Many scholars have recently begun to lean toward the idea that these

strange proportions were chosen for symbolic reasons, however, possibly to incorporate divine female imagery into the iconography of the king who proclaimed himself to represent a single god which subsumed both male and female. This interpretation is perhaps supported by the fact that the most extreme representations appear during the earlier – theologically more radical – period of Akhenaten's reign, and representations made later in the king's reign are far more moderate.[19] Whatever the reason, Akhenaten's distorted proportions were extended to representations of members of his court and also continued to be utilized to some degree in the depiction of the succeeding "Amarna Age" kings, Tutankhamun and Ay (1323–1319 BC), finally disappearing under the reign of Horemheb (1319–1307 BC) almost a quarter of a century later.

Sometimes exaggerated relative proportions are more easily understood. As in many other cultures, early Egyptian art often displays exaggeration of primary and secondary sexual characteristics in human figures such as the so-called "paddle dolls" where the enlarged lower half of the figure is decorated as a greatly enlarged pubic triangle (ill. 41). The sexual symbolism associated with such representations was employed throughout Egyptian history. Figures of men with grossly exaggerated generative members were also often produced, and groups of such male figures shown engaged in sexual activity with females are common in the Greco-Roman Period.[20] These figures were probably intended to magically increase male potency – which, like female fertility, was an important issue in societies which depended on family labor. In some cases the desire to carry on a family line may also have been an important factor in the production of such magical figures.

Thus, while Egyptian art usually strove to depict the various parts of the body in a fairly accurate manner and according to a carefully thought out canon of proportions, a number of conscious departures from realistic or canonical representation reveal the symbolic significance of their relative proportions.

The Massive

28 *King Narmer in procession. Narmer palette, Predynastic Period. Egyptian Museum, Cairo.*

Depicted on the same base line as the members of his retinue, Narmer is portrayed at a vastly greater scale in order to differentiate him from the surrounding figures and to confirm his higher status. The same principle is applied, to a lesser degree, to the smaller sandal-bearer behind the king and the figure immediately before who are themselves accompanied by hieroglyphic labels and shown on a larger scale than the undifferentiated standard bearers.

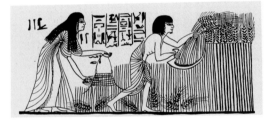

29 *Senedjem and his wife in the Fields of Iaru. Tomb of Senedjem, Thebes, Dynasty 19.*

According to Egyptian mythology, many aspects of the afterlife exhibited supernatural size. Not only were the dimensions of the underworld of huge proportions, but many of the inhabitants and other aspects were also massive. Afterlife was much like the present life with similar activities to be performed, but with bigger or better results. Senedjem and Iyneferti are thus shown working in the eternal fields – harvesting grain which grows to the height of their heads.

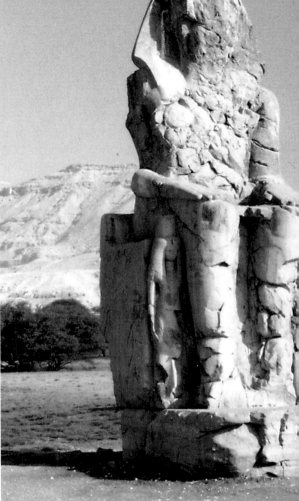

30 *Colossi of Amenhotep III. Thebes, Dynasty 18.*

Under the later monarchs of the Eighteenth and Nineteenth Dynasties, the New Kingdom tendency toward the massive in art and architecture found its apex in the works of the great builders Amenhotep III and Ramesses II. These kings had literally dozens of colossal figures of themselves constructed and placed within the confines of temples throughout Egypt.

Among the largest of the freestanding colossi carved during the reign of these kings

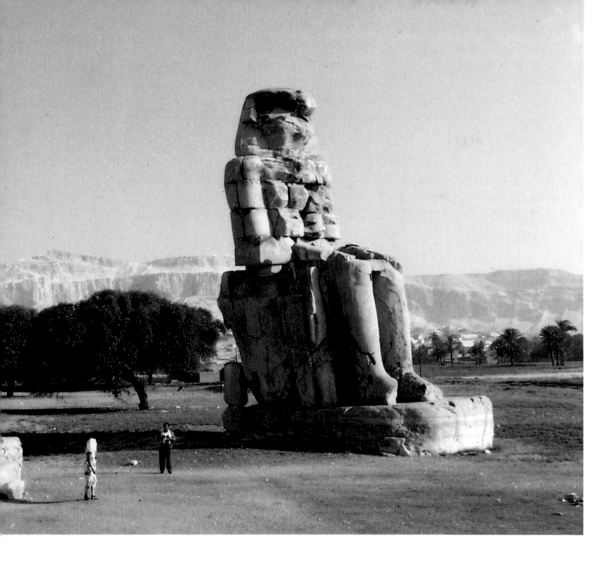

were the so-called Colossi of Memnon (named by the Greeks in honor of the mythical son of Aurora, goddess of the dawn, because of the sound emitted by one of the two figures each day at sunrise). These great statues are virtually all that remains of the massive mortuary temple built by Amenhotep III on the western bank of the Nile at Thebes. Over 60 feet (18.3 meters) high, these colossi weigh hundreds of tons and were transported from quarries hundreds of miles distant. Such colossi had their own attendant priesthoods and were venerated as intermediaries between humans and gods, functioning as a manifestation of the divine spirits of Egypt's god-kings of the past. Yet the superhuman size of colossal statues was perhaps not entirely the result of their association with divinity. The massive colossi of the rock-cut temple of Ramesses II at Abu Simbel on Egypt's southern border, for instance, may well have served at least some symbolic and propagandistic purpose, the sheer scale of the building stressing the awesome nature of Egypt's power to her sometimes unruly neighbors.

The Minuscule

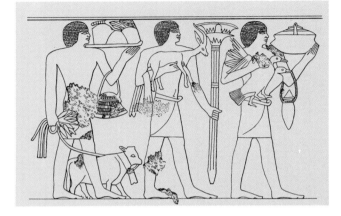

31 (Above) Offering bearers with minuscule bull. Tomb of Mereruka, Saqqara, Dynasty 6.

Egyptian artists used reduction of scale for two distinct purposes, on the one hand for status differentiation, and on the other for purely artistic, compositional reasons. Here, the bull being presented along with much smaller living offerings – antelope and ducks – is drawn to fit neatly within the available space rather than being allowed to dominate the composition as it would have done had it been drawn at actual size. This down-scaling also allows a large number of objects, figures, or animals to be shown at once. At a symbolic level reduction in size may sometimes serve to maintain a hierarchical order so that the offering does not appear more important than the offerer, the giver less than the gift.

32 Sennefer with his wife Senay and their daughter Mutnofret. Karnak (near hypostyle hall), Dynasty 18. Egyptian Museum, Cairo.

Frequently, status differentiation is the primary purpose of the depiction of certain figures at a reduced scale in Egyptian art. Here, the fully adult daughter of the mayor Sennefer is shown standing between her seated parents as though she were a tiny child. Yet Mutnofret's figure and wig leave no doubt as to her actual maturity. In many Old Kingdom tomb scenes the tomb owner is likewise depicted with the staff and scepter which are symbols of his office and prestige, while the tiny figure of his son is represented as grasping the bottom of the staff. This type of conventional depiction appears, in fact, in many representations of family groups.

33 *Battle scene of Ramesses III. Medinet Habu,*
Thebes, Dynasty 20.

This famous representation celebrates the
victory accomplished by Ramesses III over
the "Peoples of the Sea" who attempted to
invade Egypt during his reign in the twelfth
century BC. The tiny bound captives beneath
the king's feet are primarily meant to
represent literal enemy troops captured in the
battle which is depicted, but they are also
reminiscent of the generic "Nine Bows" or
enemies of Egypt which are often represented
as ethnically differentiated captives beneath
the king's throne, beneath his feet on statue
bases, or on the soles of his sandals. While the
battle scenes recorded on temple walls and in
other settings routinely show the Egyptian
king at a much larger scale than his enemies,
scenes such as this which show the direct
contact of the differently-sized figures
heighten the hierarchical effect of the
representation by emphasizing the
helplessness of the enemy and the Egyptian
king's apparent superhuman power. Other
representations which show the king grasping
or even carrying multiple diminutive enemy
figures serve an identical purpose.

The Symbolism of Size 55

Equality of Size

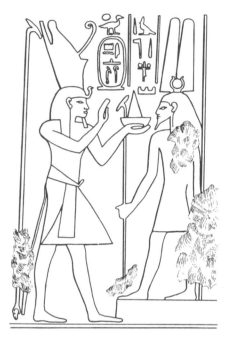

34 *The king before Osiris and Hathor. Tomb of Seti I, Valley of the Kings, Thebes, Dynasty 19.*

The principle of same-sizing – to suggest equality or near-equality of status – may be achieved through both isocephaly and equality of scale. Isocephaly indicates equality between subjects, or maintains a hierarchical difference by placing heads of figures at the same level so that an individual of lesser importance does not look down upon a more important figure. In this scene, Osiris is elevated on a platform to the exact extent that his head is level with those of the figures before him, and the goddess Hathor is depicted on a much smaller scale, so that she too conforms to the principle of isocephaly.

35 *Amenhotep III before the statue of a deity. Stela detail, Dynasty 18.*

Isocephaly is also seen in instances where a king confronts the statue of a standing deity. Here, the usual method of portrayal is to depict the figure of the god at a slightly smaller scale than that of the king so that the two appear to be of equal height when the statue is placed upon its plinth. It is as though having the king looking down upon the image would diminish the deity, just as the greater size of the god would undermine the theological position of equality held by the king.

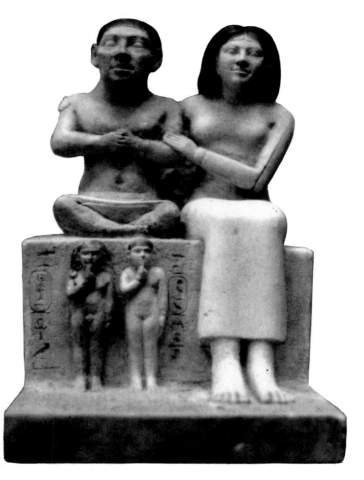

36 *(Right) The dwarf Seneb and his wife. Giza, Dynasty 6. Egyptian Museum, Cairo.*

In instances where a man and wife stand or are seated side by side, the height of the two figures is often identical. Such representations are usually the result of artistic convention, and the manipulation of reality is clear in group statues where a chief wife is shown at the same size as her husband while lesser wives are depicted on a somewhat smaller scale. In this celebrated Old Kingdom statue of the dwarf Seneb and his wife and children, Seneb is portrayed with his legs drawn up beneath him and his head artificially raised to the exact level of the head of his wife.

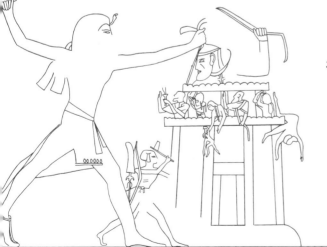

37 *(Left) Ramesses II attacking an Asiatic city. Beit el-Wali (near Aswan), Dynasty 19.*

Equality of scale does not always imply equality of status. In some battle scenes, a single enemy figure is depicted at the same scale as the Egyptian king in order to represent the enemy as a whole. In this example, Ramesses II grasps an enemy who is impossibly large for his setting but who functions as a type figure in this way. Hierarchical dominance is maintained in the composition, however, in that the heads of the king and his foe are not shown at the same level.

The Symbolism of Size 57

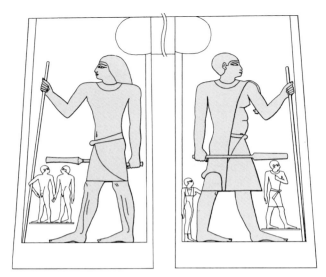

38 *Two representations of a tomb owner. Tomb of Ra-kha-ef-ankh, Giza, Dynasty 5.*

As is often the case in decorated tombs of the Old Kingdom, the tomb owner is here depicted twice: once as a young man, and again as an older, corpulent individual. This dual representation preserves the image of the deceased at the two most important points of life – when young, healthy and virile; and when somewhat older and comfortably successful. The symbolic nature of the latter depiction is seen in the way the limbs, neck, and face are not depicted with the extra flesh acquired with age and weight gain, but only the chest and torso which are depicted as broader and given several rolls of status-enhancing fat.

39 *Statue of Mentuhotep II. Deir el-Bahri, Dynasty 11. Egyptian Museum, Cairo.*

This statue illustrates another type of the adjustment of proportion seemingly for symbolic reasons. The seated figure of Mentuhotep is carved with massive legs and feet quite out of scale with the rest of the body. Such massiveness of certain features is known in other Middle Kingdom works and seems to reflect an artistic way of expressing the king's power and authority through the reaction of the viewer to such works. The impression given by these sculptures is one of a ponderous and almost barbaric strength.

58 *Measure and Meaning*

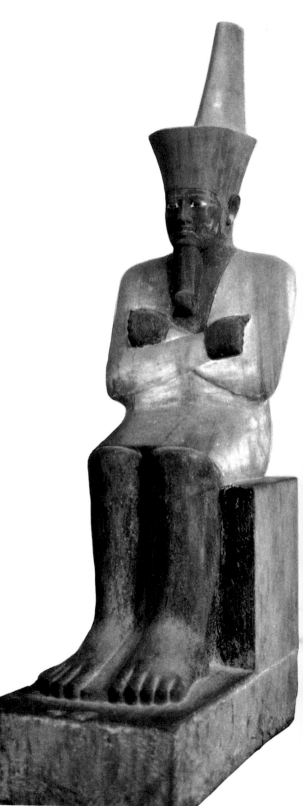

Relative Proportion

40 (Above) *Akhenaten and his mother, Queen Tiy. Tomb of Huya, Amarna, Dynasty 18.*

The odd-looking proportions seen in many representations of the heretic king Akhenaten were once assumed to be the result of some kind of congenital deformity or disease. Recently, however, the fact that the most extreme of these depictions date from early in the king's reign, while he is later portrayed with much more normal proportions, has suggested to some scholars that the odd proportions were exaggerated for symbolic reasons – perhaps in order for the king to appear as a fusion of the masculine and feminine aspects of the one god, the Aten, which he proclaimed, though this is unsure.

41 (Below) *Female "paddle-doll." Private tomb, Thebes (Assassif), Dynasty 11–12. Egyptian Museum, Cairo.*

"Dolls" such as this and figures of other types emphasizing and exaggerating male or female sexual characteristics were quite common over a long period of Egyptian history, though a higher percentage of such representations have survived from the later periods. The enlargement of breasts and hips in female figures and the exaggerated size of genitalia of both male and female images suggest that many of these figures were associated with fertility concerns, though some may have been intended as symbolic sexual partners for the afterlife.

POSITION AND PLACEMENT
the symbolism of
LOCATION

"Re sits in his abode of Millions of Years, and there assemble for him the nine gods with hidden faces who dwell in the Mansion of Khepri."

Book of the Dead, Chapter 65

THE DIMENSION of orientation and location is one of the most important of the symbolic aspects of Egyptian art, yet it is one which frequently goes unnoticed in all but its most blatant expressions. It may apply equally to the arrangement of individual elements within the smallest amuletic composition and the architectural programs of whole buildings and their decorative schemes. Its symbolic nature involves two separate aspects: absolute position and relative placement – the actual location of an object or structure, and the placement of the thing or individual elements within it relative to some other feature, area, or direction. Both of these aspects must be appreciated in order to grasp this subtle yet vital dimension of Egyptian art.

Absolute Location

Ultimately, we can only understand the locational aspect of Egyptian art to the degree that we are able to view the world from the perspective of the ancient Egyptian. According to this, Egypt was the center of the created world. Such a view transcended the merely chauvinistic or ethnocentric, since it was reinforced by the appearance of the creation itself. Egypt lay at the intersection of two great axes: the east–west axis of the sun's path and the north–south axis delineated by the River Nile.

A sarcophagus in New York's Metropolitan Museum of Art exhibits a cosmographic map of the earth and heavens which reflects

this attitude perfectly.[1] Although it dates to the Thirtieth Dynasty (fourth century BC), this "map" is doubtless based on much older ideas. Beneath the overarching body of the goddess of the heavens, the earth is represented as a disk composed of several distinct rings. The outermost apparently signifies the ocean, and within this circle, a large ring represents foreign lands and a third, inner ring contains forty-two standards representing the nomes or provinces of Egypt. In the very center of the composition the region of the underworld is depicted.

Within this cosmic framework, the Egyptians accorded special significance to certain specific areas – sacred or symbolic locations of religious and mythical importance (ill. 46). For example, Old Kingdom funerary representations commonly depict scenes relating to the burial practices of the ancient rulers of the city of Buto which functioned as a regional capital of Lower Egypt. The burial corteges of the predynastic rulers of this city seem to have visited the most important religious sites of the Delta – particularly Sais and Heliopolis, though other cities were sometimes included. Long after it ceased to represent an actual journey, however, the pilgrimage was maintained symbolically in the representational aspect of the Old Kingdom mortuary tradition through scenes depicting the funeral barge visiting Sais and Buto – the former site being represented by the shrine of the goddess Neith fronted by two flagpoles with triangular pennants, and the latter city, the site of the eventual burial, being represented by a row of vaulted shrines interspersed with palm trees.

The rise of the worship of Osiris, which had become important by Middle Kingdom times, meant that the destinations of the symbolic journey eventually were transferred to Abydos, the cult center and traditional place of burial of the underworld god in Upper Egypt. Here, a number of Egyptian kings built temples, a yearly festival was held, and the devout built tombs and chapels, or erected small stelae, or left offerings for the god. In the area known today in Arabic as *Umm el-Qaʿab* or "mother of pots," countless offering cups and jars were deposited – especially during the latest periods – and can still be seen littering the surface of the desert in the supposed area of the god's tomb. While many individuals must thus have made literal pilgrimages to this site, many of the representations that show the deceased traveling to Abydos by boat in New Kingdom tombs are doubtless as symbolic as their earlier Old Kingdom counterparts. The pilgrimage to Abydos was in one sense acted out in a symbolic fashion when the mummy of the deceased Egyptian was taken by boat across the Nile to its final resting place in the cemeteries of the west bank.

The Symbolism of Location 61

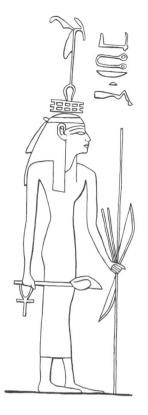

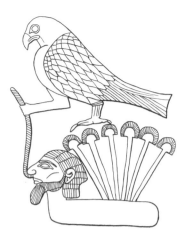

42, 43 *Personified locations: (42, left) the city of Thebes (detail, New Kingdom stela); (43, right) Lower Egypt (detail, Narmer palette).*

Many other sites and locations held religious and, therefore, symbolic significance in various parts of the country. The area of Abydos, already mentioned as the cult center of Osiris, was also *Ta wer* – "the great [or possibly first] place" – in reference to its supposed primeval importance. Similarly Esna, the major site of the worship of the creator god Khnum, was called "the divine hill, the top of which emerged from Nun [the primeval waters]," and Heliopolis, the city associated with solar worship, was the location of the *benben*, the conical or pyramidal rock which symbolized both the sun and the original creation. The Nile god Hapi was believed to dwell in a cavern beneath the rocks of the First Cataract at Aswan – the mythical place from which the Nile itself was believed to spring; and many other deities were connected with shrines and cult centers with similar mythological origins. The depiction of certain deities or their attributes may thus sometimes indicate, through association, specific sacred sites or locations. Often these locational symbols are paired or juxtaposed as representatives of Upper and Lower Egypt or are used to indicate some other aspect of geographic symbolism.

Another aspect of the symbolism of absolute location which must be kept in mind is that of mythical geography, and especially that of the underworld – for the Egyptians as "real" as the world of the living. During the Middle Kingdom the realm of the dead shifted from the heavens to the underworld, and from New Kingdom times the topography of the afterlife realm formed a mirror image of the world as the Egyptians knew it – a long river valley crossed by the sun on its nightly journey under the earth, and bordered by endless rows of desert hills which were the dark and lonely regions of the damned. The mythological and funerary works describe a number of locations

within this counterworld, and these are frequently depicted in the vignettes which illustrate papyrus copies of the underworld books. These include the region known as the *sekhet iaru*, the "Field of Reeds," or *sekhet hetep*, the "Field of Offerings," which was the home of the blessed dead, as well as various pits and mounds which were the abodes of netherworld deities and of the unjust dead. Chapters 149 and 150 of the Book of the Dead give slightly different descriptions of fourteen of the specific locations or "mounds." These are frequently illustrated in vignettes showing actual mounds or their symbolic depictions – for example, an elongated oval which may represent the twelfth mound of Chapter 150, or a crocodile with its snout in a vase which may represent the ninth mound of Chapter 149.

Located in the sixth hour (the innermost part) of the underworld, the throne of Osiris is often shown on a staircase which functioned as a symbol of resurrection, perhaps as a stair leading out of the underworld, and also as a symbol of the original mound of creation, and thus the creation or renewal of life. Several funerary texts refer to the stair and it appears in many representations as the place of judgment. A number of other specific underworld locations are named in the texts, especially Rosetau (*Ra-setchau*), an important location in the beyond which was regarded as a kind of sister city to Abydos, the cult center of Osiris, where the blessed dead would share the company of the god himself.[2] The depiction of an Egyptian in any of the favorable locations of the underworld signified the deceased's attainment of a state of blessedness and the avoidance of areas of afterlife danger and punishment.

Relative Placement

The aspect of relative orientation is just as important as absolute location in Egyptian religion and art, and the alignment of many objects in their original settings can be seen to have been symbolic. Sometimes the orientation of objects and figures occurred at a very specific, local, or "micro" level, relative to nearby objects or other figures within or around the same composition; and sometimes the alignment is apparent on a larger scale which finds its significance at a "macro" or geographic level. Examples of the former kind of alignment may be found in the positioning of the images of kings before those of protective deities. Such royal images were depicted seated or standing directly before the overshadowing Horus falcon, the Hathor cow, and the sphinx in its various forms, as well as certain other deities in zoomorphic or anthropomorphic manifestations. This orientation suggests quite concretely, of course, the idea of protection

for the king and is reflected in the hieroglyphic formula *sa ha.ef* "protection behind him" which was commonly written immediately behind the king in royal representations.

In a similar manner, to be "beneath" another figure connoted inferiority or subjugation as may be seen in the carefully controlled relative placement of figures in group compositions (see Size) as well as in scenes of victory over fallen enemies, and in the depiction of captives on the bases of royal thrones, footstools, statues, and – as indicated by items from the tomb of Tutankhamun – on the soles of shoes, the bottom of walking canes, and in similar locations.

As is the case in many ancient and modern cultures, the right side was deemed to be more auspicious than the left (probably as a result of the predominance of right-handedness among humans).[3] This fact enters into the symbolic vocabulary of Egyptian culture in a number of ways. The texts speak of the king's powerful right hand; the right ear is associated with hearing and wisdom; and the right eye is the more important, with the right eye of the god of the heavens being the sun and the moon the left. During the Old Kingdom, the male figure often stands or sits to the right of the female (and is thus on the viewer's left) in pair statues. In New Kingdom statuary this orientation was sometimes reversed, with the woman being placed at the man's right side. Thus the New Kingdom office of "fan-bearer on the king's right hand" was not a true fan-bearing servant but a member of the court with high honorific position. Left and right could also have a moral symbolism for, because the Egyptian world view was oriented toward the south, east and west were synonymous with left and right. In the judgment of the dead, therefore, Amun set the just to the right (west) and the wicked to the left (east).[4]

In two-dimensional representations such as paintings and reliefs, the orientation of figures is frequently determined simply by the direction of the inscription with which they appear (normally right to left) producing right-facing figures.[5] If an inscription is reversed because of its location or in order to provide a mirror image or antithetically balanced group, the orientation of figures is reversed also. In such cases no symbolism can usually be attached to the orientation other than that relative to the figure's facing toward or away from the sanctuary of a temple or burial area of a tomb. In two-dimensional representations of figures seated together, however, convention usually dictated that the dominant figure be shown at the "front" of the seat – closest to the offerings or inscription. This meant that subordinate individuals are often drawn in such a way as to appear to be seated at the figure's right, though this is an apparent and not a real orientation.

At the larger level, the four cardinal points (see Number) were extremely important in the orientation of buildings ranging from pyramids and temples to various other ritual structures and tombs, as well as the individual features within these structures. The dais or platform used in the *heb sed* court of Djoser (2630–2611 BC) at Saqqara, for example, was approached by staircases at each of the four cardinal points. This concern with orientation entered into the rituals themselves when the king would turn and face in each of the four directions in the performance of various rites, such as when arrows were shot or birds released toward the four points in these ceremonies.

The constant awareness of the great axes of north–south and east–west already mentioned had no small impact on art and architecture, as well as upon a number of other aspects of Egyptian culture. The oft-repeated statement that the Egyptians lived on the east bank of the Nile, where the sun rose, and buried their dead on the west bank, where the sun set, while not accurate in all cases, certainly does touch upon a symbolic reality. The dead were associated with the sinking sun, and were thus known as "westerners," with Hathor, in her guise as "goddess of the west," welcoming the deceased into the afterlife, and Osiris himself being termed "the Foremost of Westerners." The east also figured in this symbolic cycle as the area of rebirth. During Old Kingdom times the deceased was buried facing the rising sun, and after the Fourth Dynasty the mortuary temples of the pyramids, where sacrifices were presented to the deceased kings and queens, were placed at the foot of the pyramid's east face on account of this symbolic orientation.

The north–south axis also had connotations for the Egyptians' mortuary beliefs from a very early date. During the Old Kingdom, funerary mythology placed the afterlife location of the dead in the north, with the circumpolar or "undying" stars which never set. The entrance – and symbolic exit – of most pyramids was thus on their northern face, that of the great pyramid being oriented with a high degree of precision toward Alpha Draconis, the polar star at the time the monument was built over four and a half thousand years ago. Other stellar and solar orientations may also be found in Egyptian architecture – usually with symbolic implications.[6] The alignment of the temple of Hathor at Dendera with the southern star Sothis or Sirius (which was sacred to the goddess) is a salient example of this. Statuary and two-dimensional scenes may also sometimes have been positioned with cardinal or stellar orientation in mind. Thus, some statues of Osiris or the evening form of the sun god could have been placed on the western sides of processional routes and halls,[7] while

other representations of Osiris may have been placed on southern walls in accordance with their association with the constellation of the god – Orion – in the southern sky.[8]

Locational Temple Symbolism

Symbolic orientation and placement can perhaps be most easily seen in the Egyptian temple, where it was employed constantly at both the macro and micro levels. Many temples were located on sacred sites or built close enough to the Nile to be partially submerged during the river's annual flooding, thus symbolic of the watery creation of the world (see Form). Certain late temples also had shrines built on their roofs and crypts below ground level, probably symbolic of heaven and the underworld. Most temples were also aligned, at least theoretically, with the daily passage of the sun.[9] This alignment is seen in the positioning of the horizon-like pylons, towering obelisks, and solar disks painted along the architraves of the temple's east–west axis (ill. 44).

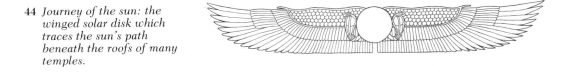

44 *Journey of the sun: the winged solar disk which traces the sun's path beneath the roofs of many temples.*

Aspects of north–south alignment were also stressed in temple architecture and decoration. This usually involved heraldic devices such as the sedge and the papyrus plants symbolizing the "Two Lands" of Upper (southern) and Lower (northern) Egypt being placed on northern and southern walls, columns and other architectural features (ill. 48).

In a similar manner, the king is often shown wearing the Red Crown of Lower Egypt on northern walls and the White Crown of Upper Egypt on the opposite southern walls – or on the northern and southern sides of doorways when their axis was on an east–west alignment. The vulture and cobra, symbols of the southern goddess Nekhbet and northern goddess Wadjet, could also function in this same way, not only as appropriate decoration for their respective areas of the temple, but also emphasizing the united rule of the king by their placement on the two sides of thrones and statue bases. An interesting variation on this same theme may exist in depictions of the double sacred cobras worn by the Egyptian queen. These twin uraei are sometimes shown wearing the Red and White Crowns of Upper

and Lower Egypt, and Earl Ertman has noted occurrences where these seem to have been placed with one orientation when the queen symbolically looks east from funerary locations on the Nile's west bank, and with the opposite orientation in some east bank temple portrayals in which the queen faced west.[10]

A number of other animals could also symbolize the Two Lands. The falcon may stand for Lower Egypt and is sometimes shown in juxtaposition with the heron, the vulture, or some other avian species in the expression of the north–south polarity. The various provincial nome signs which sometimes appear above anthropomorphic Nile or fecundity figures making them representations of the various nome gods were used in the same manner in the later periods, with the twenty-two Upper Egyptian nomes being shown on southern walls and the twenty Lower Egyptian nomes on northern walls.

From the time of the New Kingdom, the exterior walls of most Egyptian temples (including those of the pylon and first court) show scenes depicting the destruction of enemies. Although these scenes may depict actual enemies, the motif is symbolic in that it represents the much broader chaos and disorder which threatened Egyptian society – and the balance of the very cosmos itself. The depicted destruction of these enemies is no mere military boasting, therefore, but the symbolic containment of chaos and the establishment of order and harmony, with the scenes creating by their very location a magical guarantee of security and calm for the god's home which lay within their parameters. As one progresses deeper into the heart of the temple, typically the floor level rises and the height of the walls and ceilings drops. This means that the sanctuary and innermost areas are enclosed within the outer temple, as the center of an egg, implying the complete protection and setting apart of the area. In this inner area the scenes of battle are replaced by representations stressing the king's adoration and service to the gods.

Important principles of ordering and location also come into play within the space of a given wall or other decorated area. The aspects involved in this symbolic placement have been studied by John Baines, who has stressed the differing importance of representational elements found in the base area, the main area, and the upper areas comprising the frieze, architraves, and ceiling.[11]

On the lower areas of the walls and columns, representations symbolizing the marshland environment include not only stylized plants, but also figures bearing offerings – the produce of the fertile marshes and irrigated fields – toward the god's residence in the inner part of the temple (ill. 50). Frequently the offering bearers, although male, are given large pendent breasts to stress their symbolic role as

fecundity figures, and these figures are often painted blue or green (see Colors) for the same reason. In the main area which occupies the greater part of a given wall or column's surface, the primary motif is that of the king presenting offerings, tending the needs of the god, or performing some other action associated with the functioning of the cult. Here, the figures of the king face toward the god's sanctuary, or toward the central processional path of the temple if they are located away from this central axis. Images of the god or gods who inhabit the temple, on the other hand, face outward – away from the sanctuary. Finally, in the upper area of the frieze and architraves, repetitive emblematic groupings showing the king worshipping long lines of gods – often seated in the squatting position of the hieroglyph for "god" – seal off the area and subtly stress the king's position in the cosmic scheme.

Within these individual areas, then, there is found a complex hierarchy of gods and humans, as well as emblematic figures. The placement of these figures was not always dependent upon matters of decorum alone, however. Scholars such as Dieter Arnold, Lanny Bell, and Helmut Brunner who have studied the decorative schemes of various temples have found many reasons for the locational placement of images often having to do with the function of specific rooms or other areas. The personified *rekhyet* or lapwing, for example, which symbolized the people of the land and which was depicted with outstretched arms giving praise before cartouches containing the king's name, seems to have been placed in specific locations in the outer areas of some temples – perhaps to indicate areas of public gathering or worship.[12] Researchers studying later temples, such as Philippe Derchain and Erich Winter, even speak of a "temple grammar" which relates text and representations in specific sequences and locations.

In New Kingdom temples this locational significance applies primarily to the representations themselves and not to the inscriptions which accompany them, which can usually be seen to reinforce the existing representational symbolism. The symbolic location of texts may range, however, from the very common placement of the formula of protection immediately behind the person of the king as already mentioned, to rarer examples of longer texts such as a hymn to the sun god inscribed in such a location as to give it a visible link with the path of the sun.

Locational Funerary Symbolism

Some of the same locational symbolism found in the Egyptian temple carries over into other areas, especially the mortuary sphere. For example, we find many aspects of funerary orientation and alignment involving the solar cycle. This is particularly true of New Kingdom royal burials, although private tombs also reflect some of the same concerns.[13] On the one hand, the entrance to the tomb was regarded as symbolically being in the south and its end in the north, with niches in the side walls sometimes being dedicated specifically to goddesses of the east and west. On the other hand, by way of a different type of symbolic orientation, the tomb's passages were viewed as following the daily east–west journey of the sun. Each section of the entrance into the subterranean royal tomb was known as one of the passages of "the sun's path," intimating not only the daily solar cycle but also the nocturnal journey of the sun under the earth. Black or blue ceilings – often studded with five-pointed stars – represented the heavens, sometimes with images of vultures flying into the tomb, as in the solar path of the temple. Various representations of the sun god also appear, such as the Litany of Re which was inscribed in the entrance corridors of some tombs and which enumerates and pictures the many forms of the solar deity.

Another solar image represented along the central axis of the tomb was the tripartite depiction of the sun god found from the time of Ramesses II. This consisted of a solar disk, over or near the tomb entrance, containing the scarab representing the morning sun at the left and the ram-headed form of the solar deity signifying the evening manifestation on the right. As the disk itself could be said to signify the god Re at noon, the combined elements represented the three major forms of the sun god in one image (ill. 51). This image, like the winged sun disk found along the temple's central axis, visually reinforced the concept of the sun's passage and the symbolic orientation of the tomb.

The convention which allowed one form of the sun god to be represented within another also led to further developments in the iconography of the solar disk. In the burial chamber of Ramesses III (1194–1163 BC), for example, the name of the king is inscribed within a disk formed by the entwined bodies of two serpents. The disk also contains the figures of adoring goddesses and two smaller solar disks representing the sun's east–west circuit. Functionally, this rather complex composition acted as a representation of the sun disk itself, and by placing his name within its borders Ramesses identified himself directly with the solar deity and joined its cyclical daily

journey.[14] The same idea is also expressed in other ways. In the tomb of Ramesses IV (1163–1156 BC) the king's full formal titulary is inscribed along the center of the ceiling of the hall which leads into the burial chamber (ill. 52). Surrounded by golden stars on a blue ground representing the heavens, the king's names follow the path of the sun and once again identify him with the solar journey, with the cartouches containing the king's individual names being the equivalent of the solar disks on the ceilings and architraves of the temple.

In the later Ramesside burials, the lower reaches of the tomb – and particularly the burial chamber – were decorated to represent the complete cycle of the sun in both its diurnal and nocturnal phases. Thus the books of the heavens were inscribed on the ceiling of the sarcophagus chamber and texts and illustrations from the books of the earth and underworld were placed on the walls. The Egyptian royal tomb then, in the fully developed decorative program of the late New Kingdom, represents – like the temple – a model of the cosmos which was indicated not only by symbolic representations and texts but also by their location.

Interestingly, while the locational aspects of the decoration of the royal tombs usually reflected the king's association with the sun god Re (doubtless as a result of the influence of the solar aspect of temple architecture), the location and orientation of many of the funerary items placed within the tomb tended to show a greater proclivity toward association with the underworld god Osiris. This is not a firm rule, however, and a certain amount of overlapping occurs. In the Nineteenth Dynasty the inner parts of the tombs were decorated with more stress on Osiris, and during the later New Kingdom the two deities were at least theoretically united – with Re being viewed as the heavenly soul of the god and Osiris his earthbound body – an idea reflected in a number of later funerary depictions. The distinction between the heliocentric locational symbolism of the tomb decoration and the Osirocentric symbolism of the items of the burial itself, however, still tends to hold true.

If we trace the development of the Osirian elements of the funerary assemblage, we find that by the Middle Kingdom the importance of the myth of Osiris and the identification of the deceased with that god meant that first protective inscriptions and later representations of deities associated with the lord of the underworld were placed upon the Egyptian coffin. Isis, the wife of Osiris, and her sister Nephthys began to appear at the foot and head of the coffin respectively, and because the body was usually placed on its side looking eastward (with the head to the north) at this time, these deities soon became associated with the north (Nephthys) and

south (Isis). Further protection was provided by other texts and representations of the four sons of Horus on the long sides of the coffin, with Qebesenuef and Hapi on the west, and Duamutef and Imseti to the east. The gods Horus and Thoth who were inseparably involved with the myths of Osiris were also depicted on the east and west sides. The four sides of the coffin were thus personified as Isis, Nephthys, Horus, and Thoth; and because the roof of the coffin was associated with Nut, goddess of the heavens, and the floor with Geb, god of the earth, the coffin itself took on the significance of a model of the cosmos.

The directional symbolism which became associated with these deities of the Osirian cycle continued into the New Kingdom and beyond and may be found in a number of contexts,[15] though some variations developed with time. During the Eighteenth Dynasty, Isis and Nephthys were joined by Selket and Neith, with the four goddesses then being positioned at the four corners of the royal sarcophagus (ill. 53).

Through their association with the four canopic jars in which the internal organs of the deceased were preserved, the four sons of Horus also became associated with the four goddesses Isis, Nephthys, Neith, and Selket who were said to protect them. Either the four goddesses or the sons of Horus or both may thus be represented on the four sides of the chests in which the canopic jars were stored (ill. 54), as well as on the sides of the coffin or sarcophagus. Vignettes to Chapter 151 of the Book of the Dead also show these deities arranged around the mummy in the tomb in exactly the same alignment as is found on the coffins and in the decoration of some of the royal burial chambers.[16]

The royal mummy itself was placed on its back with the head toward the west at certain times in the New Kingdom, and in this position various items of the royal insignia were cardinally aligned. The vulture and uraeus which adorned the brow of the deceased king were thus situated on the south and north sides as symbols of Upper and Lower Egypt respectively (ill. 55), and the royal symbols of office, the crook and flail, (although crossed on the chest) were similarly aligned with the *heka* crook of the south being held at the right side and the *nekhekh* flail of the north on the left. Other emblems and symbols were also aligned in this way as time progressed. The Red and White Crowns appear, for example, on sacred cobras depicted on the left (north) and right (south) sides of a number of decorated coffins and mummy covers made after the close of the New Kingdom, as do a number of other objects and figures such as shrines, faunal species, and deities.

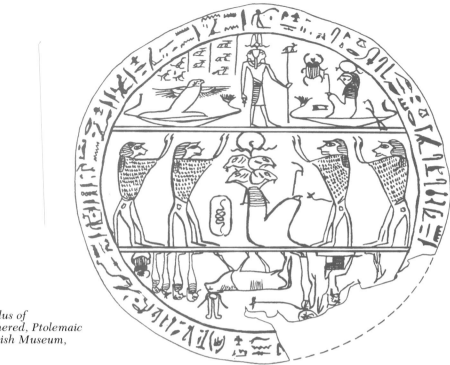

45 *Hypocephalus of Neshorpakhered, Ptolemaic Period (British Museum, London).*

The position of many of the amulets placed on the mummy was also dictated by mythological and symbolic concerns. Some representing various parts of the body were naturally placed on or near those parts, but a number of amulets were associated with specific locations on the body for purely symbolic reasons. Several of these locationally specific amulets are associated with Osirian symbolism, as might be expected. The *djed* column amulet which is thought to have come to represent the god's backbone, for example, was frequently placed on the central upper chest and especially on the neck, while the *tiet* knot, through its identification as a symbol of Isis, the wife of Osiris, also gained a specific symbolic location at the neck of the deceased.

Some amulets of specific location do have solar significance, and this is one area where the frequency of Osirian motifs in the burial assemblage is challenged. Such is the case with a special amulet designed specifically to protect and revive the head of the deceased. Chapter 162 of the Book of the Dead states that it should be made as a text written on a piece of new papyrus which was to be placed under

the head of the mummy, and in post-New Kingdom times this small piece of papyrus was mounted on a circular piece of cartonnage to form a more durable object known as a hypocephalus. The amulet often had the representation of the divine *ihet*-cow – "mother of the god Re" – inscribed upon it as "a very great protection . . . for Re when he set" and hence for the head of the deceased which was associated with the sun both through its shape and the action of lying down in the evening, or in death (when it "set") and rising in the morning, or in the afterlife. Another important solar-related amulet of specific position was the heart scarab which represented the heart itself, yet which was linked to the sun god on account of its relation to Khepri, the god of the morning sun.

Both the absolute and relative positioning of items of the Egyptian funerary assemblage could thus hold symbolic significance – as might perhaps be expected of an area so rich in the expression of symbol and magic.

Sacred Locations and Pilgrimage Sites

46 *The sacred delta sites and the tomb of Osiris at Abydos, with pilgrimage scenes.*

In predynastic times it appears that the funerary rituals of the rulers of the city of Buto, the ancient capital of the Delta region, included a ceremonial visit to the major religious sites of the area. This journey of the funeral cortege primarily involved travel from Buto to Sais and Heliopolis, though other sites such as Mendes in the eastern Delta were also visited sometimes.

Later, in the Old Kingdom, tomb decoration often included scenes of this ritual pilgrimage to the sacred sites (a) with the most important – Buto and Sais – being represented by stylized depictions of their religious buildings. These buildings consisted of a row of vaulted shrines and palm trees as the emblem of Buto, and a rectangular shrine or compound flanked by flagstaffs with triangular pennants as the emblem of Sais (b). By Old Kingdom times, however, although some of the importance of the traditional sacred sites remained, funerary pilgrimages to these locations probably rarely took place. Nevertheless, the representations continued to be painted in tombs as indicators of a symbolic pilgrimage – the desire of the deceased to enter into the ancient religious practices and traditions in order to receive their spiritual benefits.

In Middle and New Kingdom times the idea of the ritual pilgrimage was increasingly influenced by the worship of the god Osiris, and although the journey to Sais and Buto continued to be depicted, the focus of funerary attention shifted south to the god's sacred shrine at Abydos. Located in northern Upper Egypt, Abydos was believed to be the location of the grave of Osiris (represented in the illustration by an ancient depiction of the god's tomb, shown in c), and during the New Kingdom many funerary representations begin to show a ritual pilgrimage to Abydos (d). Although many individuals probably did make actual pilgrimages to Osiris' sacred site, numerous representations of the voyage to Abydos doubtless were of a purely symbolic nature, just as was the case with depictions of the Delta pilgrimage.

The funerary scenes depicting pilgrimages to these various sacred sites are clear indicators of the importance of locational aspects in ancient Egyptian religion. Even when the sites were not actually visited, they maintained a symbolic role which involved the spiritual continuity of the veneration of the sacred place. In the case of specific structures such as temples and tombs, detailed aspects of symbolic location and alignment also came into play, as will be seen in the following pages. For example, in many New Kingdom funerary scenes of the journey to Abydos, the outward journey is shown going toward the interior of the burial place, and the return journey – with unfurled sail – is shown emerging from the innermost part of the tomb.

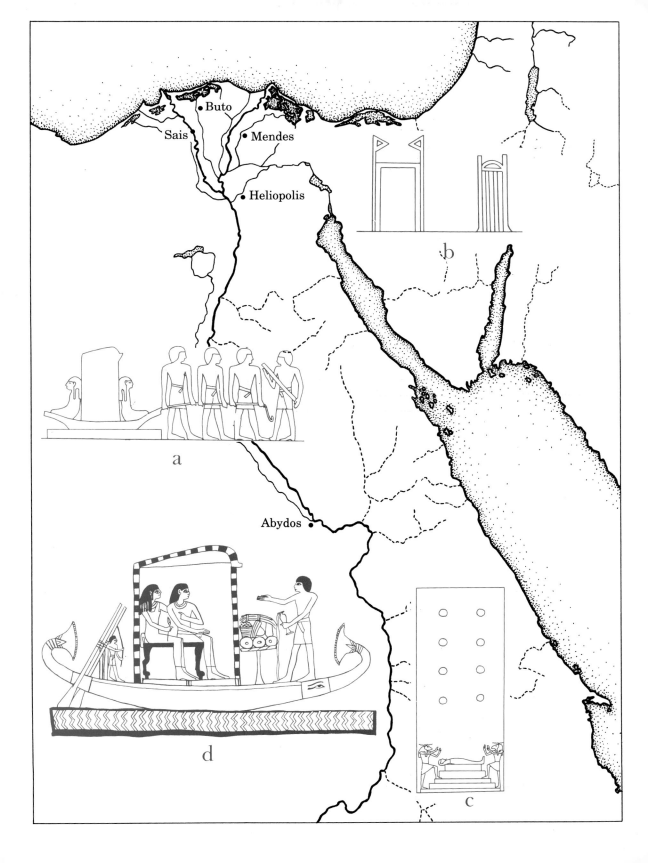

Buto

Sais

Mendes

Heliopolis

b

a

Abydos

d

c

Temple Axiality and Locational Placement

47 *Entrance pylon of the Temple of Luxor as depicted on the temple wall. Dynasty 19.*

This ancient depiction of the entrance to Luxor Temple shows the major elements of the structure's symbolic east-west axis. Theoretically aligned toward the east, the two towers of the pylon formed an architectural *akhet* or horizon over which the sun rose (ill. 24), and representations of the winged sun disk painted above doors and on ceilings along the central processional way traced the sun's daily journey. The obelisks which flank the temple's entrance also held orientational significance, and sometimes carried inscriptions to the eastern (morning) and western (evening) forms of the sun god.

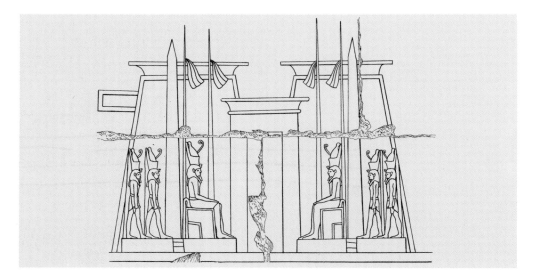

48 *Representational elements symbolizing Upper and Lower Egypt.*

A number of motifs appearing in the decorative scheme of the Egyptian temple signified the north-south axis and the uniting of the two regions of Upper and Lower Egypt. These paired symbols often appear on adjacent northern and southern walls and columns, and on other architectural features such as the northern and southern sides of doorways off the temple's main axis. They include – representing Upper (southern) and Lower Egypt respectively – the White (a) and Red (b) Crowns; the vulture (c) and cobra (d); and the sedge or lily (e) and papyrus (f).

49 *(Right) Praise to the king: decorated block. Ptolemaic Period. Egyptian Museum, Cairo.*

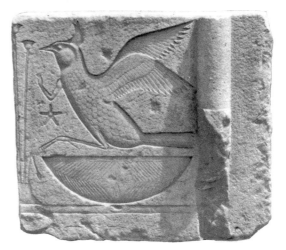

From the Eighteenth Dynasty onward, representations of a partially personified lapwing are frequently found in areas of the temple open to the public. The bird is shown on a basket before a five-pointed star, with the outstretched arms of a human in the act of giving praise. This forms a hieroglyphic rebus spelling out: "All the people give praise," with the bird's placement before a royal cartouche indicating that the object of its praise is the king.

50 *Offerings to the gods: decorated block from a shrine of Hatshepsut. Karnak, Dynasty 18.*

In other parts of the temple, and always facing in toward the shrine, the god's dwelling place, fecundity figures are shown bearing trays heaped with offerings for the god. Although male, such figures are usually shown with pendent breasts symbolic of their fecundity and may be painted blue or green as further indication of their association with the Nile or the fertile fields and marshlands. Fecundity figures are also sometimes given hieroglyphic labels identifying them with various provincial nomes – those of Upper Egypt being depicted on southern walls and those of Lower Egypt on northern walls.

The Symbolism of Location 77

Locational Symbolism in the Royal Tomb

51 *The tripartite image of the sun god flanked by Isis and Nephthys. Tomb of Merneptah, Valley of the Kings, Thebes, Dynasty 19.*

Beginning in the Nineteenth Dynasty, this tripartite image of the sun god was placed above the entrance to many New Kingdom royal tombs. The icon depicted the sun in its morning aspect (the beetle Khepri), at noon (the sun disk Re), and in its evening aspect (the ram-headed figure of Atum). The significance of this image was parallel to that of the winged sun disk represented above doorways and on ceilings along the symbolic east-west axis of the temple, for the New

Kingdom royal tomb also symbolized the passage of the sun in much of its layout and decoration. The goddesses Isis and Nephthys posed on either side of the solar disk fused Osirian imagery with that of the sun and also added a symbolic south-north axis (Isis was associated with the south, Nephthys with the north) to the east-west axis implied by the representation of the sun. In the tomb of Merneptah, the exterior sun disk is painted yellow, while parallel disks within the tomb are painted red – thus adding another aspect of locational significance through the colors of the day and evening sun.

52 *Corridor ceiling of the tomb of Ramesses IV. Valley of the Kings, Thebes, Dynasty 18.*

Centered in the pattern of golden stars on a blue field which represents the heavens, the various names of the titulary of Ramesses IV are positioned along the ceiling of the passage leading down into the king's burial chamber. The royal names thus occur along the same symbolic east-west axis as the solar disk at the tomb's entrance, and by inscribing his names along this passage of the sun (the Egyptian's names for the corridors of the royal tomb were "first passage of the sun's path," and so on), Ramesses associated himself with the sun god's daily passage across the sky and

nocturnal journey under the earth. The solar associations of the cartouches in which the king's birth and throne names were written (in its original form, the cartouche is believed to have symbolized the circuit of the sun) give additional emphasis to the idea of the king's unity with the sun. Other late New Kingdom pharaohs achieved the same symbolic statement by writing their names within the solar disk, or in other ways. In most of these cases the symbolic equation of the king with the solar deity is expressed with a locational aspect in addition to the iconography of the representation itself.

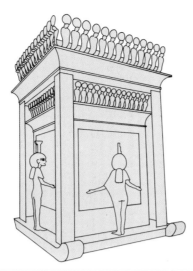

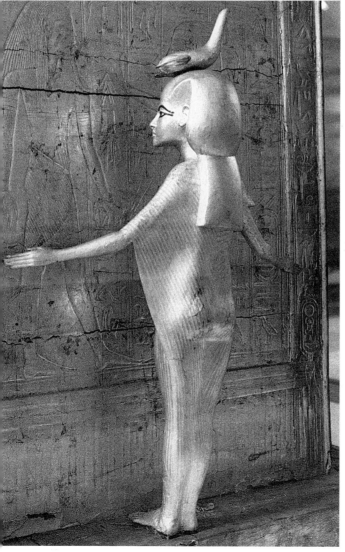

53 *(Above right) Anthropoid outer coffin and sarcophagus of Tutankhamun. Valley of the Kings, Thebes, Dynasty 18.*

This drawing of a typical royal sarcophagus of the late Eighteenth Dynasty – modeled after that of Tutankhamun – illustrates the positioning of the four tutelary goddesses at the corners of the sarcophagus. Sarcophagi of earlier and later periods exhibit variations of this scheme with Isis frequently being placed at the foot (symbolic south) and Nephthys at the head (symbolic north). Representations of other figures found on New Kingdom royal sarcophagi show similar patterns of placement, but are not so consistently oriented. Because the royal mummy was sometimes interred with its head to the west – symbolically looking from the underworld to the sunrise – the decoration of the anthropoid coffin could also take on locational aspects as shown in ill. 55.

54 *(Left) The goddess Selket before the canopic shrine of Tutankhamun (reconstructed top left). Valley of the Kings, Thebes, Dynasty 18. Egyptian Museum, Cairo.*

In addition to appearing at the corners of the king's sarcophagus, the four goddesses Isis, Nephthys, Neith, and Selket were also positioned around the sides of the canopic shrine which protected the internal organs of the deceased Tutankhamun. Here, each goddess watched over one of the minor protective genii known as the Four Sons of Horus. Selket and Qebesenuef were intended to guard the east; Nephthys and Hapi the south; Neith and Duamutef the north; while Isis and Imsety protected the west.

Locational Symbolism in the Royal Burial

55 *Intermediate coffin of Tutankhamun. Valley of the Kings, Thebes, Dynasty 18. Egyptian Museum, Cairo.*

The burial of this king's body east to west with the head at the west resulted in specific locational alignment for several items of the royal insignia.

Not only were the royal vulture and uraeus representing Upper and Lower Egypt correctly aligned to the south and north, but the *heka* crook representing the south and the *nekhekh* flail symbolizing the north – although crossed on the chest – were also held to their respective sides.

Many of the protective and restorative amulets placed on the mummy were also assigned specific symbolic locations – such as the *djed*, *tiet*, papyrus-column, and vulture amulets which were all placed on the king's neck, and the large scarab placed over the heart. Various chapters of the Book of the Dead specify the placement for these funerary amulets, though the exact symbolic reason for their position is not always clear.

SIGNIFICANCE IN
SUBSTANCE
the symbolism of
MATERIALS

*"And so the gods entered into their bodies of every kind of wood,
of every kind of stone, of every kind of clay, of every kind of
thing which grows ..."*
The Memphite Theology

BEYOND the outward aspects of form and size, Egyptian art was
also concerned with the nature of the materials with which it
worked. Outward appearance was no more important than inner
substance, symbolically, and in some cases the symbolic significance
of the material from which an object was created was primary.

Although the concept of a symbolic substance – of meaning
inherent in material – might at first seem very alien to us today, we
nevertheless come close to such an idea ourselves whenever we use
expressions such as "a golden opportunity," "a leaden feeling," or
"an iron will." In instances such as these we commonly use
substances for their metaphorical qualities. For the ancient Egyptian
the awareness of the inherent physical qualities of materials was
magnified considerably by their mythological associations and
supposed magical properties. Only when we realize this do we begin
to appreciate the importance of this aspect of symbolism in Egyptian
art.

Of the various materials which are known to have had symbolic
significance for the Egyptians, the most durable – metals and stones –
were perhaps the most important, though certain woods carried their
own specific symbolic connotations, as did incense and even a
number of quite humble substances such as wax, clay, and water. In
this chapter, we shall consider the symbolism of each of these
materials in turn.[1]

Metals

As early as the beginning of the Predynastic Period (*c.* 5000 BC) the ancient Egyptians had discovered the use of copper, gold, silver, and lead. Iron and tin and the alloys bronze and brass were eventually added to this list. Of the common metals, copper was widely used and only gradually began to give way to bronze – a mixture of copper and tin with superior metallurgical qualities – during the Middle Kingdom. But the use of these metals was primarily utilitarian (though bronze might sometimes substitute for gold), and it is not known that they enjoyed any special significance. It is mainly with the rarer metals (including, for the Egyptians, iron) that symbolism becomes a factor.

Gold was especially important, not only from an economic but also from a symbolic point of view, for this metal was regarded as a divine and imperishable substance, its untarnishing nature providing a metaphor of eternal life and its brightness an image of the brilliance of the sun.[2] The sun god Re was himself sometimes referred to as "the mountain of gold" or by similar epithets, and the solar significance of the metal may be found in a number of contexts. Gold leaf was used to cover the tops of obelisks, for example, both to reflect the rays of the sun and to symbolize them. Because the flesh of all the gods descended from Re was also said to be of gold, the use of this metal for statues and other representations of deities was certainly symbolic. The goddess Hathor, daughter of Re (and often called "The Golden One") was especially associated with gold and was believed to be a personification of the precious metal. Mirrors made of gold or its substitute, bronze, and decorated with an image or symbol of Hathor thus represented the sun and the goddess by virtue of both their substance and form (ill. 56).

The goddess Isis was also associated with the most precious metal in a number of ways. The images of this deity and her sister Nephthys were often placed upon the hieroglyph for gold at the foot and head of New Kingdom sarcophagi (ill. 57). On the fourth shrine of Tutankhamun and in some other representations, the deities Neith and Selket are also depicted kneeling on the sign for gold, though the motif appears to have originated with Isis. An amuletic "vulture of gold" placed around the neck of the mummy during the New Kingdom and Late Period was also connected with Isis and believed to impart her protection.

In a similar manner, the *sah* or afterlife "body" of the Egyptian was also thought to be a divine being with shining golden skin. This is probably the reason for the gilded masks of the finest mummies (the

word *sah* can also mean mummy), as well as the golden inner coffin made for Tutankhamun, and no doubt for many other pharaohs of the New Kingdom. The gold of these objects may have been seen as not only symbolizing the golden bodies of the gods but perhaps also as magically conferring eternal survival through its imperishable nature (ill. 60). The fact that some embalmers' workshops and the building in which the coffin and the statue of the spirit "double" were made – as well as the royal burial chamber – were called *per-nebu* or "house of gold" shows the close association of the metal with afterlife concerns which far transcended the merely economic. In a similar way, gold leaf or inlay was also sometimes added to particularly sacred objects and representations in order to stress their importance; and in this use too, we see the symbolic nature of the substance. When mixed with a percentage of silver (as it often is in its natural ore), gold becomes electrum, which was referred to by the Egyptians as *neb hedj* or "white gold." The dual nature of this metal meant that it was used sometimes with the significance of gold and at other times as if it were identical to silver.

Silver's symbolic aspects were scarcely less important than those of gold. The very bones of the gods were said to be of silver, just as their flesh was thought to be of gold, and the natural association of silver with the moon was manifested in a number of ways. Gold and silver mirrors were presented to the goddess Hathor as symbols of the sun and moon, respectively; and statuettes of baboons – sacred to the moon god Thoth – were frequently made entirely or partly of the white metal (ill. 62). Unlike gold, silver does not occur naturally in Egypt in pure form, and because it had to be imported, it was relatively scarce before New Kingdom times. The many silver objects found in the famous Tod (south of Luxor) treasure which dates to the Middle Kingdom were all apparently from Syria and the Aegean area. Egyptian conquests in Asia may have made silver more common in New Kingdom times, however, since the metal was used increasingly – often as a substitute for gold – from then on. Reigning in a period of relative decline, the Twenty-first Dynasty kings of Tanis were buried in coffins of silver which, while they continued the tradition of earlier craftsmanship, were probably constructed of the metal for economic rather than symbolic reasons. On the other hand, the presence of silver or silver leaf or inlay in smaller Egyptian works of art may often have the symbolic implications already considered.

Iron could certainly be symbolically significant, perhaps more by reason of its origin than its inherent nature, though the two aspects would not have appeared separate to the Egyptians. Because most iron used in Egypt before the end of the Eighteenth Dynasty was of

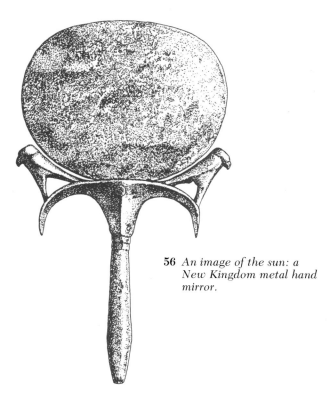

56 *An image of the sun: a New Kingdom metal hand mirror.*

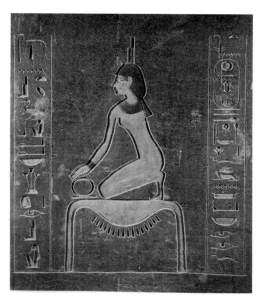

57 *Isis associated with the most precious metal: the goddess kneels on the hieroglyphic sign for gold. Sarcophagus of Amenhotep II, from Thebes, Dynasty 18.*

meteoric origin rather than manufactured, the metal was known as *bia-en-pet* or "metal of heaven." This meteoric, cosmic origin gave the metal a sacred significance, and the amulets and other small objects of iron found in Egyptian tombs may well have been believed to have been invested with particular magical potency (ill. 61). This was probably also the reason for the use of iron blades in the ritual adzes used in the "opening of the mouth" ceremony on statues and on the mummy of the deceased.

Finally, although it was a common metal, lead was also used symbolically, and apparently in a variety of contexts. Records indicate that quite an amount was used in temple workshops, though it seems seldom to have been used for statues of gods. Lead was used quite extensively, however, in the production of magical objects such as the plaques used to cover and protect the embalming incision of the mummy. Magical love charms in the form of inscribed tablets and also small figurines of couples were also made of lead, though it is difficult to see what aspect of the metal formed the basis for this fertility association. Because figurines of captives which were intended to be destroyed were also sometimes made of lead (ill. 63), it has been pointed out that the material seems to have been employed

in destructive, productive, and defensive magic – a surprisingly wide range of applications for a single substance.[3] It is possible that the unique qualities of lead – its malleability, low melting point, and mysterious heaviness – may have combined to suggest a supernatural potency which was felt to be especially effective in any magical context.

Stones

The ancient Egyptians had a large number of types of stone available to them, and many of these were used from the earliest period. Apart from common building stones such as limestone and sandstone, a number of minerals were used in specific contexts with apparent symbolic significance. The most important stones of this type included:

Alabaster (Calcite) Although it was used to a limited degree in building, this fine translucent stone was mainly employed in the production of small objects such as vases, bowls, and lamps. In these contexts, the stone was favored above all others throughout much of Egyptian history. All but three of the seventy-nine stone vessels found in the tomb of Tutankhamun were of alabaster (ill. 66). The stone was quarried in Middle Egypt, the Sinai, and a number of other locations.

Basalt This hard black stone was quarried at a number of sites, and was especially plentiful in the Faiyum and at Aswan. Used for the construction of sarcophagi and in the building of pavements, basalt was also utilized occasionally for statues and small objects. This black stone had a natural association with the underworld and with the concept of revivification. An intrusive basalt statue of Osiris on a bier, for example, was found in the First Dynasty tomb of King Djer at Abydos (which was venerated as the tomb of Osiris during the later periods); and along with other black stones, basalt was used during the Macedonian period for healing statues covered with magical spells and vignettes which were designed to transfer their power to water poured over them (ill. 65).

Breccia A composite stone having fragments of one type of rock embedded in a matrix of another, two types of breccia were available to the Eygptians: a green variety, found in the Wadi Hammamat, in the eastern desert; and a red and white variety, found in the western desert and at various sites along the Nile. Breccia was occasionally used for vases and other stone objects.

Diorite Various forms of this stone occur in Egypt – usually banded or speckled, and of green and white or black coloration. Although fairly

widespread, much diorite was quarried at Tushka in Nubia during the Old and Middle Kingdoms. Statues (as the great Chephren statue in the Cairo Museum), bowls, and other fine objects were made from this stone.

Flint Occurring plentifully in nodules and layers in limestone rocks, this stone was worked from prehistoric times. Although rarely used for anything but knives and the blades of other implements, flint evidently took on a significance of its own – for long after blades were routinely made of metal, ceremonial knives used in religious contexts continued to be made of flint.

Granite A crystalline composite of quartz, feldspar, and mica, this hard igneous rock occurs in Egypt in pink, gray, and black varieties. Used extensively in building, for sarcophagi, and for some statues and small objects, granite was plentiful at Aswan, and in the Wadi Hammamat, and sometimes carries the significance of its particular color.

Quartzite A hard, crystalline form of sandstone, quartzite was used from Old Kingdom times for building and for sarcophagi and other monuments. It was called by the name "wonderful" (*biat*) by the Egyptians, and its white, yellow, or red coloration gave it important solar connotations (ill. 64). A number of kings were thus portrayed in this material during periods in which solar deities were especially prominent[4] – such as the reigns of Amenhotep III, Akhenaten, and Ramesses II.

Serpentine A hard, siliceous stone which is marked with a snake-like pattern, serpentine is fairly common in the eastern desert and was used for the production of small objects from the Predynastic Period. Because of the pattern of its veining, the stone was used for magical stelae and amulets made to ward off the attack of snakes and scorpions.

These stones were all used in different circumstances and settings, sometimes for symbolic reasons. In the Pyramid of Unis (2356–2323 BC), last king of the Fifth Dynasty, for example, while the king's sarcophagus was constructed from a single piece of polished black granite – possibly used for the symbolic significance of its color – three walls of the burial chamber were constructed from limestone and the fourth at the head of the chamber was made from elaborately carved and painted alabaster. The different stones used for these walls may simply have been chosen for decorative rather than symbolic reasons, however. Similarly, the use of a wide range of stones in the production of vases, jars, and bowls was especially prevalent in the earlier periods – sometimes in quite amazing numbers. In the funerary galleries beneath the Third Dynasty Step Pyramid of Djoser

at Saqqara, for example, over 30,000 stone vessels were found carved from alabaster, breccia, rock crystal, serpentine, and other minerals – perhaps chosen for decorative or symbolic reasons.

Of the semiprecious stones, turquoise, carnelian, malachite, and lapis lazuli (imported from the east) were especially important. These stones were all believed to have amuletic properties and lapis, for example, was regarded as a highly potent substance symbolic of the heavens because of its blue, gold-speckled coloring (ill. 67). Several chapters of the Book of the Dead specify the materials from which various amulets were to be made – clearly with the idea that the use of the correct material would increase the magical potency of the amulet concerned. Different chapters also sometimes give different spells for the same amulet made of different materials. For example, Chapter 26 records a spell for a heart amulet of lapis lazuli ("whereby the heart is given to a person in the underworld"), whereas Chapter 27 gives a spell for the same amulet but made of green feldspar ("whereby the heart of a person is not taken from him in the underworld"). Other stones are also mentioned as suitable for this same amulet and in each case the spell is slightly different, so it may be that the material chosen would have been believed to affect the general amuletic principle in each case.[5] Manufactured glass (Egyptian *iner en wedeh* "stone that flows" or "stone which is poured") may also be grouped with semiprecious stones, since it was usually produced as a substitute for those substances.[6]

The fact that the Egyptians used all of these stones for the manufacture of various objects from the earliest periods cannot be seen as simply the result of the utilization of a plentiful material, since scarce, difficult to obtain, and extremely hard stones were often used when more common and easily worked varieties could have sufficed. The same might also be said of the great stone structures constructed by the Egyptians from the Third Dynasty onward. Although wood may have been relatively scarce, building techniques using mud brick were perfectly developed and might just as well have continued to be used in the construction of monumental architecture as they were in Mesopotamia. The incredible expenditure of energy and resources involved in large-scale building in stone with the limited cutting and transportation techniques available to the Egyptians may well indicate the importance of the symbolic aspect of timeless endurance associated with stone. As Jorge Ogdon has commented, the symbolic and religious significance of stone is well known in the science of the history of religions, for the material possesses the characteristics of permanence, immutability, and incorruptibility that suggest the existence of another reality, another form of being which escapes the

short-lived and corruptible existence of human life. This same Egyptologist has also drawn attention to the fact that the provision of both a stone funerary stela (which usually incorporated a representation of the deceased) and a stone statue in the Egyptian tomb allowed the spirit of the deceased "to attain an imperishable state of being through the possession of an image made in an imperishable material."[7]

As a natural corollary of the permanence of stone, the material could also be viewed as a direct link with the beginning of time and thus with the creation of the cosmos itself. From at least early dynastic times Heliopolis possessed a cone-shaped stone, the sacred *ben-ben*, which may have been meteoritic in origin and which symbolized the specific site where the primeval god became manifest. Much later, but in the same tradition, a similar cone-shaped stone was venerated in the temple of Amun at Napata, far to the south in Kush, and the temple of Amun at the oasis of Siwa in the northern area of western desert also had a conical stone symbol which was described by one Roman author as an umbilicus or navel of the earth. These stones were all symbolic of cosmic origins and the underlying basis of the world, and like the funerary use of stone objects, were clearly seen as an interface between the visible world and the divine reality beyond[8]. Occasionally, in New Kingdom texts, the stone used for statues is given the epithet *djesert* ("sacred") perhaps at least partly as a result of the nature of the material as well as the fact that it was being used to construct a dwelling place fit for the presence of a god.[9] The reverence felt by the common people for the very stone of the gods' dwellings is seen in the outer walls of many temples, such as Medinet Habu, where stone has been scraped away for healing and other magical uses.

Wood

Egypt itself has always been poor in fine woods, but a number of species from domestic and imported sources provided material for a variety of uses, some with symbolic significance. From Old Kingdom times the Egyptians imported fine cedar from Lebanon for objects such as the doors and pylon masts of the temples, as well as the most expensive coffins and items of furniture. Other imported woods used for fine quality items included cypress, ebony, elm, fir, oak, pine, and yew,[10] while wood from various indigenous trees was used mainly for less important work. Of these indigenous species, the poor but relatively plentiful wood of the date palm was used primarily for rough beams in roofing and other construction, but many different

articles were produced from the wood of the acacia, willow, thorn, persea, sycamore, and certain other native trees.

The sycamore (*nehet*) was a tree of particular mythical significance. According to the Book of the Dead, twin "sycamores of turquoise" were believed to stand at the eastern gate of heaven from which the sun god Re emerged each day,[11] and these same two trees sometimes appear in New Kingdom tomb paintings with a young bull calf emerging between them as a symbol of the sun. While the cosmic tree could take on a male aspect as a form of the solar god Re-Horakhty, the sycamore was usually regarded as a manifestation of the goddesses Nut, Isis, and especially Hathor – who was given the epithet "Lady of the Sycamore." Many representations show the arms of the goddess reaching out from a tree of this species to offer the deceased food and water. Because of this, sycamore trees were often planted near tombs, and models of the leaves of the tree were used as funerary amulets. Burial in the wooden coffin could also be viewed as a return to the womb of the mother tree goddess[12] (ill. 68).

The persea (*ished*) was also a sacred species, and although it does not seem to be mentioned in texts before New Kingdom times, from the Eighteenth Dynasty onward the wood, fruit, and leaves of this tree were frequently used in funerary contexts with symbolic meaning. Small twigs and leaves of the persea have been found in many tombs, and the fruit of the tree was found in the tomb of Tutankhamun. At least one headrest has been identified as being made of this wood, here too the choice of material perhaps being tied to the afterlife significance frequently associated with the form of these objects – i.e. as a symbol of the horizon between sleep and waking, life and death (see Hieroglyphs). The persea also had solar significance, and a sacred *ished* was grown in Heliopolis from Old Kingdom times, and later in Memphis and Edfu as well. On the ceiling of one of the chapels of the Temple of Dendera, twin *ished*s are depicted on the tops of the two peaks of the horizon hieroglyph showing their cosmic role, like the sycamore, in association with the rising sun. In the later New Kingdom, the motif of a divine *ished* upon which the king's name and the years of his reign were inscribed by the gods was especially popular.

The willow (*tcheret*) was also particularly important in iconographic symbolism. This tree was sacred to Osiris because, mythologically, it was a willow which sheltered his body after he was killed, and in which the god's soul often sat as a bird. Many towns had tombs where a part of the dismembered Osiris was believed to be buried, and all of them had associated willow groves. A festival called "raising the willow" was held each year which assured that the fields

and trees of the land would flourish. The tree could thus function in Egyptian art as a symbol of life, fecundity, and rebirth, as well as an emblem of a number of deities.

Several gods were said to have "come forth from," to manifest themselves in, or to be in some other way associated with, specific trees. Re-Horakhty and the goddesses Hathor, Isis, and Nut were identified with the sycamore, and Osiris with the willow as already seen. Horus was connected with the acacia, the jackal-like Wepwawet with the tamarisk, and Herybakef (a god of the Memphite region equated with Ptah) with the moringa. These associations could result in the symbolic use of a certain wood for the image of a given god, or for an item made to be presented as a gift to that deity, though difficulties in the identification of ancient woods may mean that the significance is not always recognized today. Nevertheless, the Egyptian texts always specify the kind of wood to be used for ritual and magical purposes – such as tamarisk (*iser*) or zizyphus (*nebes*) for the making of ushabtis, the small figures buried with the deceased which were intended to carry out tasks in the afterlife in his or her place – so each type clearly did have its own symbolic value.[13]

Wood could be used for destructive magic in the making of figures to be burnt and the transformation of this wood into black charcoal may have been seen as symbolic, for like metal or stone, the color of wood could be significant. Red and yellow woods were sometimes chosen to represent the symbolic skin colors of the male and female in the production of wooden statues and portrait heads, and the black ebony (*hebeny*) obtained from sub-Egyptian Africa was sometimes used to represent dark skin tones. Wood could also be painted, of course, and most sculpture in wood – and also in soft stone – was covered with a layer of gesso, a mixture of gypsum and glue to which pigments were applied. The fact that certain symbolically appropriate woods or other materials seem to have been occasionally used when the finished work was to be painted over demonstrates the importance of the hidden – yet very real – material symbolism. Wood could also be inlaid with other substances such as colored stones, metal, or glass, and thus take on the added significance of those materials.

Other Substances

There are many other substances which are known to have carried symbolic connotations for the ancient Egyptians, although the significance of some is not entirely understood. The hair of the giraffe-tail, for example, was used as an amulet, though the exact

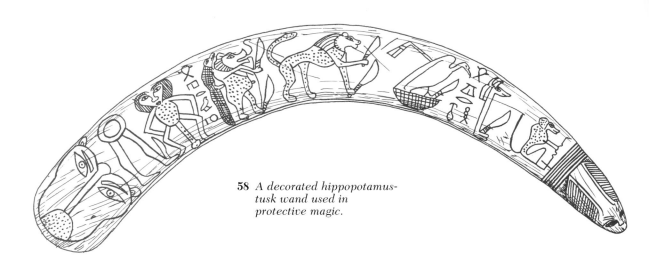

58 *A decorated hippopotamus-tusk wand used in protective magic.*

reason for this is lost to us. In other instances the symbolism of the substance seems readily understandable. Thus, hippopotamus ivory was considered especially potent – probably because of the great strength of the animal from which it came – and was used in the production of magical "wands" or "knives" which were decorated with the images of protective gods and creatures and apparently placed on or around beds to protect the sleeper during the night.

Similarly, the Egyptians made use of a wide range of oils, creams, ointments, and unguents for cleansing and scenting the body (soap was not invented until Roman times), for medicinal purposes, and to rejuvenate and prevent premature aging of the skin in an arid climate – the latter use being carried over to the funerary sphere with direct symbolic intent regarding the magical rejuvenation of the dead.[14]

Of the materials whose symbolism is clear, incense was certainly one of the more important. The incense used in the temple ritual and for various other purposes was an extremely valuable commodity produced from aromatic gums and resins, many of which were imported into Egypt. Incense was referred to as "the fragrance of the gods," and there is evidence to suggest that this meant far more than just the fragrance dedicated to or enjoyed by the Egyptians' deities. A number of scholars have pointed out that in many of the cultures of antiquity, the gods revealed themselves not only by sight and sound, but also by smell. The fragrance of burning incense thus not only revealed the divine presence, but also was in one sense a manifestation of the god or goddess for whom the incense was burnt. In the coronation of the Egyptian king, the incense burnt before the new pharaoh was said not only to "cleanse" the king, but at the same time, to emanate from his own person.[15] Representations of incense being offered before gods, therefore, have far greater significance than the

mere presentation of a costly and pleasing perfume. Symbolically, the very presence of the substance can be taken as an indication of the interaction between the human and divine spheres (ill. 70). The use of incense was, therefore, magically significant for the transformation of the deceased into a divine state, and this is reflected in the relation of the Egyptian name for this substance, *senetcher*, with the word *senetcheri* "to make divine."[16]

A number of other materials were used by the ancient Egyptians with as much regard for their symbolic and magical significance as for the physical availability or suitability of the materials themselves. One such substance is wax which was used for figures such as images of the four sons of Horus and also for some of the earliest ushabtis. Maarten Raven, who has done extensive research into the symbolism of materials and substances, has shown that the magical and symbolic use of beeswax can be attested from at least the First Intermediate Period, and that from Middle Kingdom times the applications of the substance in these contexts was wide ranging – with examples of destructive, productive, and defensive magic all being found in the use of different types of wax figurines.[17] The symbolism was further expanded during the New Kingdom and during the Late and Greco-Roman periods with the use of wax in medical, religious, and funerary contexts, and in the production of love charms and other practices. Thus wax was clearly not regarded simply either as a beneficial or harmful substance, but rather an ambivalent one (rather like lead, as we have already seen) which could lend its qualities to a number of differing symbolic and magical circumstances. Raven has suggested that this range of applications may well have been based directly on the material's physical properties – its preservative qualities (defensive symbolism), combustibility (destructive symbolism), and malleability (productive symbolism) – but he has also shown that the symbolic aspects of the substance go beyond its basic physical properties. According to the Egyptian's mythological beliefs, wax was considered a supernatural material – produced by bees which were themselves directly related to the sun god – and thus symbolically fitting in contexts relating to Re, as in the small beeswax foundation statuette of Ramesses XI (1100–1070 BC) and the goddess Maat (the daughter of Re) which was found in the king's tomb at Thebes (ill. 69). Wax was also used in the production of molded metal objects through the *cire perdue* or "lost wax" method, though this was a technological rather than symbolic application of the substance.

Clay or mud could also be employed with some of the same significance as wax and is sometimes mentioned as a substitute. Like beeswax, clay can be easily modeled – or destroyed – and is a

primeval substance which recalls both the original creation and the ongoing process of life and fertility. Deposited by the Nile in its annual inundation, mud was a natural symbol of life and was sometimes packed into mummies, probably with this meaning in mind rather than simply as an inexpensive filling. The fact that mud or clay was commonly used in the production of the so-called "corn mummies" which were placed in tombs also makes this significance likely. These figures contained seeds of grain which symbolized the resurrection of Osiris – and the deceased tomb owner – upon their germination in the damp mud with which they were filled. Clay could also be used in destructive and protective magic as may be seen in the clay figurines which were produced to be used in the ritual cursing of enemies, and in clay models of harmful or venemous creatures such as the scorpion which were intended to protect against the real animal. The great Harris Papyrus mentions an egg of clay which was to be thrown into the water to ward off nearby crocodiles, and in Chester Beatty Papyri we find the prescription of a spell "to be recited over a crocodile of clay" for the banishing of headaches. In the religious ritual known as the protection at the cenotaph of *Kom-Djeme* – a site in the area of Thebes connected with Osiris – four balls of clay, with the names of protective divinities inscribed upon them, were thrown toward the four cardinal points, signifying universal protection from evil.[18] The ancient Egyptian woman gave birth to her children on clay "birth bricks," the protective and life-giving significance of which probably added to their practical utility. Perhaps the most impressive use of mud, however, was in the "magical bricks" used in the royal tombs of the New Kingdom. These simple, unbaked bricks were placed in niches, one on each side of the tomb, and seem to have had a particularly potent protective aspect, though their exact nature is not fully understood. Raven has suggested that this protective function of clay may even be involved in the Egyptians' encircling of their temples with massive mud brick girdle walls.[19] While this practice may seem at first sight to be based simply on economic considerations, it must be remembered that virtually every other part of the Egyptian temple was constructed of stone, and that almost every aspect of temple architecture involved symbolic considerations. On the other hand, the mud used to construct the *temenos* walls could have been somehow associated with the symbolism of their alternating concave-convex foundations which are known to have signified the primeval waters from which the first land emerged (see Forms).

Finally, water itself was an important symbolic substance in at least three different ways. In a desert climate such as Egypt's, water

was understandably a very real symbol of fertility and of life itself. Water could thus represent the god Osiris (it is often referred to as the "exudition" of the god), just as earth could represent his wife Isis, a polarity which found symbolic expression in the inundation of the Nile and the fertile union of water and earth. On the other hand, the symbols could be reversed; in the annual festival of Osiris, a model phallus representing the god was carried at the head of the procession with a jar of water symbolizing his wife. Far from being crude symbols of reproduction, these elements were a manifestation of a much deeper cosmogonic imagery.

Because the world had begun with the watery chaos of the First Time, water was a natural symbol of creation and this is probably one of the reasons for the sacred lake found within the grounds of many temples.[20] Water was also used for purification, and this was both a practical and symbolic reason for such bodies of water. The purifying nature of water is also seen in funerary representations which show one of the various goddesses associated with the afterlife – such as Hathor or Isis – welcoming the deceased king into the afterlife with a symbolic lustration, or purification. This is shown by means of the hieroglyph which signified water 〰 being painted above the outstretched hands of the goddess, or of some other figure as in ill. 71.

All of these various materials indicate that for the ancient Egyptian the natural properties of the substance from which an object was made could be symbolically just as important as the object's form, size, color, or any other external aspect. Often the significance of a given material may be based on something as simple as its weight, malleability, or surface shine – or a combination of such factors – yet the simplicity of such qualities in no way detracts from the profound symbolic importance with which the materials were invested.

Egypt's Raw Materials

59 *Map of Egypt and surrounding areas with the major locations of important materials.*

Rich in some substances and poor in others, Egypt was nevertheless positioned strategically between two continental landmasses and had sea access to other areas. The Egyptians were therefore able to secure a wide range of natural materials, including various metals, stones, woods, and other substances having symbolic significance.

Gold, both economically and symbolically of great importance, occurs in the Eastern Desert and was also imported from the south. Silver occurs naturally in the gold ores available to the Egyptians, but they were unable to extract it. The white metal was thus rarer than gold in the earliest periods and only became somewhat more plentiful in New Kingdom times when it was imported from Palestine, Syria, and the Aegean. Iron, imported into Egypt in the later periods, was only known indigenously in very small amounts of meteoritic origin. Lead, on the other hand, was relatively plentiful, because it could easily be extracted from the ore in which it occurs at a number of sites.

Of the various stones, alabaster was quarried in Middle Egypt, in the Sinai, and in a number of other locations. Limestone was cut at various sites along the Nile, such as the famous quarries at Tura on the east bank at Cairo. Granite, on the other hand, was more localized and was chiefly obtained from the extensive beds at Aswan, and from the Wadi Hammamat to the north of Thebes. Quartzite, basalt, and diorite were also found at Aswan and in a few other scattered locations, with a major source of basalt occurring in the Faiyum. The Western Desert produced some of the less plentiful stones such as steatite and serpentine; and semiprecious stones such as malachite and turquoise were chiefly mined in the Sinai.

Because most of the indigenous woods available to the Egyptians were of relatively low quality, finer woods were often imported. Cedar, a premium wood with many uses ranging from the doors of temples and palaces to the construction of the finest coffins, was shipped from the Lebanon. Cypress, fir, and the wood of some other conifers were also imported from the region of Syria from very early times. Ebony – which is the heartwood of a number of different tropical trees – was highly prized for small decorative objects and was often used with symbolic intent. It was obtained through Egypt's southern neighbors from at least the First Dynasty, although the wood is not mentioned in texts by its Egyptian name *"hebeny"* until later in the Old Kingdom. Of the other substances with symbolic associations which were used by the Egyptians, most were locally produced, though a few, such as the various kinds of incense, were obtained from quite distant areas.

MEDITERRANEAN SEA

cedar
silver

PALESTINE DEAD
SEA

Tell el-Gamma

iron

Nile Delta

quartzite

LOWER EGYPT

Gebel Ahmar
Cairo
Memphis Tura
limestone
calcite
(alabaster)

THE FAIYUM

basalt
dolerite

copper

copper
malachite
turquoise

Timna
copper

Serabit el-Khadim

SINAI

EASTERN DESERT

WESTERN DESERT

Beni Hasan
limestone
Tell el-Amarna
limestone
Hatnub
calcite
(alabaster)

steatite
serpentine

Nile River

copper

granite

RED SEA

lead and galena

granite

Abydos
limestone

incense

UPPER EGYPT

WADI HAMMAMAT
Thebes

Gebelein
limestone
el-Kharga Oasis

copper

lead and galena

lead, basalt, granite,
diorite, quartzite

gold

copper

Aswan

0 100 200 km.

0 50 100 miles

Qirtassi

sandstone

LOWER NUBIA

ebony and gold

Metals

60 (Right) Gilded mummy mask of Thuya. Valley of the Kings, Thebes, Dynasty 18. Egyptian Museum, Cairo.

Gold: This metal was regarded as a divine metal on account of its color and brightness (symbolic of the sun) and its untarnishing nature (symbolic of eternal life). The flesh of all the gods descended from the sun god Re was believed to be of gold, and images of the deities were formed from this substance in many cases. The *sah* or afterlife "body" of the ancient Egyptian was also thought to be of divine nature with shining golden skin, and the masks of the finest mummies were of gold or gilded with a layer of gold on a base of some other substance, as in this finely wrought mask of the lady Thuya.

61 (Above) Dagger with iron blade. Tomb of Tutankhamun, Valley of the Kings, Thebes, Dynasty 18. Egyptian Museum, Cairo.

Iron: Because the only iron naturally available within Egypt in the earlier periods was of meteoritic origin, this metal – known to the Egyptians as the "metal of heaven" – was regarded as divine and of great potency.

Although iron objects began to be imported into Egypt during the New Kingdom, many of the small iron blades and other objects used in ritual contexts may well have been believed to have been invested with particularly powerful magic, as was the case in the iron blades of the ritual adzes used in the "opening of the mouth" ceremony.

62 *(Below) Silver and serpentine baboon. Dynasty 25–31. Harer Collection, California.*

Silver: A highly regarded metal, silver also had divine associations, for the bones of the gods were said to be of this substance, and it was used extensively as a symbol of the moon in mirrors and in many figures of lunar gods such as Khonsu and Thoth. As a creature sacred to Thoth, the baboon was often represented wholly or partly in this metal, as in this example in which the body of the baboon is carved from stone, while its face is inlaid with silver in order to heighten the creature's lunar symbolism.

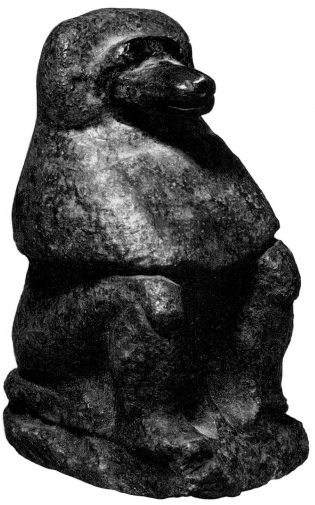

63 *(Above) Bound captive amulet of lead. Late Period. (After Petrie.)*

Lead: Probably due to its characteristics of heaviness and malleability, lead was extensively used in the production of various magical and symbolic objects – of both a protective and destructive nature. The plaques made to cover and protect the embalming incision on the mummy were sometimes made of this substance, as were many protective amulets. Made use of in destructive magic, the figure illustrated here is of a type intended to be ritually destroyed as a substitute for real enemies. Made entirely of lead, it was also wrapped in a sheet of the substance.

The Symbolism of Materials 99

Stones

64 *(Right) Quartzite statue of Amenhotep III. From Luxor Temple, Dynasty 18. Luxor Museum.*

A hard, crystalline form of sandstone, quartzite was used both in building and in the construction of statuary. The stone occurred in white, yellow, and red varieties, the latter type being almost purple in some cases. These colors gave the stone solar connotations, which are exploited to the full in this statue of Amenhotep III as Atum – god of the evening, setting, sun – whom it represents not only in its iconography, but also in the sunset-like hues of the stone itself.

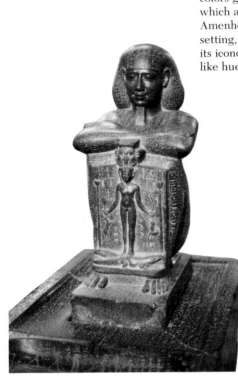

65 *(Above) Basalt healing statue of Djedhor. Macedonian Period. Egyptian Museum, Cairo.*

One of the hardest minerals available to the Egyptians, this dense black stone was used both in building and in the construction of statues and some smaller objects. Its black coloration gave the stone a natural association with the underworld, and basalt was used for many statues of the netherworld deity Osiris, as well as for sarcophagi, stelae, and other objects used in funerary contexts. During the fourth century BC, the stone was also used for the construction of healing statues such as the one illustrated here.

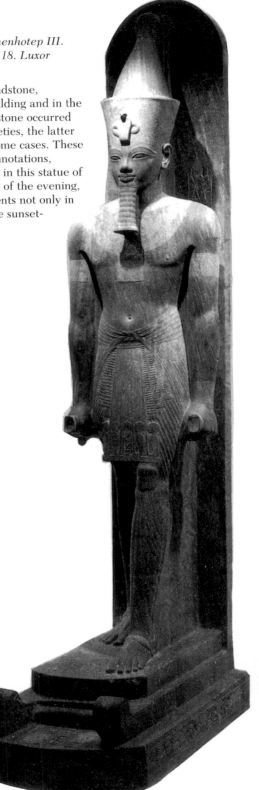

66 *(Below) Alabaster canopic chest. Tomb of Tutankhamun, Valley of the Kings, Thebes, Dynasty 18. Egyptian Museum, Cairo.*

This fine, translucent stone was employed in the construction of shrines, altars, and other structures but found most frequent use in the production of smaller objects such as offering jars, vases, bowls, and lamps. Alabaster's "white" coloration (it actually ranges from a pale milky white to a much deeper hue, often with bands and markings of orange, brown, or other colors) meant that it was thought especially suitable for items intended for religious and mortuary use where purity was stressed. Almost all of the vessels and other stone objects found in the tomb of Tutankhamun were of alabaster.

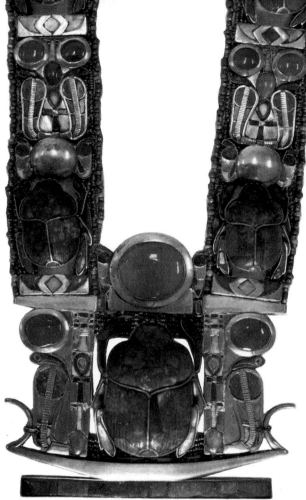

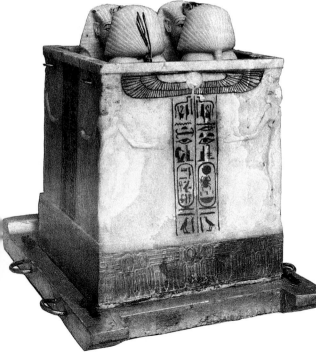

67 *(Above) Lapis lazuli scarab pendant. Tomb of Tutankhamun, Valley of the Kings, Thebes, Dynasty 18. Egyptian Museum, Cairo.*

Symbolic of the heavens because of its blue ground color and star-like golden speckles, this semiprecious stone was highly valued and imported into Egypt from considerable distances. Used primarily in the construction of items of jewelry, the "heaven" symbolism of lapis is often seen in its use for objects such as the solar/heaven-associated scarab. The hair and beards of the gods were said to be of this substance, and the stone was thus utilized in the construction of divine images. The god Amun who came to be depicted with blue skin was called "lord of lapis lazuli."

The Symbolism of Materials 101

Other Materials

68 *(Above) Base of a wooden coffin. Akhmim, Dynasty 22. (After Koefoed-Petersen.)*

Wood: A number of deities were associated with different trees, and beginning in the New Kingdom Nut, Hathor, and Isis were commonly represented in the guise of "tree spirits" providing food, water, and shade for the deceased in the afterlife. Nut also appears frequently on the top or bottom of wooden coffins, stretched out to cover or embrace the deceased. Here the symbolism of the wood itself is joined with that of the representation, for the wooden coffin represents the womb of the goddess to which the deceased returns.

69 *(Below) Beeswax statuette of Ramesses XI and the goddess Maat. Tomb of Ramesses XI, Valley of the Kings, Thebes, Dynasty 20. Luxor Museum.*

Wax: While wax was sometimes used for the modeling of objects to be cast in bronze, other objects were made of this material for purely symbolic reasons. Mythologically, wax had solar significance as a symbol of the sun god Re and his daughter Maat, and figures of these deities were sometimes made from this substance. Like lead, wax also had protective and destructive associations and was used both for amuletic charms and for the figures of enemies and malevolent beings which were made to be ritually destroyed.

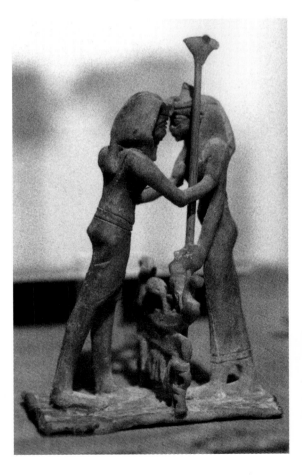

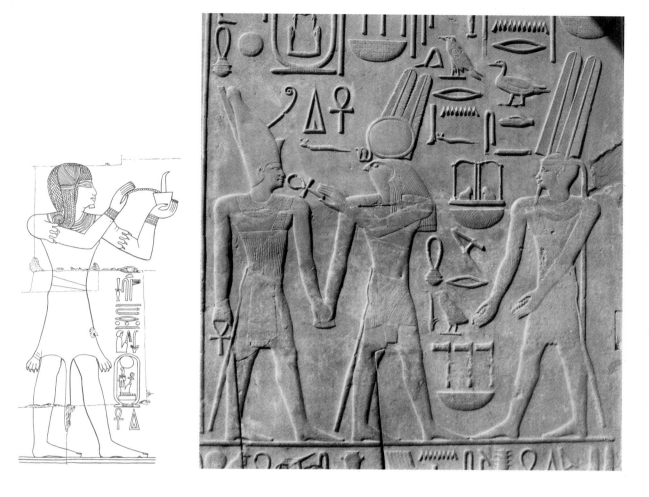

70 *Incense offered before an image of Seti I. Temple of Seti I, Abydos, Dynasty 19.*

Incense: In many ancient cultures the gods revealed themselves not only by sight and sound, but also by smell. So the fragrance of burning incense was not only a pleasing offering to the gods, but could also be regarded as a manifestation of the deity for whom the incense was burnt. Incense could also take on a specific identity through the phenomenon of personification, and the depiction of the substance in religious rituals can be taken as a symbolic indication of the interaction between the human and divine spheres.

71 *The god Amun sprinkles water on the king. Shrine of Sesostris I, Karnak, Dynasty 12.*

Water: Formless and ubiquitous, it was a natural symbol of the primeval sea from which the world had arisen at the time of creation. The very basis of life, water was also a potent substance which figured in many offerings and in rituals symbolizing personal and cosmic renewal and fertility. Used in cleansing and ritual purification, water could be a symbol of purity and acceptance. Scenes such as this which show a deity welcoming the king with a sprinkling of pure water could thus connote a number of meanings.

THE APPEARANCE OF
THE WORLD
the symbolism of
COLOR

*"... He rules the plains of the Silent Land, even he the golden of
body, blue of head, on whose arms is turquoise."*
Book of the Dead, Introduction

IN A LAND of harsh sunlight and bleached desert vistas such as
Egypt, bright, vibrant colors take on a particular importance of
their own. Color becomes an important way of adding life and
individuality to an image, so that it is perhaps not surprising that the
color of an object was regarded by the Egyptians as an integral part of
its nature or being, just as a man's shadow was viewed as part of his
total personality. In this sense, color was virtually synonymous with
"substance." In fact, the word *iwen* used to signify the concept of
"color" in the Egyptian language can be translated as not only
"external appearance," but also "nature," "being," "character," or
even "disposition;" and the determinatives used to write the word in
the hieroglyphic script were either an animal pelt ⟨glyph⟩ or a lock of
human hair ⟨glyph⟩ – showing the connection in the minds of the
Egyptians between color and individual appearance and being.[1]

The Egyptian Palette

This underlying connotation is one of the reasons why the colors used
in Egyptian art so frequently make a symbolic statement, identifying
and defining the essential nature of that which is portrayed in a way
that complements and expands upon the basic information imparted
by the artist in line and form. Naturally, this is not to say that every
color and every variation in color has some symbolic significance in
Egyptian art. Indeed, the contrary can be established in many ways.
In groups of overlapping objects or figures, for example, the Egyptian
artist will invariably alternate the colors of otherwise identical

subjects in order to differentiate them from one another. This is the reason why rows of people are frequently alternated as light and dark, as are plowing oxen and chariot horses. Even apart from practical considerations such as these, it is evident that the Egyptians enjoyed the use of color for its own sake in much of their art and decoration, and that the selection and use of colors could be for purely aesthetic purposes.[2] It is true to say, however, that wherever symbolism enters into Egyptian art, the use of color is likely to be significant.

The modern artist not only routinely deals with the changes which occur in colors because of highlighting and shadow, but also adjusts for concerns such as "color perspective" – the fact that certain colors seem to press forward or "leap out" from the picture, while others seem to recede into the background. Such things would have been of no real concern to the Egyptian artist even if he had fully understood them, since his own brand of artistic realism viewed color as a largely immutable aspect of nature which remained symbolically vital only if it remained unchanged. In order to explore the Egyptians' symbolic use of color, we must first examine the range that was available to the ancient artists as well as the way in which the colors themselves were perceived and regarded.

The colors found in Egyptian paintings and applied to works of sculpture and architecture are one of the most commanding aspects of Egyptian art. Because they were made from mineral compounds which retained their essential characteristics,[3] the colors are largely permanent and still brilliant in many cases, thousands of years after they were applied. This freshness and vibrance of color is something which often surprises those who are visiting Egypt for the first time, but it is authentic; those temples and tombs which display smudged, faded colors are usually the result of generations of curious hands, rather than any deficiencies in the ancient paints.

Egyptian art appears to reflect a wide range of color, but in fact the palette available to the ancient artist was limited to about six colors (including black and white). So it is a tribute to the skill of those artists that such apparent variety exists in their work. The principal colors and their sources included:

Red Naturally occurring oxidized iron provided the color for the red iron oxides and red ocher used by the Egyptian artist in representing flesh tones and wherever red was needed.

Blue A pigment commonly known as "Egyptian blue" was manufactured by combining oxides of copper and iron with silica and calcium to produce a rich, though relatively unstable, pigment – which in some cases has darkened or changed color.

Yellow Like red, naturally occurring ocher or oxide was the main source for the yellow pigment found in Egyptian art. From the latter New Kingdom on, orpiment (naturally occurring arsenic trisulphide; probably imported) supplied another source of yellow.

Green This color could be produced in the form of a manufactured paste similar to that used for blue, or from malachite, a naturally occurring copper ore. In either case the ultimate source of the color was from mineral copper.

White Strong, clear whites were produced from the plentiful chalk and gypsum (calcium sulphate) available in Egypt.

Black Various forms of carbon – sometimes from soot, but also from ground charcoal or burnt animal bones – were utilized in the production of black pigments.

Some less common colors were also occasionally produced by the use of other substances, and the primary pigments were mixed by the Egyptian artists to produce the various secondary colors which are sometimes found – e.g. gray, pink, brown, or orange. White chalk could be added to any of the pigments to lighten their hue, or carbon black might be used to darken them. Despite the possible variety, however, Egyptian artists on the whole still preferred the relatively strong and pure colors of their basic palette, and it is not coincidental that it is with these basic colors that Egyptian symbolism is mainly concerned.

Color and Connotation

The primary colors used by the Egyptians all find symbolic expression in Egyptian art, and this may also be the reason for the choice of specific substances – especially colored stones and metals – in the production of statues and in the inlays used in jewelry and other items (ill. 74). It is easy to see the basic significance of the colors, but the *ambivalence* of meaning exhibited by some of them under differing circumstances must be carefully noted.[4]

Red (*desher*) The color associated with fire and with blood, red could symbolize life and regeneration (as in the funerary use of henna), but could also symbolize dangerous forces beyond the realm of total control. It could signify the red, hostile desert regions of Egypt; and Seth, the god of those regions and of chaos, was said to have red hair and eyes. Red could thus be used to signify anger, destruction, and death, and expressions such as *desher ieb* "furious" (literally red of heart), and *desheru* "wrath," are formed from the basic word for this color. Egyptian scribes used red ink rather than the usual black to write the hieroglyph for "evil" and for unlucky days of the year, as

well as the names of hostile monsters and gods such as Apophis (the cosmic serpent) and Seth. The color's connotations in regard to the god Seth, however, could vary. Venerated during the Hyksos period, Seth also became the patron deity of the Ramesside kings of the Nineteenth and Twentieth Dynasties. The fact that Ramesses II (and perhaps others of his line) may have had red hair[5] could well have had something to do with the changed view of the red-haired Seth during this period – and shows how symbolism might sometimes be affected by very practical considerations! Red was used to represent the normal skin tone of the Egyptian male without any negative connotation, but it could also signify the fierce nature of the radiant sun, and as such the color was used for the serpent amulets representing the "Eye of Re," the fiery, protective (and potentially destructive) aspect of the sun god. The purple-red quartzite used to make a statue of Amenhotep III as Atum – the god of the evening sun – which was recently discovered in Luxor Temple may well symbolize the setting sun in its color [see Material]. In these examples we see something of the constant ambivalence which characterized the symbolic usage of the color red, and the way in which care must be taken in attempting to understand its use.

Blue (*irtiu* and *khesbedj*) This color could represent the heavens as well as the primeval flood, as will be seen, and in both ways it functioned as a symbol of life and rebirth. By the same token, blue could signify the river Nile and its associated crops, offerings, and fertility, and many of the so-called "fecundity" figures which represent the river's bounty are of this hue. The phoenix or heron, an ancient symbol of the primeval flood – and the inundation of the Nile which was an annual reminder or re-enactment of the watery origins of the world – was often painted in bright blue tones considerably different from the light gray-blue of the bird's actual plumage. In this case, as in the deep red-brown used for the skin of the Egyptian male, the color is perhaps "enhanced" for symbolic reasons, for the Egyptians were quite capable of producing and using a lighter, more natural gray-blue as a number of examples show. Another creature usually depicted as being blue was the sacred baboon, which although it does not exhibit this color in nature, is almost invariably painted with a blue (or green) mantle and with blue body and legs. In this instance the reason for the chosen coloration is not clear, though it may well have had a symbolic basis, perhaps connected with the fact that the baboon – like the ibis, which was commonly painted blue – was a symbol of the god Thoth. Alternatively, blue may have had solar connotations under certain circumstances, as in a number of solar-related objects manufactured from blue faience.[6] Finally,

because the color blue came to be connected with the god Amun-Re, a number of portraits of Eighteenth Dynasty kings with blue faces are believed symbolically to show their assimilation to that god.[7]

Yellow (*khenet* and *kenit*) The color of the sun, yellow (and thus gold) was seen as symbolic of that which was eternal and imperishable. The flesh and bones of the gods were held to be of pure gold, and thus the yellow metal was the natural material for the construction of images of deities as much from a symbolic perspective as from considerations of the inherent worth of the precious substance. Two-dimensional representations of deities are also often given yellow skin tones to reflect the mythologically golden nature of their bodies, as is the case in the depiction of the jackal-headed god Anubis who is shown accepting the mummy of the deceased in ill. 80. Because funerary scenes such as this are believed to depict a masked priest representing Anubis, it is possible that such priests colored their bodies yellow to perform the function – if this color was not simply added to the representation by the artist. "White gold" (the mixture of gold and silver now called electrum) was often regarded as being the equal of pure gold (see Materials), and the color yellow could also interchange with white and take on the symbolic meanings of that color.

Green (*wadj*) Naturally a symbol of growing things and of life itself (to do "green things" was a euphemism for positive, life-producing behavior in contrast to "red things" which symbolized evil), green was also a potent sign of resurrection. Early texts refer to the afterlife itself as the "field of malachite" after the vivid green mineral used by the Egyptians in the production of this pigment. This is the meaning behind the statement in the Pyramid Texts: "O you who stride out . . . strewing green-stone, malachite, turquoise of the stars, if you are green, then the king will be green (even as) a living rush is green."[8] In a similar manner, in Chapter 77 of the Book of the Dead, it is stated that the deceased desires to become a great falcon "whose wings are of green stone." As such wings would certainly not be functional, it is clear that the symbolism of the color is what is important. The skin of the great underworld deity Osiris was frequently painted green (as will be seen below), and in the Twenty-sixth Dynasty the face of the deceased as represented on the coffin was given the same color as part of the symbolic association of the dead individual with the god. The common amulet known as the "Eye of Horus" is usually green because of the positive connotations of the color as an expression of the aspects of healing and well-being associated with the eye. *Wadjet* "the green one" was the name of the tutelary, or protective, serpent goddess of Lower Egypt, and hence a name of the crown (though it

was actually red) of that region. The color was also associated with Hathor.

White (*hedj* and *shesep*) The color best suited to denote cleanliness, and thus ritual purity and sacredness, white was almost invariably used to depict the clothing of most Egyptians and was especially symbolic in regard to the priesthood. The "Instructions of Merikare" (a ruler of the Ninth or Tenth Dynasty) speak of service as a priest in terms of the wearing of white sandals.[9] White alabaster (calcite) was used for the production of ritual objects ranging from small bowls and other vessels to the massive embalming table used in the mummification of the Apis bulls at Memphis. Many sacred animals were also of this color, including the "Great White" (baboon), the white ox, white cow, and white hippopotamus. The word *hedj* "white" was used to denote the metal silver which was used with gold to symbolize the moon and sun respectively [see Materials]. Statues of the god Nefertem, the "lord of perfumes" who was associated with the lotus flower, were often made of silver instead of gold or bronze, probably as a result of the connection of the metal's color with that of the white flower. Because the traditional crown of Upper Egypt was known as the White Crown (though it seems to have originally been constructed from reeds and therefore actually green), white also became the heraldic color of southern Egypt.

Black (*kem*) The color of night and of death (a black hole was sometimes used to signify "death" and "destruction of enemies"), black symbolized the underworld as might be expected, but could also – as a natural corollary – signify the concept of resurrection from the dead and even fertility and thus paradoxically life itself.[10] The symbolic association of the color with life and fertility may well have originated in the fertile black silt deposited by the Nile in its annual flooding, and Osiris – god of the Nile and of the underworld – was thus frequently depicted with black skin. The fact that Egyptian coffins were often decorated with inscriptions on a black ground throughout the Late Period may have associated them with the underworld god, though the reason may have been purely of a stylistic nature. The Osiride significance of the color and the fact that black and green may interchange in this role is certain, however, as may be seen in various representations of Osiris, and in the heart scarabs which protected the most important organ in the mummy. These scarabs may be of black or green stone, perhaps equally signifying their relationship with the deceased – who had become one with Osiris – and the general theme of life and resurrection. Statues of the gods were also often carved from black or green stones and the interchange of the two colors was undoubtedly based on their symbolic equivalence.

Black stone seems to have been considered a particularly potent symbolic substance and was almost always the material chosen for the magical healing statues commonly inscribed with vignettes and spells during the Macedonian and Ptolemaic Periods, although equally hard stones of other colors were available. As the color of the rich, dark soil of the Nile Valley, black (*kem*) also symbolized Egypt itself (*kemet*: "the Black Land") from the earliest times.

Natural, Symbolic, and Conventional Color

The dual usage of colors – on the one hand where objects are given the same hue as they appear in nature, and on the other, where objects are assigned colors to which they are symbolically linked – is clearly found in the colors used in the depiction of Egyptian hieroglyphs.[11] Each hieroglyph – itself a miniature picture – in the Egyptians' written language had its own color or color combination which was faithfully kept whenever multiple colors were used in formal inscriptions or in decorative elements. Sometimes, in fact, the difference in color was used to differentiate two otherwise identical signs. This is not to say that variation could not occur, as for example in different periods or when a sign was to be painted on a background of the same color, but hieroglyphs left uncolored in several New Kingdom royal tombs indicate that at least in this type of inscription the signs were carved or outlined then colored consecutively – perhaps all the red signs followed by all the blue, etc. – rather than working with all the colors sign by sign.[12] This method shows the degree to which the color of the signs was regarded as an integral part of their nature. Although color was omitted in everyday writing, in order to save time or expense, it was nevertheless viewed as a very real part of the complete sign.

In situations where the signs were not simply painted in black or red paint, each sign received its own basic color, or even a combination of colors if the inscription was elaborate enough. A number of examples of this principle are shown in ills. 75 and 76, where some of the signs typically colored green, red, yellow, and blue during the New Kingdom are given along with multicolored examples. The colors assigned to the various signs are in most cases simply the colors of the objects themselves. That the signs depicting the arm, leg, hand, mouth, or other body parts were usually red is only natural, as is the portrayal of reeds and other plants as green, wooden objects as red, water as blue, and so on. But the standardized depiction of other signs probably reveals a symbolic association between the object and its assigned hue, as may be seen in the

coloration of the sickle (usually made of wood) as green, the metal butcher knife as red, or the white bread loaf as blue. Similarly, items of clay are depicted as blue (though this may be related to the common use of blue glaze), and the horns of animals may be painted blue or green.

Even when the reasons for the use of certain colors are not immediately apparent, it seems sure that some connection usually existed in the minds of the Egyptians between a given sign and the color used to depict it. The same is true of the frequent juxtaposition of certain colors by the Egyptian artist, which is often understandable symbolically as signifying wholeness or completion through the combination of opposing or related colors. The symbolic opposites red and white (or its alternate hue yellow) find completion together as the colors of man and woman, and the red and white crowns which signified Seth (red) and Osiris (black) in some contexts.[13] Green and black are also often used in this way as symbolic opposites (life and death) which nevertheless parallel each other and thus constitute a completion.

black are also used as symbolic opposites (life and death) which nevertheless parallel each other and thus constitute a completion.

The fact that each color had specific symbolic connotations for the ancient Egyptian is sometimes complicated for the modern viewer by the fact that the Egyptians appear to have classified some colors quite differently from the way in which we would categorize them, and some colors apparently were quite interchangeable.[14] Blue and black seem to have been interchangeable in many circumstances – such as the representation of the hair and beards of the gods. While hair was normally depicted in its most common color, black, the hair and beards of the gods were said to be of lapis lazuli, and thus blue. In actuality, however, the two colors are interchanged in Egyptian art, and the hair of most gods may be depicted in either color. This is seen in ill. 80 where the wig of the mummy is painted blue as is that of the god Anubis. Other clues abound that the two colors were symbolically synonymous. One of the lesser-known pectoral ornaments found among the treasures of Tutankhamun depicts the king as wearing the distinctive Blue Crown as he appears before the god Ptah (ill. 77), but the crown is composed of black inlay despite the fact that the artist used blue for the flesh of the god, as well as for the goddess Sekhmet who also appears in the composition.

Light blue seems to have been treated as being functionally the same as green from a symbolic standpoint. This is seen in the interchange found in rows of matched hieroglyphs or other decorative elements used in such things as necklace pendants, for example.

The flesh of Ptah, which is usually shown as green in most representations of this god, is thus depicted in light blue inlay in the pectoral of Tutankhamun in ill. 77. In this same composition, then, black and blue are interchanged as are light blue and green. White and yellow were also interchanged on occasion (as we shall see); and red and black could also interchange in representations of the underworld where both colors could be associated with annihilation. At the base of the walls of the burial chamber of Ramesses VI (1151–1143 BC), for example, the figures of bound, headless "enemies" are depicted alternately in red and black to symbolize their destruction.

The reason for this direct interchange of colors is not fully understood, though it seems possible that a natural explanation might exist – such as the interchange between the blue and black of the day and night skies, both representing the same heaven. In a similar manner, it is possible that pale blue and green were classified together since both are found in intermingling hues in the waters of the river and marshlands or in the naturally occurring variant shades of the stone turquoise, which was highly prized by the Egyptians and which may range from light blue to green. In this way red and yellow may both be seen in a fire's flames and the changing appearance of the sun (ill. 78), and the interchange of white and yellow may represent the unity of the two colors as perceived in sunlight under different circumstances in nature and for other symbolic reasons (ill. 79). This type of interchange is one of the most important aspects of Egyptian color symbolism and may now be examined in more detail in two specific areas where it appears frequently in Egyptian art: the use of colors to represent the different spheres of the cosmos, and the use of colors to symbolize different classes of living beings.

The Colors of the Cosmos, The Hues of Gods and Men

The heavens may be symbolized by black or blue in Egyptian art, though the latter color is more commonly used for this purpose. While blue is the color of the sky, it is also the color of the cosmic waters which the Egyptians imagined as existing above the earth – and which may actually have been the reason in their minds for the sky's blue coloration. Inasmuch as it was the color of the sun and the stars, yellow/gold could also represent the heavens, though its use in this general and abstract sense is relatively rare. The basic interchange remains that of black and blue, with both of these colors being employed in parallel compositions depicting the heavens.

72 *Color equivalence: heart scarabs such as this are frequently red, blue, or yellow – all solar-related colors.*

In a similar manner, although the kingdoms of Upper and Lower Egypt were represented by the red and white crowns, and these colors were used heraldically for the respective areas, they represent a primarily political duality; the colors red and black were more symbolic of the land of Egypt itself. Red was used to signify the untamable desert (actual sand was depicted in a light red color with black, red, and white dots suggesting grains of different kinds of stones) as well as the sometimes dangerous foreign lands beyond; while the black of the fertile Nile soil which contrasts so starkly with the surrounding sand was symbolic of fertility and life. Black thus symbolized the natural sphere of Egypt, but the color green also signified the concept of "earth" as opposed to heaven, as well as the sea (the "Great Green"). A direct interchange is possible, therefore, between black and green as colors symbolic of the earth.

In Egyptian representations of the underworld, or in scenes having a clear underworld setting, the colors black and blue (or the combined blue-black) frequently interchange as they do for representations of the heavens. Horemheb (1319–1307 BC) and Ramesses I (1307–1306 BC) both used a blue-gray background on the walls of their tombs, perhaps to symbolize the entrance of the deceased pharaoh into the underworld or into the heavens,[15] especially since the walls of the burial chamber (called the "House of Gold") were painted in a vivid yellow which was clearly symbolic of the chamber's name in the royal tombs of the later New Kingdom. The fact that green could also symbolize the underworld – referred to in some mortuary texts as the "fields of malachite" – also leads to an interesting interchange between black and green in this area. The main colors of the underworld may thus be seen to be those of the heavens (black and blue) and the earth (black and green), both spheres being mythically present in the nature of the underworld itself.

The seemingly enigmatic Egyptian saying that it was impossible to know the color of the gods meant simply that their substance and being were beyond human scrutiny and comprehension, but it well

illustrates the concept introduced at the beginning of this chapter that the color of any object or being was virtually synonymous with its essential nature. So then, a hymn to the sun god preserved in the British Museum states "Your splendor is like heaven's splendor, your color is brighter than its hues."[16] Mythically, the flesh of the gods was held to be of gold and they are thus often painted yellow (ill. 80). In actuality, specific colors were assigned to various deities in accordance with their perceived nature and functions in the cosmos. Because blue, for example, represented the heavens and the cosmic waters, this is undoubtedly the reason why this color was used for the four male deities of the Hermopolitan Ogdoad or group of eight gods (Nun – primeval waters; Heh – infinity; Kek – darkness; and Amun – void). Blue was also used for the body coloration of the gods Osiris, chief deity of the underworld; Ptah, the ancient god of Memphis; Re-Horakhty, a form of the sun god; Horus, the ancient sky god; Khnum, the creator god associated with the Nile; and various fertility deities (ill. 81). Osiris, as already seen, was usually represented as having either green skin, the color of life and resurrection; or black skin, signifying the realm of the underworld, but also resurrection.

But the colors used in the representations of the gods are not always this perfectly understood. A case in point is that of the colors red and blue (including blue-black) which were used in different representations of the god Amun.[17] Although Amun was held to be blue according to the relatively late teaching of Hermopolis, most early depictions of this god show him with red skin color – the same as that of men, which seems to be the original form of depiction. As time progressed, however, blue (or blue-black) images of the god began to appear. The earliest blue examples of the god presently known date from the reigns of Thutmose III (c. 1479–1425 BC) and IV (c. 1400–1390 BC),[18] but the form becomes increasingly common later in the New Kingdom, and both occur in the same structures built or restored after the reinstitution of the official worship of Amun which followed the Amarna heresy. In some structures the red form of the deity was primarily used, whereas in others the blue form is found, yet there is no differing title given to the two forms of the god, nor any apparent rule dictating which color should be used for the god in a given circumstance, or why the variation should exist at all. Although some difference surely existed in the minds of the Egyptians originally, the two forms simply came to be used interchangeably until, for some reason, by the Nineteenth Dynasty the blue form was the sole representational aspect of the deity to survive.

Egyptian men were almost invariably shown with the same russet or red-brown skin tone which was used for many of the gods, though

this situation should probably be viewed the other way around, since the gods of the Egyptians were, of course, created in the image of humans. The color appears from the beginning of the dynastic period and probably signified nothing more than a tanned, outdoor complexion in contrast to the paler skin tone of the woman. In that sense, the color is symbolic rather than naturalistic, yet clearly based on objective reality.

Foreign peoples of different races were given appropriate skin colors, but these were usually very stylized characterizations (ill. 82). While Nubians and other peoples to the south of Egypt (including the black "Cushite" kings of the Twenty-sixth Dynasty) were depicted as black in contrast to the Egyptians' red-brown coloration, Libyans, Bedouin, Syrians, and Hittites were all shown with light yellow skin, and these ethnic groups must be differentiated on the basis of specific clothing and hair styles. Important for the understanding of Egyptian symbolism, however, is the fact that skin color alone does not always define ethnic or racial type. For example, because black was used for the skin of underworld deities and by extension became the color of the deceased (the color of the pitch-covered mummy was also black), its use does not always signify a dark complexion and can frequently be symbolic. This can be seen in several representations of Tutankhamun. Usually, this king is shown in the canonical reddish skin tones used of all Egyptian males, though occasionally he is shown in a much paler shade.

In several works found in his tomb, Tutankhamun is depicted with completely black skin. Most striking are the two life-size "guardian statues" that stood either side of the burial chamber entrance; inscriptions on their kilts state that they are the dead king's *ka*, a kind of spiritual double. In the same way, all the examples in the tomb are of a funerary nature and their color is directly attributable to the symbolism of black as an indicator of the afterlife.

In one instance, that of the double cartouche-shaped ointment container (ill. 73), two images of the king – one with pale, pink-toned flesh, the other with the same pink-toned arms and feet, but a black face – are shown side by side in order to portray the king in life and in death.[19] Other variations in canonical skin tone can also be found; though if these variations exist for symbolic reasons, then the meanings are somewhat less obvious. In the British Museum's great Harris Papyrus, which records gifts made by Ramesses III of the Twentieth Dynasty to temples throughout Egypt, the king is shown in several vignettes with startlingly white skin, and a *yellow* White Crown (ill. 79), which can be no more realistic than the black representations of Tutankhamun already considered. [▶p. 125]

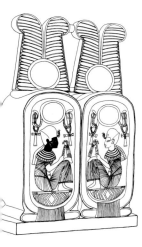

73
Double cartouche-shaped case, from the tomb of Tutankhamun.

Color and Connotation: the Symbolic Meanings of Colors

74 *Colored amuletic inlays in glazed faience. Late Period, Dynasty 27–31. Harer Collection, San Bernardino, California.*

The objects illustrated in this photograph represent various deities and amuletic objects which were intended to be inlaid in a wooden coffin both for their symbolic and magical function. The various colors used for the amulets illustrate some of the symbolism associated with each color:

Red The color of fire, the sun, and blood, red could symbolize any of these, or the more abstract concepts of life and destruction associated with those physical things. Of the amulets shown here, red was thus chosen for the heart ☐ (third row) and the solar-symbolizing scarab (fifth row).

Blue This color was naturally associated with both the heavens and with water. Relating ultimately to its symbolism of water, blue could represent the concept of fertility, and was associated with Osiris. The amulet of this god (fourth row) and his symbol, the *djed* pillar ☐ (first row), are of this color.

Yellow An alternative solar color, yellow could be used for solar symbols such as the scarab (second row) and winged scarab (bottom row), as well as certain other symbols such as the Isis knot ☐ (sixth row). Yellow

could also represent the golden bodies of the gods.

Black Primarily a color of the underworld and funerary deities, black is here represented by two amulets of the mortuary god Anubis in his canine form (second row). Also symbolic of fertility through its associations with the rich dark earth of the Nile valley, black could be used in non-funerary contexts.

Green The color of luxuriant vegetation and thus of life itself, green could signify health and vitality, and the sound or undamaged eye of Horus is often depicted in this color. Green was also specifically used in association with certain symbolically significant creatures such as the serpent (both ends of the second row) and baboon (fourth and sixth rows).

White The color of purity, white was used to represent a number of sacred animals such as the white cow (fourth row). As a solar hue, this color could also be used as an alternative to yellow in some contexts, and the White Crown was one of the heraldic emblems of Southern Egypt in contrast to the Red Crown of the North.

There is also a good deal of interchange in the use of some of these colors – a phenomenon which is considered more fully in the following pages.

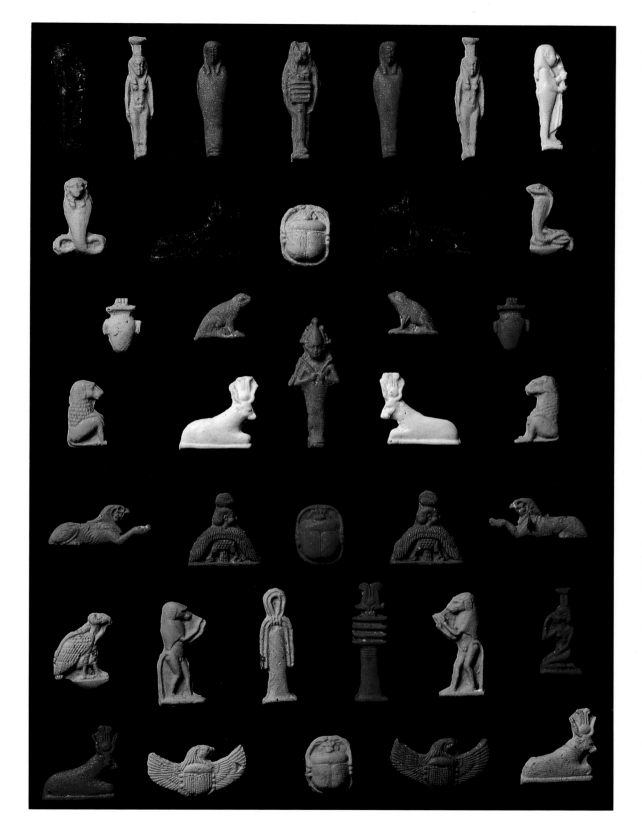

Natural, Symbolic, and Conventional Colors

76 (Right) Colored hieroglyphic signs on the coffin of Petosiris (detail). Tuna el-Gebel, Dynasty 30. Egyptian Museum, Cairo.

The use of natural and assigned coloration may be clearly seen in the elaborately painted hieroglyphs on the wooden coffin of the priest Petosiris which was constructed in the fourth century BC. Here most signs are given their canonical colors, such as the human body parts which are simply colored red. But as is the case in many inscriptions, variation does exist in the choice of some colors. For example, the wooden door bolt —∞— is red in the second column and yellow in the fourth due to a color equivalence which is explained in the succeeding pages. In the same way, the ⬎ knife which is colored blue in the fourth column is frequently painted red in other texts. Some signs are clearly depicted in ways which do not reflect the actual colors of the objects – such as the green quail chick with blue and yellow wings in the fourth column; and some signs are elaborately decorated with multiple colors which may also show little resemblance to the objects they represent. The checkered flagpole ⌐ near the top of the second column is an example of this. Certain multicolored signs such as this one show color combinations which occur frequently, yet which are not understandable to us. It seems likely, however, that natural and symbolic colors were utilized in the decoration of hieroglyphs, along with some colors which were the result of arbitrary yet widely accepted convention.

75 (Above) A selection of hieroglyphic signs grouped by color.

In the Egyptian system of writing, each hieroglyphic sign had its own color in which it was usually painted whenever inscriptions were produced polychromatically. Many signs exhibit the natural color of the thing depicted, such as plants and objects composed of vegetable products (e.g. woven reed mats or baskets) which were colored green; human body parts, objects made of wood, and certain animals which were reddish in color; certain pale-colored animals and birds as well as objects composed of linen which were yellow; and the signs for water and sky which were blue. Other signs were assigned colors for reasons which sometimes appear to be symbolic, but in other cases were perhaps the result of convention. The *ankh* sign was frequently colored blue, as was the hieroglyph for the throne and that for the bread loaf, although none of the objects represented by these signs was necessarily blue. Some hieroglyphs were also given multiple colors such as the *djed* sign which was commonly painted in red and blue, and the many species of birds which were depicted in the hieroglyphic script and which were often elaborately colored in great detail.

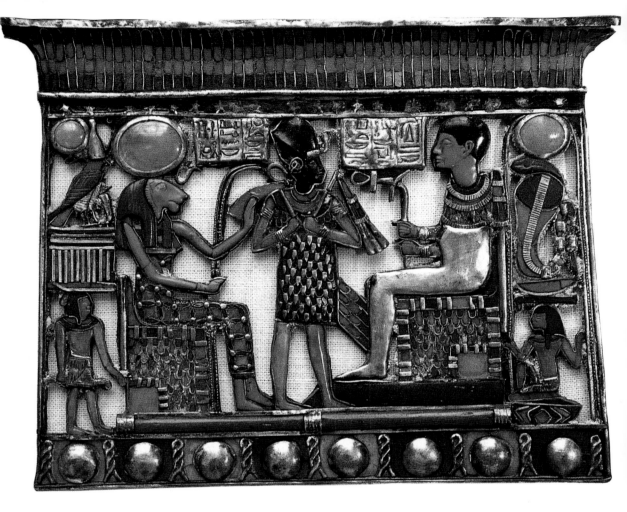

77 *Royal Pectoral. Tomb of Tutankhamun, Valley of the Kings, Thebes, Dynasty 18. Egyptian Museum, Cairo.*

The interchange of colors which exists in Egyptian art is partly a result of the different classification of colors used by the Egyptians (who sometimes regarded colors as having a range different from that assigned by us), and partly through the principle of equivalence whereby two different colors were treated as one due to symbolic connections between them. These factors of color interchange may be seen in this pectoral of Tutankhamun, which depicts the king wearing the Blue Crown before the enthroned god Ptah. But the king's crown is composed of black inlay

rather than its normal dark blue color – despite the fact that the artist utilized blue inlay for the flesh of the god Ptah, and for the goddess Sekhmet who stands behind him. The light blue coloration for the skin of Ptah illustrates another interchange, for this god is usually depicted as having green skin. The interchange of the colors black and dark blue and green and light blue seen in this pectoral is a fairly common occurrence in Egyptian art and is discussed in detail in the text of this chapter. The interchange means, of course, that an object colored black should sometimes be interpreted symbolically as though it were blue, a blue object as though it were green, and vice versa.

The Interchange of Colors

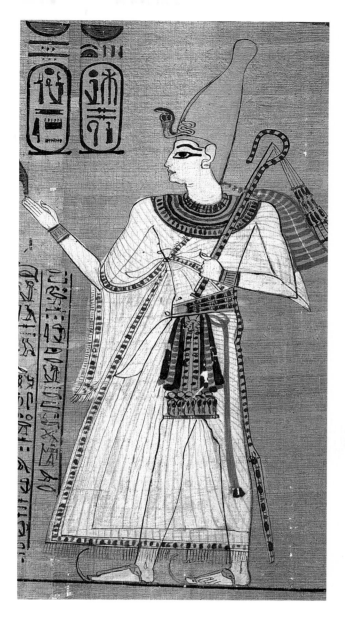

78 *(Above) Heart and* tiet *knot hieroglyphs.*

These two hieroglyphs illustrate how the interchange of colors may extend beyond the area of skin coloration to the color values associated with other objects and symbols. The heart hieroglyph, which is usually colored red (as are many bodily organs), and the *tiet* knot which is usually colored yellow (as are most items of linen fabric) both interchange in that the heart may sometimes be colored yellow and the *tiet* knot red. In the latter case, the red coloration may be symbolic since the *tiet* hieroglyph is known as the "Blood of Isis." Other instances show that the two colors interchange in a broad range of objects as they were regarded as somehow equivalent by the Egyptian artists.

79 *(Above right) Ramesses III before the gods. Harris Papyrus (detail), Dynasty 20. The British Museum, London.*

In this vignette from the great Harris Papyrus, Ramesses III is shown appearing before the chief gods of Thebes, Heliopolis, and Memphis, the major cult centers of the land. The king wears the White Crown of Upper Egypt, but the crown is yellow rather than white, and the king's skin, which would normally be painted red if he were alive or golden yellow – as a god – if he were deceased, is not yellow but white. The two colors are used in this way because of their essential equivalence. For the same reason, the White Crown is painted yellow in a number of other representations, though the use of white skin coloration is less common.

Colors of Gods and Mortals

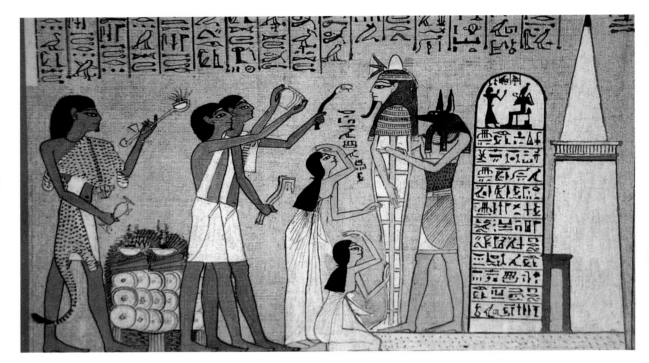

80 *Opening of the mouth scene. Funerary papyrus of Hunefer, Dynasty 19. The British Museum, London.*

The primary colors used to depict gods and mortals are well illustrated in this funerary scene in which a number of human and symbolically divine beings are depicted together. The Egyptian male – represented here by the officiating priests – was almost invariably shown with a red-brown complexion at least partially symbolic of an active outdoor life. Egyptian women – as seen in the mourner crouched at the mummy's feet – were usually portrayed with much lighter, yellow or occasionally pink or white skin tones, and older men were sometimes shown with the same lighter complexion. Most gods – represented here by the color assigned to the face mask of the deified mummy – were depicted as having golden skin and blue hair, while the jackal-headed deity Anubis – who stands behind the mummy – was shown with black skin symbolic of mummification and the netherworld. The chief underworld deity, Osiris, was also depicted with black skin, or with a blue or green skin color relating to the god's associations with the Nile and vegetation – and thus with the concept of fertility.

81 *Nome god bearing offerings (detail; limestone). Temple relief, Dynasty 18. The Cleveland Museum of Art.*

A number of deities associated with the Nile and with abundance and fecundity are portrayed with blue (or sometimes green) skin, symbolizing to some extent their connection with green plant life but to a greater degree with the life-giving element of water itself. Frequently, in fact, the wave pattern used to represent bodies of water is added to the skin of such figures. The deity illustrated here is one of the provincial or "Nome" gods which were often represented on the lower sections of temple walls, facing toward the shrine, and bringing offerings to the main gods. In this particular case, the nome deity is one of a procession of alternating red and blue figures.

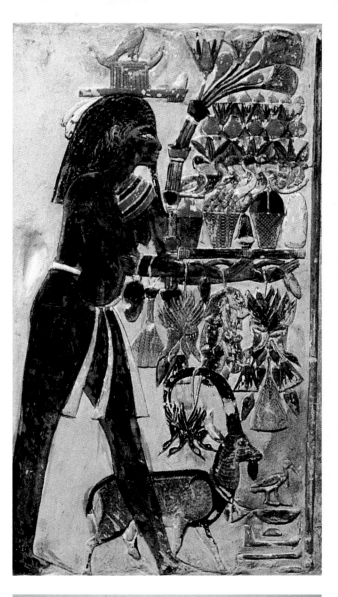

82 *The four races of humankind. Tomb of Seti I, Valley of the Kings, Thebes, Dynasty 19. (After Minutoli.)*

The Egyptians classified a number of different races and peoples but four were usually used to portray all humankind. The Egyptian male was portrayed with a red-brown complexion. The Syrian or Asiatic, representing the peoples to the north and east, was shown in pale whitish tones. The Nubian, representing the peoples of the south, was characteristically black; and Libyans – peoples to the west – were shown as near white. Paintings illustrating the funerary Book of Gates which was inscribed on the walls of many New Kingdom royal tombs frequently depict figures such as these representing the four human "races" harmoniously coexisting in the afterlife.

In contrast to the coloration given to men, women are usually depicted with pale yellow skin in Egyptian art. This probably indicated the typical indoor occupations of women and may have been a mark of beauty comparable to the idealized white of medieval European paintings of women. Interestingly, yellow was occasionally used for the skin color of elderly men, probably indicating their more sedentary and indoor lifestyle.[20] A good deal of variation existed in the shade and tonal value of yellow used, however, and some representations actually use a pale orange color to depict the skin of Egyptian women. During the Amarna Period women were sometimes shown in the same red tones as men which may have resulted from the sharing of gender characteristics often seen in this period, or alternatively, the desire to avoid the similarity with yellow portraits of goddesses.

Other exceptions also exist – especially in the New Kingdom – in which the skin color of women is brought into a closer alignment with that of men by the use of a lighter tone of the color usually reserved for depictions of males. In the tomb of Nefertari in the Valley of the Queens, for example, this favorite wife of Ramesses II is represented in naturalistic pink flesh tones, even though the female deities with whom she appears are painted in the traditional pale yellow assigned to females. This tomb exhibits workmanship of the highest caliber, and the varying chromatic hues – differing tones of red and pink – used for the skin coloration of this queen are the closest to modern concepts of highlighting and shade that Egyptian art comes. Yet these representations are set in a context where each object portrayed and every hieroglyph in the associated inscriptions is carefully given its canonical color – a symbolic matrix which Egyptian art rarely left.

These, then, are the basic principles of the color symbolism of Egyptian art. A vital and largely unchanging aspect of Egyptian painting and sculpture, the significance attached to various colors seems to have remained, overall, relatively static throughout the many centuries of pharaonic history, and is largely accessible to us. Our knowledge of the usual connotations of the colors is enhanced by an appreciation of the principles of color ambivalence and interchange, as well as by awareness of the frequent juxtaposition of certain colors with their symbolic complements. Although there are undoubtedly areas where the significance of certain colors is not yet recognized or fully understood, color symbolism is clearly an important aspect of the overall symbolism associated with Egyptian art which we may clearly grasp, and one which adds considerably to our understanding of the works produced by the ancient artists and craftsmen.

83
Detail from the burial chamber of Tutankhamun's tomb. In many royal tombs of the New Kingdom, the king's burial chamber – known as the "house of gold" – was painted with a gold background. While the name and color of the chamber might seem to suggest the riches of the king's burial, the symbolic significance probably relates to the concepts of imperishability and afterlife associated with the divine metal.

MEANING IN MANY
the symbolism of
NUMBERS

*"Accurate computation is the gateway to knowledge of all things
and of dark mysteries."*
Bremner-Rhind Papyrus

OF FUNDAMENTAL importance in understanding ancient Egyptian culture is the fact that Egyptian scholars and theologians saw the relationships between similar words or objects as more than merely "coincidental," and as a reflection of order, design, and meaning in the world. Just as verbal and "visual" puns were felt to reflect an important aspect of reality, the relationships between the abstract numbers found in myth and in nature were also seen as meaningful patterns reflecting divine planning and cosmic harmony. These underlying patterns are the "mysteries" to which the writer of the Bremner-Rhind papyrus refers, rather than, as some mystically-oriented individuals have assumed, the magical symbols and spells of some arcane system of thought.

Numerical Symbolism

The desire to read such a mystical use of numbers – or "numerology" as it is commonly called – into Egyptian culture has existed almost since western Europeans began to develop an interest in the remains of Egyptian civilization. But although it was effective enough for everyday calculation, Egyptian mathematics lacked even some of the most basic aspects of mathematical understanding and was hardly the source of some forgotten "higher knowledge." A telling example is found in the many numerological studies of the pyramids, and especially the Great Pyramid of Khufu or Cheops, which has been claimed to show in its dimensions the whole history of the world, past, present, and future. This pyramid does reveal a relatively high level of mathematical competence coupled with careful astronomical

observation on the part of its ancient engineers, and these factors are clearly seen in the construction and orientation (see Location) of the structure – but they should not be exaggerated into claims of advanced Egyptian understanding of astronomy or of important mathematical constants. In this regard it is often stated in mystically-oriented literature that the fact that the length of the slope of the great pyramid is exactly divisible by *pi* proves the Egyptians' knowledge of this constant. Yet the fact is easily understood when one realizes that the Egyptians probably measured such large distances with the help of drum measures which were rolled along the surface to be measured, and any length of exactly so many revolutions of a drum measure would of course be exactly divisible by *pi*. Misconceptions of this kind persist despite the fact that such aspects of pyramid construction have repeatedly been explained by Egyptologists.[1]

But if we say that the real symbolism inherent in Egyptian numbers does not lie in advanced knowledge or in the mystical and the profound, this is not to deny the symbolic significance that numbers could have had in ancient Egyptian culture. In the early part of the twentieth century, the great German Egyptologist Kurt Sethe showed that quite a few numbers were regarded as sacred or "holy" by the Egyptians,[2] but this element of sanctity and significance was accorded the numbers themselves only inasmuch as abstract principles had become associated with them. This is especially true of some of the primary integers which serve as the basic building blocks of most computation and numerical description – especially 2, 3, and 4 (and also 7) and their direct multiples, for most other numbers with symbolic significance for the Egyptians are simply multiples or combinations of these.

These numbers will all be discussed below, but any discussion of the symbolic concepts associated with given numbers must be prefaced by the caveat that here, as elsewhere, no single interpretation of a given symbol is everywhere applicable. Numbers found in Egyptian literature, for example, may or may not hold the same significance as in the representational arts,[3] and even in the same area of written or artistic expression, a number may take on different symbolic significance under different circumstances. The number one, for example, quite naturally appears as a symbol of individuality or pre-eminence in many contexts, and especially in relation to the deities who are described in terms of their unique importance and "oneness," particularly when the god is viewed as being primary in the process of creation – the monad from which all else descended. But even here the one contains a plurality, for although the creator god initially stands alone, he soon produces offspring who are

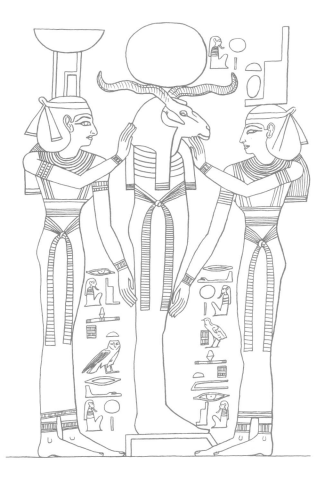

84 *Re and Osiris as one god, flanked by Nephthys and Isis, from the tomb of Nefertari, Thebes, Dynasty 19.*

inherent within him and eventually makes himself into millions. The one contains and becomes many, and one may thus represent the unity of many as much as it represents individuality or uniqueness. The number one may also be seen as a fusion of two or more separate entities or principles, and there are thus androgynous deities such as Atum and Neith containing male and female aspects, or gods embracing apparent opposites such as the single deity, Heruifi, with the head of both Horus and Seth, or Osiris and Re fused as the body and spirit of one god (ill. 84) – with the mummiform body of the netherworld god and the ram's head of the sun god.

The significance of numbers in Egyptian art must be seen then as another dimension of symbolism like color, size, or shape – things routinely employed by artists as their "symbolic pigments." But it must also be realized that a number may actually have no specific significance in the context in which it appears. Artists might choose to

depict groups of gods or animals, for instance, in numbers that are perhaps significant in themselves (e.g. 2, 3, and 4), but do not necessarily add or say anything about a particular context.

This may be seen where different numbers of objects or figures occur in various examples of the same motif. In representations of the barque of the sun god, for example, the vessel may be shown being pulled by various zoomorphic or anthropomorphic figures – jackals, cobras, *ba*-birds, gods, or combinations of these. Sometimes the barque is towed by three figures, sometimes four, or more; and just as the various creatures may be regarded as equally symbolic in their role of pulling the mythical barque, so their varying numbers may be seen as equally symbolic because each simply represents a "fitting" number. But in other instances, as we shall now see, the specific symbolism of numbers is both clear and important.

TWO: the Number of Duality – and Unity

The phenomenon of duality pervades Egyptian culture and is at the heart of the Egyptian concept of the universe itself. But rather than focusing on the essential differences between the two parts of a given pair, Egyptian thought may stress their *complementary* nature as a way of expressing the essential unity of existence through the alignment and harmonization of opposites – just as we today might use "men and women," "old and young," or "great and small" to mean "all" or "everyone."

Heaven and earth, light and dark, day and night, the sun and moon (for the Egyptians, the two eyes of the god of heaven), or the sun and stars swallowed in turn by the sky goddess Nut are only the most obvious examples of this dichotic unity seen at the cosmic level. The same dualism is found in north and south, east and west (ill. 88), the geographic reality of the red land of the desert in juxtaposition with the fertile black land of the Nile Valley, and in pairs of gods and goddesses which represented these and many other binary aspects of the world. Underlying duality may also be seen in the concept of body and spirit (ill. 89), as well as in many of the word pairs by which aspects of reality were labeled and which often describe the world in terms of the opposite yet complementary aspects of stasis and change.[4] Stasis (*wenen*: "exist") implies the notion of creation as perfect and complete and may be juxtaposed with change (*kheper*: "develop"), the notion of creation as dynamic and recurrent. The dichotomy may be expressed mythologically or representationally by male and female elements, as in the personified figures of "eternity" in its two forms of *djet* "Eternal Sameness" and *neheh* "Eternal

Recurrence" (ill. 85); the first divine pair Shu and Tefnut; and the cosmos itself – for while the heavens are characterized as female, the gods of the earth are male. The duality may also be symbolized by generational poles – Osiris the deceased father who rules in the underworld, and Horus, the living king who rules on earth – and in many other ways.

None of these elements can be seen as opposites from the Egyptian perspective, however, for they constitute the complete world and as such take part in a shared identity. Representations of a Nubian and an Asiatic together symbolized the concept of Egypt's southern and northern enemies, for example; and the usual iconographic representation of the moon combined the circle of the full lunar orb with the crescent of the new moon – the one resting in the other in a complementary unity which better described the lunar symbol than either image alone. Thus, while duality can symbolize opposite forces or conditions, it may just as well suggest the exact opposite in stressing different aspects of a single, united whole.

This dualistic view of life went far beyond abstract theological speculation and had the most practical applications, influencing actions ranging from the way in which artists arranged elements within their compositions to the manner in which great monuments were constructed. Figures depicted in all types of compositions are often set antithetically in pairs.[5] Stelae of the New Kingdom and later periods frequently show two deities back to back or in separate halves of the composition, and these deities are usually adored by two opposed or mirror images of the king, or in private instances the tomb owner. Alternately, a major deity such as Osiris or Re is often accompanied by another deity such as Isis or Maat, and the deceased is accompanied by his wife or by a god such as Anubis or Horus. These simple groupings appear meaningless in the sense of any important inherent symbolism, yet the conscious nature of the pattern seen in countless examples of paired deities, figures, or symbols is unmistakable.[6] Often, in fact, a pair of deities – especially goddesses – are depicted identically in dress and appearance and differ only in name as though their very duality gave them significance enough. At the larger scale, men working on the construction of royal tombs and other official building projects of the New Kingdom were divided into two gangs, symbolically "representing" Upper and Lower Egypt. In fact, the administration of the whole state showed similar divisions representing the two ritual and administrative divisions of the land.

This division of Egypt into the "Two Lands" of the Delta and Nile Valley (ill. 90) was once assumed to have been based on prehistorically defined regions which were fused in the "unification" of the

85 *Male* (neheh) *and female* (djet) *personifications of eternity, from the first funerary shrine of Tutankhamun.*

land at the dawn of history. Nowadays, this binary division is regarded as having been more likely a symbolic representation of a much more complex political development. It seems, in fact, that the idea of the Two Lands was to a great extent a product of later ages; nevertheless, once this duality was in place, a wide-ranging and powerful symbolism evolved which required double rituals for kingship and the cult.[7] This involved double coronation, accession, and jubilee activities, and double offerings (ill. 91) and other religious rituals on the part of the king, as well as royal graves and cenotaphs in both the Lower Egyptian site of Saqqara and the Upper Egyptian city of Abydos, and dual elements of royal insignia, crowns, and dress. Deities and their symbolic attributes as well as heraldic plants and animals were organized according to the underlying division, and northern and southern "sister" cities such as Heliopolis and Thebes (referred to as the "southern Heliopolis"), Buto and Nekhen, and Busiris and Abydos were similarly paired. Symbolically, however, such dualism must have meant much more to the ancient Egyptians than merely the celebration of united dual kingdoms, for it was based upon and thus affirmed the nature of the creation itself.

THREE: the Number of Plurality

The essential significance of the number three was simply one of plurality for the ancient Egyptian, as may be seen in the fact that from the earliest times the hieroglyphic script used a group of three pictorial determinatives (later three orthographic strokes | | |) as the indicator of plurality (ill. 92), just as words of dual number

received two identical determinatives or strokes. Thus, by virtue of his or her own written language, every literate Egyptian was conditioned to see the concept of plurality in the number three and its multiples.

Sometimes three seemingly unrelated deities are grouped representationally. On the sarcophagus of the Twenty-first Dynasty king Pinedjem II, three deities with the heads of a ram, a lion, and a jackal stand in the coils of a serpent. The deities are named as Re, Isis, and Anubis respectively, though a number of variants of this same motif occur in which the gods may be depicted with the heads of other animals or given other names. This would seem to show that the groups are simply representative of important netherworld deities – the number three representing plurality rather than any specific group. In the same way, the abodes of the deceased mentioned in Chapters 149 and 150 of the Book of the Dead usually numbered fourteen, but in one papyrus they are simply listed as three.[8]

Egyptian religion also used the number three to signify a closed system which was both complete and interactive among its parts. The many triads of deities which developed from New Kingdom times provide clear examples of this, as do a number of group statues depicting the Egyptian king flanked by two deities – such as the famous Fourth Dynasty triads of Mycerinus with Hathor and one of the various nome deities. Perhaps the earliest known reference to the idea of a trinity in Egyptian religious literature states that the primordial god Atum gave birth to Shu and Tefnut "when he was one and became three,"[9] though the linking of the three solar deities, Re, Khepri, and Atum constituted a more commonly depicted trinity (ill. 93). The three major deities of the Egyptian state in the New Kingdom – Amun of Thebes, Re of Heliopolis, and Ptah of Memphis – formed one of the most important triads, and these three gods were fused to some degree into a single triune god or trinity which embraced all gods. According to a Nineteenth Dynasty document dating to the reign of Ramesses II, for example, "All gods are three . . . Amun, Re, and Ptah."[10] According to this conception the solar deity Re was the god's face, Ptah his body, and Amun his hidden identity – or, as expressed in another manner in the same text, "His *ba* is in the sky, his body in the west, and his cult image in southern Heliopolis [Thebes]," for Thebes was known as the "City of Amun," Heliopolis as "City of the Sun," and Memphis as "Mansion of the *ka* of Ptah."

Divine triads were also often grouped in a father, mother, and son relationship – with those of Osiris, Isis, and Horus (ill. 94), or Amun, Mut, and Khonsu, being the most prominent examples; but there were many more, and in some triads the Egyptian king functioned as

the divine son, or at least represented him. Like the triune groupings already mentioned, these divine family models clearly did not intimate mere plurality in their three-part structure, but each seems to have symbolized what might be called a unified system, or numerically, a unified plurality.

On the other hand, although the number three is often representative of a closed harmonic system in groups of deities, the number three can also function as a sign of tension in the symbolism of Egyptian mythology, for at least one myth – that of Isis, Horus, and Seth – places a very different stress upon the number. Interestingly, as has recently been pointed out, this story can be compared with the role triangle of monster/divine mother/son found in myths of the Levantine cultures of Ashkelon, Joppa, and Gaza. In Egypt, it is the pregnant Isis who seeks refuge from the hostile and treacherous Seth and hides in the marshes of the Delta until she delivers her son Horus who eventually grows to maturity to fight and defeat the "monster" Seth.[11] Here, the three characters represent an opposed duality with an intervening figure who is responsible for "tipping the balance." Yet this kind of threefold tension is rarely found in Egyptian art and seems to be a principle which does not frequently extend beyond the mythological and literary spheres. Usually, it is the unity of an integrated group which is implied by the number – three functioning as a united whole representative of many.

Finally, the number three may have distinctly cyclical connotations. This undoubtedly resulted from the use of the number in the reckoning of time, for the Egyptian year was divided into three seasons, and each of the twelve months was divided into three ten-day periods. Within the day itself, prayers and sacrifices were also offered three times in the temples. Representationally, this cyclical aspect of the number is seen in depictions of the three forms of the solar deity Khepri, Re, and Atum reigning over the morning, noon, and evening of the day (ill. 93), and in a number of other instances.

FOUR: the Number of Totality and Completeness

Apart from two, the number four probably appears more frequently in Egyptian art and ritual than any other number – in contexts ranging from the four sides of pyramids and altars to groups of gods and ritual objects and activities. Egyptian religion is replete with groups such as the four sons of Horus, four funerary goddesses, four magical bricks, four baboons, and four elder spirits.[12] Frequently the number appears to connote totality and completeness and is tied to the four cardinal points. It is difficult to discern, however, if the number took

on its symbolism through its relation to the cardinal directions, or whether they were themselves chosen as a result of the number's already existing meaning. The former seems perhaps the most likely as the Egyptian landscape is naturally oriented according to the twin axes of the Nile's south–north flow and the sun's east–west movement (see Location).

The four cardinal points are certainly an ancient concept, and in the Pyramid Texts we find many references to them. The four pillars of the sky – visualized in one example as the four legs of the cosmic cow – stand at these points, and the "four quarters of the heavens" find constant mythological reference, sometimes showing that these areas may take on a larger, cosmic significance. Four "rudders" control the universe in later writings and representations; and Horus, the ancient falcon god of the heavens, whose eyes were the sun and moon and whose speckled plumage was the starry sky, is sometimes treated as a quadripartite deity in the most ancient religious writings, apparently ruling over four areas of the cosmos – in this instance, possibly the earth, sky, heavens, and netherworld.[13]

Usually, however, the four areas represent the four quarters of the earth alone. This is the case in most religious rituals which find representational expression, as may be seen by comparing several examples. Four arrows were shot to the four cardinal points and four birds released in the same directions in the king's coronation and jubilee ceremonies, and many censing and purification rituals involved "words to be recited four times" which were spoken to the four cardinal points. When shown together in depictions of such rites, the gods Horus, Seth, Thoth, and Anti (a falcon deity) usually represent the north, south, west, and east respectively.[14] In the ritual known as the "consecration of the *meret* chests," four sledge-mounted chests – each with four feathers attached and containing linen of four different colors – were dragged before the image of a god four times (see Actions). A protective ritual which was performed in the temple scriptorium or *per-ankh* shows the same concern with the number four. The ceremony involved the making of a clay figure of Osiris to "subjugate the entire world," and this figure is depicted in a late papyrus (ill. 96) standing above the symbol of Egypt's enemies. In the ritual itself, figures buried in four containers – each topped with a protective serpent at its four corners and surrounded by the names of the four cardinal points and their associated dieties – implied complete and universal protection.[15]

Because this aspect of completeness is also fundamental to the number's symbolic use, it often takes precedence over or replaces direct links with the symbolism of the geographic four quarters. From

the Egyptian perspective, the "four races of mankind" comprising Asiatics, Nubians, Libyans, and Egyptians (see Colors) may have been connected with the four regions, yet their representational use came to imply simply "all people." The ritual known as the "driving of the calves," which was commonly depicted on the walls of temples of the New Kingdom and Greco-Roman periods, shows the king driving four calves – specified as red, black, white, and speckled – in the presence of a deity (ill. 98). While the ritual may have been originally associated with ancient agricultural rites, it seems to have developed meanings connected with the royal *sed* festival and with the cycle of rituals associated with the worship of the god Osiris.[16] The precise role of the four calves in the ritual clearly depends, then, upon the aspect which is stressed in a given example; but in all cases the fact that four animals participate in the ritual is probably not only linked to the four cardinal points (which are mentioned specifically in some of the inscriptions), but also signifies the completeness of the action which is being performed.

While the concept of completeness associated with the number four may have sprung entirely from the totality encompassed by the concept of the four cardinal points, then, the symbolic use of the number is frequently one of completion alone without directional overtones at all – as in a love poem in which it is said that the hand would be kissed four times.[17] The principle operates in the same manner in representational art. In the underworld books four forms of a given god or groups of four deities are frequently found and thus depicted in vignettes in the papyri and decorations of the royal tombs. Thus the god Osiris is depicted in four forms in the sixth section of the Amduat; and in the eighth hour of the Book of Gates, the ancient earth god Ta-tenen is depicted in the form of four rams, identical except for their crowns, with the appellations "form one," "form two," "form three," and "form four." The various underworld "hours" are also inhabited by many groups of three or four gods, and while the members of triads are usually distinguished from one another in representational works, the deities found in groups of four are often undifferentiated – showing their purely "generic" nature.

Other Symbolic Numbers

Seven One of the most important symbolic numbers, seven is nevertheless difficult to define in terms of specific meaning though it often seems to have been associated with the concepts of perfection and effectiveness, and as the sum of three and four, may have been believed to embody the combined significance of these two numbers

– plurality, completeness, and totality. The number seven is frequently associated with deities in different ways. The sun god Re was said to have seven *bas* or souls, and several other deities were considered to be "sevenfold" or to have seven forms. The many different manifestations of Hathor that were worshipped in various locations were frequently consolidated into a more manageable and comprehensible group of seven, but the fact that different groups of Hathors existed – comprised of different goddesses – shows that the sevenfold grouping was symbolically more important than the specific deities included. The number also appears in groups of different deities which were brought together. The company of gods revered at Abydos comprised seven gods, and the number is frequently associated with Osiris, the great god of that area. In one festival in the god's honor, for example, a model of Osiris was embalmed and then kept for seven days before being buried, as Egyptian myth declared that the god had remained seven days in the womb of his mother Nut before she bore him.

Seven was also a number of great potency in Egyptian magic,[18] and spells such as those for the seven magical knots to be tied to relieve headaches and other health problems or the seven sacred oils used in embalming are frequently found. Mythologically too, seven is important for the same reason. In one myth of Isis, seven scorpions escort the goddess in order to provide her with maximum magical protection. Neith is said to have carried out her work of creation through seven statements, and the sevenfold laugh of the creator is mentioned in late magical texts.

Multiples of seven are also extremely common. According to myth, the body of Osiris was cut into fourteen parts by Seth – perhaps based on the days of the waning moon, but also, as a multiple of seven, perhaps representing seven parts for Upper and seven for Lower Egypt. The Book of the Dead provides spells to be repeated as the deceased passes through the gates of the House of Osiris of which there are usually twenty-one, though in one papyrus seven are shown,[19] showing the relationship with the base number. It is also probably not coincidental that the number of the forty-two judges who sat in the tribunal of the afterlife to judge the deceased was a multiple of seven; that although in Old Kingdom times the nomes or administrative provinces of the country numbered 38 or 39, in the later periods of Egyptian history these districts were set at 42; and that the early Christian writer Clement of Alexandria (second century AD) stated that the Egyptians had 42 sacred books in their culture. Such uses of the number underscore its symbolic application in many contexts.

Almost all, if not all other numbers which are found with symbolic significance in Egyptian art and culture may be found to be multiples or sums of the numbers two, three, four, and seven. Usually, these multiples simply enhance or intensify the meaning of the basic number, though in some cases it is possible that new meanings were associated with the larger number.

Eight As four (totality) doubled, and hence intensified, eight appears to be used symbolically in some cases, as when the god Shu created eight *heh* deities to help support the legs of the goddess Nut in her guise as the great heavenly cow. The number often appears in relation to Hermopolis, the "City of Eight" where the eight-deity "ogdoad" led by the god Thoth was revered. The representational use of the number, however, is relatively infrequent.

Nine As three (plurality) multiplied by itself, the number nine represented the concept of a great number and is used in this way in several contexts. Most commonly, the number appears in conjunction with the enneads or groups of nine gods. The so-called ennead of Heliopolis (though it was not limited to that location) was the most frequently cited group, consisting of the creator Atum and the first two generations of gods who followed him: first Shu, Tefnut, Geb, and Nut; then Osiris, Isis, Seth, and Nephthys. Although the members of such enneads are often specified, the number really represents a general or even all-encompassing group. The nine gods who stand before Osiris in the sixth hour of the underworld thus represent the rule of that deity over all the netherworld gods, just as the "nine bows" symbolize all Egypt's traditional enemies. In a similar manner, references to beings such as "spirits nine cubits tall"[20] simply stress the great number involved – in this case, their great size.

Ten This number was especially connected with the measurement of time and space. As noted above, the Egyptian month consisted of three ten-day periods, and a generation was held to be 30 years, just as the king's first jubilee or *sed* festival occurred after the same period of time – all reflecting the plural ($\times 3$) of this number. Other multiples of ten often show the same kind of direct or indirect temporal significance. The ideal, if rarely or ever attained, length of life was said to be 110 years – perhaps 10×10 plus 10 for good measure; and according to Plutarch, 60 was associated symbolically with the crocodile as these creatures "lay 60 eggs and hatch them in the same number of days, and those crocodiles that live longest live that number of years." Though doubtless reporting folk wisdom of the most suspect kind, the importance of this multiple of ten is evident. According to the same author, the number 60 was in fact, "the first of

measures for such persons as concern themselves with the heavenly bodies."[21] In architecture and in spatial planning the Egyptians also often preferred measurements which are multiples of ten, and it has been pointed out, for example, that the great hypostyle hall in the temple of Karnak measures almost exactly 200 by 100 cubits.

Twelve While twelve may have temporal significance relating to the hours of the day and night (ill. 102), as a multiple of both three and four, twelve may also connote the combined significance of those smaller numbers. Relatively few groups of twelve occur, however, one example being the four groups of three gods with the heads of ibises, jackals, falcons, and phoenixes which represented the "royal ancestors" of the cities Hermopolis, Nekhen, Pe, and Heliopolis respectively. These deities are sometimes found in vignettes accompanying Chapters 107 and 111–116 of the Book of the Dead, but often only some and not all twelve of the various deities are depicted.

Infinity Although the Egyptians had no mathematical concept of infinity as we know it, their literature and inscriptions make frequent reference to the "millions of years" which were the gift of the gods. Chapter 62 of the Book of the Dead states ". . . limitless eternity is given to me, for I am he who inherited eternity, to whom everlasting was given." Expressions such as these show the symbolic importance of "eternity," and the figure of the god Heh who represented "millions" is often incorporated into representational works of the Eighteenth Dynasty which visually depict the same theme.

The Extension of Numbers

One of the most important principles for understanding the numerical symbolism of Egyptian representational works is that of the extension of numbers. This relates to the fact that in two-dimensional works of art two objects or figures are often depicted where four are implied, three are shown where six or nine are intended, etc. In this way the number actually depicted must be mentally "extended" in order to properly understand its significance in the composition in which it appears.

A common example of the principle where two represent four is found in the pair of *was* scepters which were used to depict the pillars of the sky and which were shown standing on the *ta* or earth hieroglyph, and supporting the *pet* or sky hieroglyph. This group was frequently used as a framing device (ills. 86, 87) around the sides of temple reliefs, symbolically placing the compositions in a cosmic setting. Because these representations are only two-dimensional, however, an abbreviated view of the various elements is given. Just as

86, 87 *The heaven, earth, and sky support frame placed around many images (86). Three-dimensional extension showing the actual form of the cosmos represented by the frame (87).*

the sky hieroglyph must actually have been conceived as a front or side view of the canopy of the sky, four *was* scepters would of course be necessary to support this canopy at each corner. There is no doubt, in fact, that this is how the Egyptians visualized the world, and some representations do show four pillars supporting the sky. Thus, the two scepters usually depicted in the framing device actually represent four and are to be understood in this way.

In the same manner two dancers are frequently depicted where four individuals participated in certain funerary dances. Similarly, in a classic study of the royal purification ritual, Sir Alan Gardiner showed that the two gods usually depicted performing the act of lustration – Horus and Thoth (ill. 124) – actually represented the four gods of the cardinal points Horus, Seth, Thoth, and Anti who transferred to the king a portion of their power as the divinities of the four quarters of the world.[22] Private representations of funerary purifications (which were symbolically parallel) actually show four priests performing the rite, but the royal depictions of this ritual almost always depict only two of the deities, perhaps for purposes of symmetry and representational balance. Whatever the reason, once again we see two representing four and thereby carrying the connotation of the extended number, though the use of the two deities Horus and Thoth (paralleling the common use of Horus and Seth) may also have connoted the dualism of Upper and Lower Egypt.

Similar extensions may be seen to occur with all of the "base" numbers of Egyptian symbolism. A single figure may be called "ennead" and thus represent nine, while stressing the aspect of unity imparted by one; three bows may be depicted for the hostile "nine bows" symbolizing Egypt's enemies (ill. 69), yet still represent the plurality of three; or four gods may be used to represent a group of twelve, while still suggesting the totality of four, and so on. In each case the reduced number connotes the greater number which it implies, but may also carry the significance of the smaller number.

The Symbolism of Numbers 139

Two: the Number of Duality

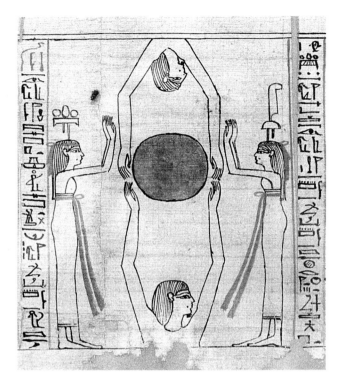

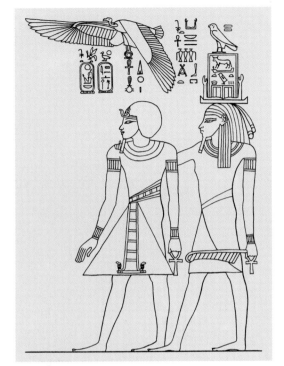

88 *Duality in nature: east and west with deities of heaven and earth. Illustrated papyrus (detail), Dynasty 19. Egyptian Museum, Cairo.*

Nature presented many aspects of dualism to the ancient Egyptian, the north-south orientation of the Nile and the east-west passage of the sun being two of the more important. In this vignette personified deities representing the east and west adore the sun which is raised by the arms of a deity representing the earth and received by another deity representing the heavens. Dichotomies such as these reinforced each other and suggested yet further aspects of dualism in the world of the Egyptian.

89 *Amenhotep III and the royal ka. Tomb of Amenhotep III, western Valley of the Kings, Thebes, Dynasty 18.*

The underlying dualism which is found in ancient Egyptian thought finds constant expression in many aspects of the culture's art. One of the most basic dichotomies, that of the physical and spiritual, is manifested in representations of the Egyptian gods in an earthly setting. The *ka* or spiritual double of the individual is also sometimes shown in the company of the physical body at the time of birth and of death when the physical and spiritual aspects of the person are depicted separately.

90 (Right) *Unification motif. Throne of a colossus of Ramesses II (detail), Luxor Temple, Dynasty 19.*

The dualism observed in nature and imposed by the Egyptians upon many aspects of their culture explains the regional duality of "Upper" (southern) and "Lower" (northern) Egypt which seems to have been based as much on philosophical considerations as it was on political or geographic realities. This duality was expressed in the many different emblems used to symbolize the two halves of the country and in the *sema-tawy* or "binding of the two lands" motif which showed northern and southern figures binding the heraldic plants of the two regions together.

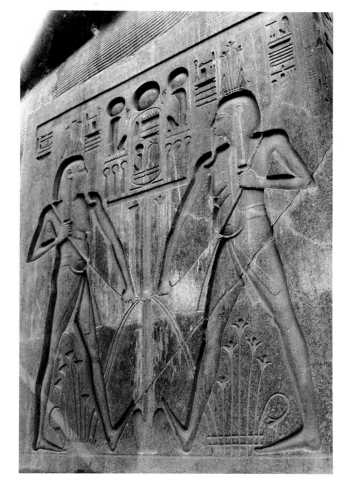

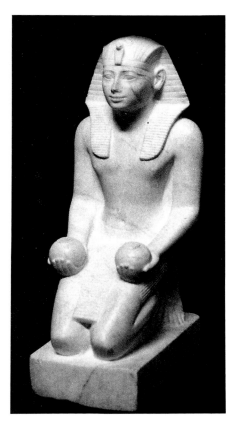

91 (Left) *Thutmose III kneeling with two* nu *pots. Deir el-Medina (Thebes), Dynasty 18. Egyptian Museum, Cairo.*

To a large extent it is actually unity rather than diversity which is stressed in many of the dualisms seen in Egyptian art, as may be seen concretely in the above examples. Sometimes this idea is more subtly expressed, however, as when the king presents two identical pots of water, milk, or wine as an offering to the gods. Many Egyptian rulers were portrayed in this manner in the fulfillment of a ritual which symbolized both the presentation of the Two Lands and of their produce.

The Symbolism of Numbers 141

Three: the Number of Plurality

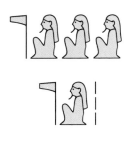

92 *(Left) Plurality in the Egyptian language: the use of threefold markers.*

Above all else, three was the number associated with the concept of plurality. In the hieroglyphic script, plural words were usually followed by a group of three marker signs by which plurality was designated. In the word for "gods" (*netcher*) shown here, two forms of the plural marker are seen. The first instance shows the flag-like sign for god followed by three god determinatives, and the second shows the god determinative followed by three short strokes.

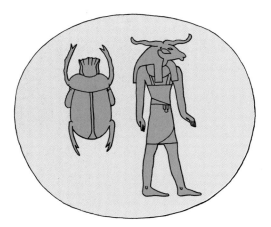

93 *(Above) Plurality and unity: three forms of the sun god. Tomb of Seti II, Valley of the Kings, Thebes, Dynasty 19.*

The concept of plurality may also be linked with that of unity. For example, Egyptian art often portrays three forms of the solar deity together – the scarab beetle representing the god Khepri of the morning sun, the solar disk representing the daytime sun Re, and the ram-headed god Atum as the evening sun. In a similar manner, Amun, Re, and Ptah were said to be the soul, face, and body of god.

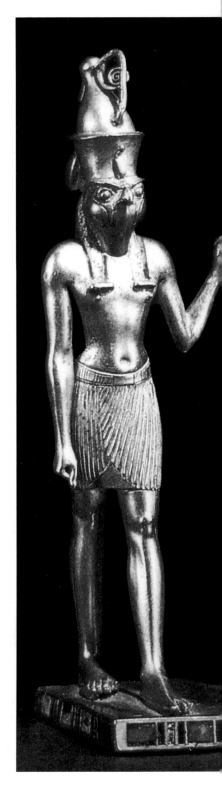

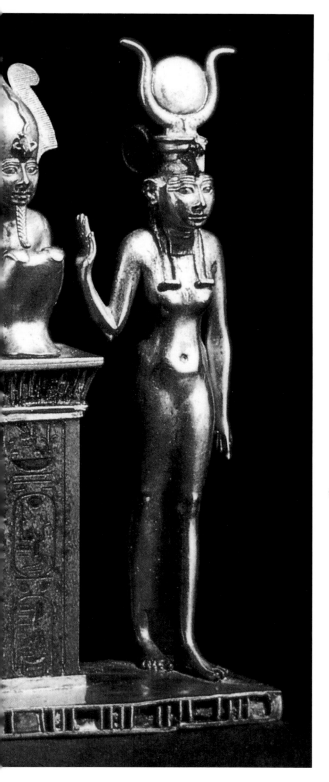

94 *(Left) The divine triad: Osiris, Isis, and Horus ornament. Dynasty 22. The Louvre, Paris.*

The unity expressed by the number three can also be seen in the many divine families which Egyptian theology constructed of a god, his wife, and their child. Sometimes distinctly disparate deities were brought together to construct such groups, but they were theologically appealing and widespread. The divine family of Osiris, Isis, and Horus was immensely popular and was widely venerated for most of later Egyptian history. The Theban triad of Amun, Mut, and Khonsu was also extremely important during the New Kingdom, as were other, though more locally important groups such as the family of Ptah, Sakhmet, and Nefertem which was worshiped in Memphis.

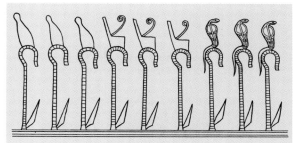

95 *(Above) Third shrine of Tutankhamun (detail). Valley of the Kings, Thebes, Dynasty 18. Egyptian Museum, Cairo.*

The interrelationship of three and its natural multiples six, nine, and twelve may be seen in that these larger numbers are often broken down in representational works into constituent groups of three – the number which held the basic significance of plurality. This is clear in this depiction of nine knife-bearing staves or scepters from the sixth chapter of the Book of That Which Is in the Underworld. These divine staves are topped, from left to right, by three white crowns of Upper Egypt, three red crowns of Lower Egypt, and three serpents which were often associated with the royal crowns. Groups of deities and other figures may be divided into threes in a similar manner.

The Symbolism of Numbers 143

Four: the Number of Totality and Completeness

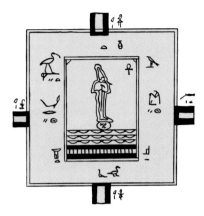

96 *(Above) Figure of Osiris within a temple scriptorium. Papyrus Salt 825. Ptolemaic Period. The British Museum, London.*

The number four was primarily related to the concepts of totality or universality through its relation to the four cardinal points. The four directions are depicted in this representation of the god Osiris shown standing on nine bows (see ill. 101) within the confines of a temple scriptorium. The structure has four entrances, each oriented toward one of the four cardinal points, and labeled with the hieroglyphic notations north, south, east, and west. At the four corners the names of four deities are also written.

97 *(Below) Divine votaress shooting at four targets. Edifice of Taharqa, Karnak, Dynasty 25.*

This scene depicts part of a ceremony known as the "rites of protection" in which the king and a priestess performed actions intended magically to protect the cenotaph of the god Osiris. The texts associated with the representation show that the votaress shot four arrows at four targets which symbolized both the four cardinal points and the principal foreign peoples which were under Egyptian rule in those directions. These four ethnic groups are represented in a good many contexts which show their destruction or subjugation.

98 *(Left) Ritual of driving the four calves. Luxor Temple (detail), Dynasty 18.*

The number four may often be utilized without any direct reference to the cardinal points, however, and in many instances the number simply signifies the concept of completeness. The rite of driving the calves which is represented in a number of New Kingdom temples, for example, shows the king driving four calves (specified as red, black, white, and speckled) before the statue of a deity. The calves represent one of each kind of coloration naturally found in cattle and thus signify the totality or completeness of the action which they perform.

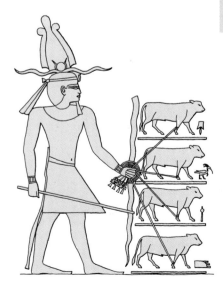

99 *Canopic jars in decorated chest. Deir el-Bahri (made for Pady-imenet, priest of Monthu), Dynasty 22. Luxor Museum.*

A number of deities are depicted in four forms or in groups of four, and the genii or minor gods known as the four sons of Horus (or Osiris) who guarded the mummified internal organs of the deceased represent such a group. These deities – the human-headed Imseti, falcon-headed Qebesenuef, jackal-headed Duamutef, and ape-headed Hapi – were themselves protected by the four goddesses Isis, Nephthys, Neith, and Selket. The four goddesses are depicted on the sides of this canopic chest with the sons of Horus whom they guarded.

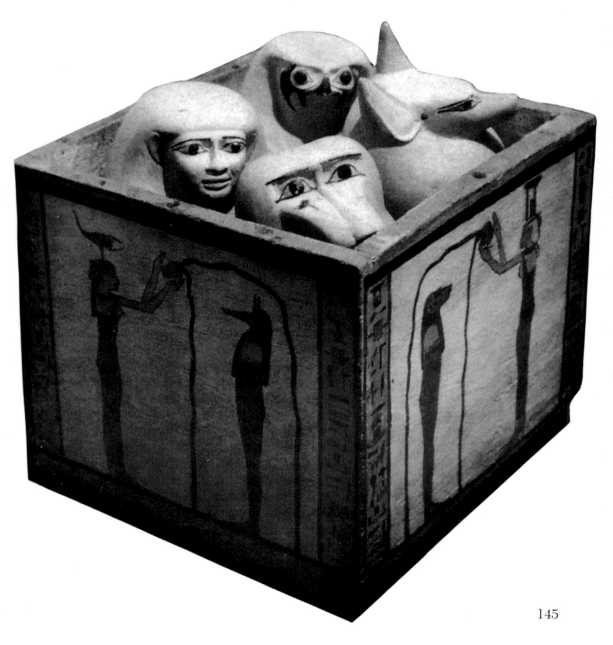

Other Symbolic Numbers

100 *Seven divine cows. Papyrus of Nestanebettawy (detail), Dynasty 21. Egyptian Museum, Cairo.*

Seven: While groups of six and eight – simple multiples of the symbolic numbers three and four – are often found in Egyptian art, neither number is as symbolically important as seven, the sum of three and four. In fact, the number seven often seems to convey the meanings of these numbers – such as plurality,

completeness, and universality – and is found in a wide range of contexts. The seven cows seen here, for example, are commonly depicted in funerary settings illustrating Chapter 148 of the Book of the Dead. In this text, along with their attendant bull, the seven cows appear to represent the sustaining powers of the universe. A number of deities, such as Hathor and Maat, were said to be "sevenfold" or to have seven *ba*s or manifestations, such as the god Re.

101 *(Right) Deities in the divine barque (third shrine of Tutankhamun). Valley of the Kings, Dynasty 18. Egyptian Museum, Cairo.*

Nine: As the multiple of three by three, the number nine represented a plurality of plurals, and thus ultimate plurality itself. In this way, nine may represent a great number or even "all possible." Enneads of nine deities – such as the group depicted on this divine barque – may thus represent all the gods. In this case the figure of the deceased and deified Tutankhamun is included along with a number of major deities. In a similar manner, the god Osiris is sometimes shown accompanied by nine figures representing the host of subordinate deities which attends him, and the so-called "Nine Bows" or ethnic groups found beneath the king's feet on the bases of statues and thrones, and in other locations, represented all of Egypt's traditional enemies.

102 *Goddesses of the night hours. Tomb of Ramesses I, Valley of the Kings, Thebes, Dynasty 19.*

Twelve: The number twelve often carries the connotation of completeness; it may have been viewed as a multiple of three and four and hence a "completion of plurality" or a "plurality of completeness." Naturally, the number was also associated with twelve hours of the day and night. The scene illustrated here shows the twelve goddesses of the night hours as depicted with the text to the third chapter of the funerary Book of Gates. The goddesses stand on triangles divided into solid and wave-patterned areas signifying the land and water of the netherworld. Between them, a monstrous serpent (depicted with twelve coils in some scenes) represents the dark forces of chaos and unbeing which threaten the sun's journey through the underworld, and which must be overcome each night.

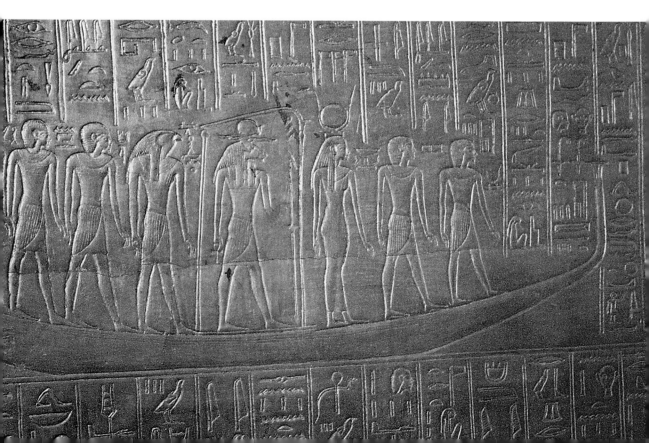

WORDS AS MAGIC, WORDS AS ART
the symbolism of HIEROGLYPHS

"Bring me a water-pot and palette from the writing-kit of Thoth and the mysteries which are in them."
Book of the Dead, Chapter 94

WRITING lay at the very heart of the civilization of ancient Egypt, and few aspects of that society appear more characteristically Egyptian. From its development sometime before 3000 BC to its latest known use at the end of the fourth century AD, the hieroglyphic script was employed by the Egyptians for almost three and a half millennia. Eventually, the Greek and Latin alphabets replaced it and the ability to read the old inscriptions disappeared completely – remaining lost for over 1,400 years until the meanings of the signs were revealed through the efforts of modern scholarship. Throughout the intervening centuries, the hieroglyphic signs seen and copied by explorers and travelers were believed to be purely symbolic in nature – a mysterious picture writing containing the mystical or spiritual secrets of a forgotten age – and even as late as the beginning of the nineteenth century many eminently learned men attempted to see the most absurd symbolic meanings in the ancient signs.

Not until Jean François Champollion and his immediate successors finally demonstrated the true nature of the Egyptian script in the early nineteenth century did its all-important phonetic aspect become clear enough that the actual meanings of the inscriptions could begin to be recovered. Yet ironically enough, as will be seen in this chapter, it is only with the understanding gained in the era of modern Egyptology that we have come to realize that the Egyptians frequently did use their hieroglyphic signs symbolically in certain contexts – and especially in the construction of their works of art. But to grasp the extent of the Egyptians' symbolic and magical use of their

script we must first understand something of the origins of hierogly-phic writing and the way in which it was viewed by the Egyptians themselves.

The Living Words of Gods and Kings

The earliest inscriptions which survive from the formative period of Egyptian history indicate that the birth of the Egyptian hieroglyphic script was connected with, and very probably developed by, the administrative personnel of the royal court.[1] At least, it is true to say that the bulk of the surviving inscriptional evidence represents ritual and ceremonial activities performed by the king. Because these royal activities were often depicted in official representations with summary written "captions," there was from the earliest times an important interaction in Egyptian culture between the function of writing and the use of representational works of art – an interaction which we shall examine shortly.

Throughout their history, the Egyptians themselves attributed the origin of their writing system to the gods. This divine source is seen in the very name which the script was accorded: *medu netcher*: "the words of the god" or "divine words." This meaning was preserved in the word *hieroglyphs* ("sacred writing") which the Greeks later gave to the Egyptian inscriptions. But the Egyptians' characterization of their hieroglyphic script goes deeper than we might casually assume. Not only did the hieroglyphs command a measure of respect as a divinely appointed system of communication, but in many instances, they were also treated virtually as living things – entities which were themselves endowed with divine power.

The signs could also be used to represent the many gods and goddesses who were identified primarily by the hieroglyphs worn on their heads. These tended to be deities who appeared in pairs or in larger groups without differentiating attributes. Thus, just as Isis was depicted with the hieroglyph for "throne" atop her head, and the goddess Maat was differentiated in the same manner by the feather used to write her name (ill. 103), the figure of a lesser-known deity is depicted on the third golden shrine of Tutankhamun with the identifying signs for bread and beer resting on his head (ill. 112). But these signs represent far more than simple labels and functioned in many cases as emblematic signs embodying the very nature of the gods.

Above all, the hieroglyphic script was associated with Thoth, the ibis-headed god of wisdom who was regarded as the patron deity of the art of writing. It has even been suggested that the hieroglyphic

103
The goddess Maat is identified by the feather she wears, Isis by the hieroglyph for "throne" on her head.

system actually may have originated with the temple administration of the cult of this particular god, though this speculation remains incapable of any kind of proof.[2] What is certain is the frequent association of Thoth with the hieroglyphic script and the appearance of the god throughout Egyptian history in many representational scenes where writing is depicted. A relief from the temple of Ramesses II at Abydos (ill. 111), for example, shows the god enthroned, holding a long scribal palette in his left hand; in his right he holds a reed with which he writes the inscription that appears incised before him. Ramesses himself is shown assisting the god by holding a water pot while he also holds a stylized scribal outfit in the exact shape of the hieroglyph for these objects. That kings would have themselves shown in such compositions, or as squatting scribes diligently engaged in the act of reading or writing, underscores the importance – both real and symbolic – of the gods' words in Egyptian society.

Although a cursive script was developed at an early date to speed the process of writing with brush and ink, the system of carefully carved and painted hieroglyphs utilized in both monumental and ornamental contexts was maintained throughout Egyptian history. Many of these inscriptions are works of art in themselves, as may be seen in the fine examples carved on the walls and columns of the reconstructed Middle Kingdom limestone barque shrine of Sesostris I (1971–1926 BC) in the Temple of Amun at Karnak. The hieroglyphs appearing on this monument and many others include detailed, lifelike depictions of animals, birds, and humans carved according to a tradition of realism which was already old in the time of Sesostris.

This intense realism may well have contributed in no small amount to the Egyptian's attitude of reverence toward their system of writing, for the hieroglyphs were regarded as being possessed of a magical life of their own – a fact which is perhaps seen in the Fourth Dynasty tomb of Itet at Maidum, in an inscription in which the tomb owner actually seems to speak of the representations and signs of his funerary monument as his "gods."[3] The magical potency associated with the signs may certainly be seen in the way in which hieroglyphs representing hostile or dangerous creatures were often incompletely drawn or purposely mutilated in order to render them harmless (ill. 113). Particularly dangerous animals might also be drawn as though transfixed with knives or spears through the head or back. Sometimes non-threatening birds or animals were mutilated, probably to prevent them from magically consuming the offerings left for the deceased, or from interfering with the afterlife environment in some other way. Yet it is possible that it is the magical potency of a *living*

being which is being abrogated in these mutilated signs, simply because the hieroglyph of a living thing was regarded by the Egyptians as being magically alive. Thus the torso and legs of hieroglyphs of human figures are sometimes omitted – leaving only the head, shoulders, and arms intact in order to show the sense of the hieroglyph in question.[4]

In short, the hieroglyphic signs were themselves powers with which to be reckoned. In fact, the Egyptians' hieroglyphs far transcended a simple system of communication and were regarded as symbolic entities which could function magically not only within written texts, but also in many aspects of what we, today, consider artistic representations.

Images and Words: The Interaction of Words and Pictures

It was not coincidental, therefore, that the Egyptians used the same word to refer to both their hieroglyphic writing and the drawing of their artworks, and it was often the same scribe who produced both. The noted historian of Egyptian art Cyril Aldred stressed this fact when he wrote that "... once a scribe had learnt to draw the full range of ... [hieroglyphic] signs with requisite skill he had become *ipso facto* an artist, since the composition of his pictures is the assemblage of a number of ideographs with some interaction between them."[5] This is just as true of three-dimensional works of art as it is of paintings and drawings. As Champollion realized some one hundred and seventy years ago, a statue is often "in reality ... only a single glyph, a veritable character of written script."[6]

This use of the hieroglyphic signs in Egyptian paintings and sculptures is sometimes merely the result of the artist following the familiar and accepted forms of the written script, and may have no special significance attached to it. In other cases, however, "embedded" hieroglyphs may convey a specific idea or message and the individual hieroglyphic elements of these representations must be recognized and "read" like the signs of an inscription, if their intended meaning is to be grasped.[7]

The hieroglyphic signs may appear overtly in a work of art, at what we might call a primary level of depiction, or they may be included more subtly, at a secondary level. At the primary level, hieroglyphic signs are incorporated quite clearly in essentially their normal written forms, and the painting or sculpture may be composed almost entirely of such signs. This may be seen in many Egyptian artworks which not only depict an individual, but also spell out his or her name through the hieroglyphs used in the composition.

This "rebus" technique will be considered below, but an example of the principle may be seen in the well-known statue of Ramesses II (ill. 104), where the king is shown as a young child sitting with a finger in his mouth in the pose which is always shown in the hieroglyph for *mes* or child. On his head the king wears a sun (*re*) disk, and with his left hand he holds a stylized *su* plant. Thus the statue not only physically represents the king, but also spells out his personal name – *Ra-mes-su* or Ramesses. The figure of the god Re which is carved above the entrance to the rock-cut temple of Ramesses at Abu Simbel depicts another of the king's names in the same manner. In this representation the god holds a staff in the shape of the hieroglyph *user* or power in one hand, and a figure in the form of the goddess Maat in the other. This creates a meaningful composition in its own right with Re being shown controlling "power" and "order" or "truth," but the figure of the god and the objects he holds may also be "read" together as *User-maat-re* – Ramesses' throne name.

At the secondary level of depiction, objects or people may spell out a symbolic message by being represented so as to suggest the form of hieroglyphic signs. The many statues in which the goddess Isis holds her son Horus or husband Osiris before her in such a way as to form with her arms the hieroglyph meaning "to embrace" are all examples of this secondary level of association, as are many representations showing gods holding their arms in the form of the *ka* hieroglyph behind the king (ill. 105) – as we read in one of the Pyramid Texts: "O Atum, set your arms about the king ... as the arms of a *ka*-symbol."[8]

In a similar manner, the wings of a number of vulture pendants and winged sun disks are formed to suggest the hieroglyph ⊏⊐ "sky" or "heaven"; and the Sphinx Stela of Thutmose IV (ill. 106) shows two images of the reclining sphinx with the sun disk between them forming the *akhet* hieroglyph ◠ . Alternatively, the king's cartouche which is also positioned between the two creatures could have been intended to represent the sun in this hieroglyphic form.

Egyptian paintings and sculptures may thus contain, or even be wholly composed of, hieroglyphic forms, and the interaction between writing and pictorial representation was one of major symbolic importance. In fact, the hieroglyphic signs form the very basis of Egyptian iconography, which was concerned with the function of making specific symbolic statements through pictorial rather than written means. The embedded or "encoded" hieroglyphic forms also frequently interact to some degree with the texts or inscriptions with which they are associated, for the use of hieroglyphic forms in Egyptian art rarely occurs in complete isolation from the written word.

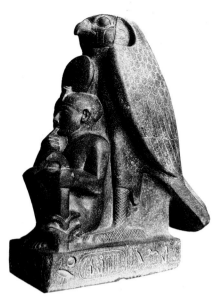

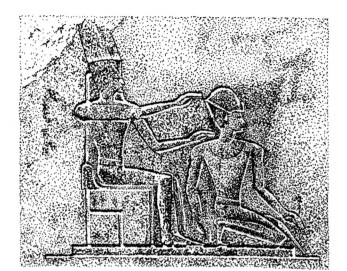

104 *Interaction of word and picture: statue of Ramesses II as a solar child, from Tanis, Dynasty 19.*

105 *Hieroglyphic symbolism: deity investing the king at his coronation, with arms outstretched in the form of* the ka *hieroglyph. Detail from fallen obelisk of Thutmose III, temple of Amun, Karnak, Dynasty 18.*

106 *Detail of Sphinx Stela of Thutmose IV, Giza.*

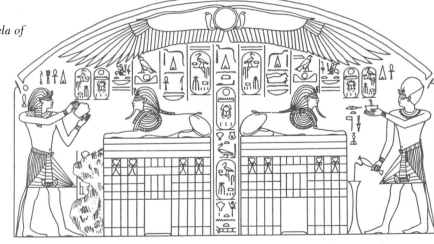

Sometimes, the representation actually functions as part of an associated text. In Old Kingdom funerary inscriptions, the hieroglyph of a reclining dog or jackal which represented the mortuary god Anubis is sometimes enlarged beyond the scale of the other hieroglyphs in the inscription until it becomes a full-size represen-

The Symbolism of Hieroglyphs 153

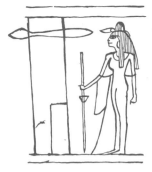

107, 108
Representation as hieroglyph and hieroglyph as representation: the figure of Anubis in a funerary inscription (left). The hieroglyph for mansion in a funerary vignette (right).

tation of the animal – although it continues to function in its normal hieroglyphic sense. In ill. 107, we see an example of this practice in a text which begins with the formula usually used in such inscriptions – "An offering which the king gives, and which Anubis gives in front of the divine booth . . ." – with the figure of the jackal reclining directly above the second half of this inscription.

In other cases, the interaction is merely a thematic one with the embedded hieroglyphic form being connected with the associated text in only a very general way. For example, a number of vignettes in New Kingdom funerary papyri depict the deceased standing before the hieroglyph *hut* [] signifying "mansion," sometimes with the sign for "great" added to the picture to indicate "great mansion" – an epithet used of the tomb chapel (ill. 108). Here, the written hieroglyph, made large, functions as part of the representation (in this case, the tomb) which illustrates the theme of the text with which it appears.[9]

A detailed study of the influence of representational forms on hieroglyphic texts lies beyond the scope of this chapter, but it should be noted that the pictorial nature of the script was also exploited in a number of ways in hieroglyphic inscriptions. Because hieroglyphics may be written left to right or right to left, for example, individual signs may be turned to face each other by drawing one of them in the opposite direction to the rest of the writing in instances where this arrangement would suggest some kind of interaction between the two figures, or be symbolically significant in some other way. A hieroglyphic text may thus be overlaid with representational information, just as representations may be given hieroglyphic meaning. As the German Egyptologist Wolfgang Schenkel has shown, in some cases, such interactions are truly "displays of pure virtuosity"[10] – a fact which is no less true of the Egyptian's use of their hieroglyphs in representational contexts.

A Flexible Script: Different Ways to Convey Concepts

Because of the particularly flexible nature of the hieroglyphic system of writing, the symbolic use of hieroglyphs in representational works of art may occur in a number of ways. The hieroglyphic signs essentially carried information of two types – sounds which could be used to write words phonetically, and visual images which could be used to portray objects and ideas pictorially. The hieroglyph which depicted a reed leaf 𓇌 , for example, could signify the sound of the Egyptian word for reed (*i*), which might be used to write other words which contained this sound, or it could be used pictorially to signify the reed itself. The hieroglyphic writing of most words was usually accomplished by the use of signs of both types of value, combining a phonetic spelling of the word with a pictorial "determinative" indicating the kind of thing being represented. But the phonetic and pictographic values of the signs could be utilized in different ways, both in writing words, and in the creation of two- and three-dimensional works of art:[11]

Phonetically Objects and ideas could be signified simply by spelling out the word by means of phonetic signs (using a separate sign for each sound) in a similar manner to that in which modern alphabets function. The name of the god Amun, for example, was usually spelled out as 𓇋𓏠 : the reed leaf 𓇋 *i* + the playing board with game pieces 𓏠 *men* + the letter 𓈖 *n* (which was added to reiterate the final sound value of the word for the sake of clarity) thus forming the word *imen* "Amun," which is followed by a determinative sign meaning "god."

The purely phonetic use of hieroglyphs rarely occurs in representational contexts, however, and interaction usually takes place in the following ways:

Ideographically Through direct depiction, signs (called ideograms) could be used which pictured the object concerned. In the case of the god Amun this deity could be signified by the depiction of a seated figure 𓀯 identifiable through the two tall plumes worn on his head.

In representational works images may function as hieroglyphic ideograms as seen in the example of the depictions of Anubis, and the hieroglyph used to represent the tomb, just discussed. In a similar way, the representation of the tomb owner on stelae and tomb paintings is often made to substitute for the "person" determinative which is normally placed at the end of a personal name. In the tomb of the Twelfth Dynasty official Sa-renput at Aswan, for example, Sa-renput is shown seated on either side of the doorway to his tomb, in

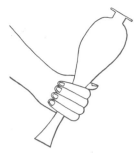

109 *The name of Hesy-re indicated through the rebus principle: the* hes *vase at left, and the sun (*re*) disk at right.*

the same manner as the hieroglyphic sign for a revered spirit (ill. 114). The column of hieroglyphs immediately above Sa-renput's head records his name but it is the representation itself which forms the required determinative at the end of the name.

Through the rebus principle Hieroglyphs representing objects are chosen to depict syllables or words which produce another word or even a short statement. In English, a drawing of two gates and a head could represent "Gateshead" in this manner. In Egyptian, the god Amun's name was sometimes written in rebus form by means of a composite hieroglyph consisting of an oval containing the final letter *n* of the god's name ⬮ . The oval surrounding the *n* signified the Egyptian word *imy* "who [or that which] is in" – as in the phrase "he who is in [*imy*] his mansion," and the letter *n* within the oval completed the spelling of the god's name im(y) + n = *imen* "Amun".

In two- and three-dimensional representational works, and especially in sculpture, the rebus principle is commonly used in exactly the same manner to spell out a personal name. A carved wooden panel from the Third Dynasty tomb of the noble Hesy-re at Saqqara shows this man holding two items which are probably offerings (ill. 109). In one hand (on the side which would be "read" first by someone looking at the panel) the tomb owner holds a *hes* vase and in the other (which would be "read" next), he holds a circular object like a sun (*re*) disk. Although they are not part of any formal inscription, the offerings together spell out Hesy-re's name and continually provide a reminder of the identity of the offerer. This practice was especially common in the late New Kingdom (ill. 115).

Through visual analogy This could be analogy of form as in the case of the hieroglyph depicting a roof which is used for the word "sky"; or analogy of meaning, as when walking legs ∧ are added to the reed leaf 𓇌 in the word 𓇌𓂽 *ii* "come," and other words signifying motion. Although there is no exact parallel for this kind of visual analogy among the ways in which the name of Amun was written, the *principle* might be compared to the way in which the final n of the god's name was "hidden" within the oval of the writing ⬮ , with the sign thus "acting out" the meaning of the god's name "the hidden one."

Simple analogy of form is found in the many objects made in the shape of a symbolically significant hieroglyph such as the *ankh* (see

below). Analogy of sense or meaning is found in the predynastic ceramic bowl shown in ill. 116 and now in New York's Metropolitan Museum of Art; it was made in the period from 3400–3000 BC and is set upon two feet as though to convey the idea of a servant's bringing the bowl with its contents.[12] Several centuries later, a hieroglyph depicting a bowl above two legs began to be used to signify the concept of "to bring," or something brought. Although this particular bowl precedes the similar hieroglyphic sign, we see in their juxtaposition a clear example of how the Egyptians utilized the principle of visual analogy by acting out a given meaning.

Through visual metaphor The pictorial, ideographic writing of a word is used to denote something else through extension of meaning. Just as metaphors are used verbally – as in "the evening of life" for old age – the depiction of a thing may be used to represent something with which it is associated. Thus, the name of Amun could be signified through visual metaphor using the process of semantic extension. Several creatures, notably the ram and the goose, were mythologically associated with Amun, and the representation or hieroglyph for one of these animals may stand for the god.

That the depiction of these creatures in representational contexts could carry the same symbolic meaning is seen in a number of locations such as the so-called "Botanical Room" constructed by Thutmose III in the Temple of Amun at Karnak. There, among the representations of many species of plants, animals, and birds, the image of the goose was obliterated by the agents of the pharaoh Akhenaten in their quest to destroy all reference to the god Amun.

Another common example of this kind of visual metaphor may be found in many depictions of the sacred baboon. Because the baboon was a symbol of Thoth – the lunar god who was also god of writing and wisdom (ill. 117) – its image could be used to represent those qualities commonly associated with that god. Thus, in both the written hieroglyphic script, and in larger representational works, the baboon may signify wisdom, knowledge, judgment, writing, and even excellence. In fact, statues which represent an Egyptian scribe with a baboon clinging to his head or back may not only symbolize the god's patronage and inspiration of the scribal profession, but could perhaps also be seen as connoting "scribe of Thoth" or even "excellent scribe."[13]

While Egyptian writing made use of all of these different forms of expression in texts and inscriptions, exactly the same communication principles were chosen when hieroglyphic forms were used in the construction of large-scale representations.

Flexible Images: Hieroglyphs as Objects and Objects as Hieroglyphs

The importance of hieroglyphic forms as symbolic images may be seen in the way in which the forms of many signs were mentally "projected" by the Egyptians into their world. This occurred in two ways: hieroglyphic forms were utilized in the design of items that the Egyptians constructed; and they were also projected on to natural objects which resembled the forms of the hieroglyphs in such a way that these objects were viewed – and represented – as though they were virtually identical with the written signs. These constructed and visualized forms may be seen in things ranging from the smallest objects of everyday use to buildings and even, on occasion, to landscapes.

This process may be seen in the way in which the hieroglyphic sign for *akhet* or "horizon" ☁ was utilized in a good many different contexts (ill. 118–123). The sign depicts the two peaks of the mountain glyph with the solar disk appearing between them on the horizon from which the sun emerged or disappeared. The horizon thus embraced the idea of both sunrise and sunset, and was sometimes represented with the twin lions of "yesterday" and "tomorrow," a double lion deity who guarded both ends of the day, or a leonine sphinx. An example of this may be seen in the relief scene carved on the famous "Sphinx Stela" (ill. 106) in which twin sphinxes are placed back to back with the winged sun-disk above and between them so that the whole composition is a complex elaboration of the horizon hieroglyph. The same hieroglyph may be seen to have been "imagined" and constructed in all of the following contexts:

Visualized objects In the drawing of a metalworker blowing on the fire which he uses as a forge (ill. 117), the raised lip of the fire pit is shown in sectional profile with the heaped charcoal fire in its depression appearing just as the glowing sun between the two peaks of the horizon.

Constructed objects The Egyptian headrest (ill. 119), for example, could imitate the *akhet* in its form and symbolism, for the sleeper's head rises from it like the sun from the horizon.

Visualized buildings In a vignette from the Book of the Dead of Neferubenef, the shadow and *ba* of the deceased are shown at the entrance to the tomb (ill. 120). This structure is represented with raised sides or ends and has been depicted with the disk of the sun resting on the tomb's roof in such a way as to provide an *akhet* or horizon. As death was referred to as "going to one's horizon" the visual association is of course especially apt.

Constructed buildings The *akhet* also appears in actual architecture (ill. 121). Because the Egyptian temple was theoretically aligned on an east-west axis, the two towers which flanked its entrance may well have signified the two peaks of the horizon between which the sun rose. In an inscription at Edfu the pylon towers are, in fact, specifically referred to as the goddesses Isis and Nephthys "... who raise up the sun god who shines on the horizon." The statue of the sun god was thus sometimes displayed to the people from the terrace between the towers, and the term for this "appearance" *khai* was the same as that used for the rising of the sun over the horizon.

Visualized landscapes The mountains to the west of Thebes where the royal mortuary temples and necropolises lay are part of a vast chain, yet from Thebes they appear as a lone group rising suddenly on the horizon. This group is highest at its southern and northern ends with a pronounced depression in the center (ill. 122). As the sun set in these western mountains it formed a clear and literal *akhet* in the eyes of the Egyptians. The shape of the hills to the east of Akhetaten, the new capital chosen by Akhenaten in central Egypt, have also been likened to this shape, and this aspect may well have been in the king's mind when the site was chosen.

Constructed landscapes In the New Kingdom, *Hor-em-akhet* "Horus in the Horizon" (the god of the rising and setting sun) was often represented as the leonine sphinx. The Great Sphinx of Giza was viewed as a literal "Horus in the Horizon" since it lay between the twin peaks of the giant *akhet* formed by the pyramids of Cheops and Chephren (ill. 123).[14] While it is not known that this meaning was present in the minds of the original builders of the Sphinx, there is evidence to show that the Egyptians developed certain locations on account of the forms of their topography.[15]

Flexible Symbols: The Multiple Meanings of Life

The hieroglyphic forms used by the Egyptian artists provided flexible images which could impart their symbolic values in different contexts. In addition, many individual hieroglyphs could embody a range of meaning which found expression in a number of different ways. The *ankh* hieroglyph ☥ , for example, provided a wide choice of symbolic expression centered on the basic concept of "life" – from life-sustaining water, air, and food, to the life-force in verdant plant growth and sexual fecundity.

The connection with water is seen in the common representational device in which *ankh* signs were used as a visual equivalent of streams of the life-giving liquid, as in the depiction of ritual

purification found on blocks from the dismantled red granite shrine of Hatshepsut at Karnak (ill. 124). Instead of streams of water, however, streams of *ankh* signs flow down to cover the monarch. This type of scene not only illustrates the interchange of word and visual image in Egyptian art, but also demonstrates that from the Egyptian perspective the symbolic values of the signs obtain a virtual reality of their own.

Actual ceremonial libation jars and vessels used to pour offerings of water before the gods were often made in the shape of the *ankh*. An early dynastic slate dish in New York's Metropolitan Museum of Art, which consists of a pair of arms in the shape of the *ka* sign for "spirit" embracing an *ankh* sign, is one of the earliest examples of this.[16] The vessel perhaps forms a discrete prayer or wish: "[may my] spirit live"; but regardless of the question of whether the hieroglyphic forms may be "read" together, the fact that this dish was probably used to hold water that was poured out as an offering provides a particularly clear example of the use of symbolism in the earliest times. The life-giving power of the *ankh* would be thought to be magically transferred to the water it contained, making it all the more efficacious if it were poured out in offering to the deceased.

The close connection between the *ankh* and water is also seen in a painted scene from an Eighteenth Dynasty tomb at the Theban village of Deir el-Medina (ill. 110) which shows the mortuary god Anubis standing with the spirit of the deceased before his tomb. The long *was* scepter carried by the god terminates at the top in an *ankh* sign as is often the case in such representations, but here the association between the *ankh* sign and life-giving water is complete, for a stream of water issues from the crossbar of the *ankh* and falls to the ground before the tomb.

The *ankh* was associated with air through the idea of the breath of life, the concept behind the innumerable depictions of the gods holding the sign to the nose of the king, as well as the partially personified *ankh* signs with human arms which are frequently shown holding fans behind the figure of the king implying the constantly attendant giving of the breath of life.

The *ankh*'s connection with food offerings is less often seen, though this too is clear. A late Eighteenth Dynasty tomb relief from Memphis shows two altars loaded with bread loaves which are depicted in the form of *ankh* signs with the table providing the T-shape and the circle of a centrally placed bread loaf forming the loop of the hieroglyph (ill. 126). Each offering table "*ankh*" is framed within a triangle signifying the hieroglyph *di* "give" and thus producing a rebus which reads *di ankh* – "given life." The composition also functions at the

110
The ankh *sign as water, detail of a New Kingdom tomb representation, from the Theban village of Deir el-Medina.*

level of a double pun as it is the *ankhu* or "offerings" upon the table which "give life."[17]

The *ankh* could also be symbolized by floral bouquets and the "papyrus swathe" (bundles of flowers and plant foliage tied around a central bunch of papyrus stalks) which was commonly offered to the gods. The flower or leaf of the lotus may also symbolize the *ankh* in some compositions. Several Eighteenth Dynasty objects thus fuse the name of the king with the depiction of a lotus blossom in the form of an *ankh*,[18] and the stem and leaf of this plant not only frequently appear behind the figure of the king in inscriptional contexts which promise life and protection to the monarch, but the same plant is sometimes found as an offering table (the stem being the stand and the leaf functioning as the table top). A stela in the Cairo Museum shows the figure of a man presenting a huge *ankh* sign to the enthroned Osiris (ill. 127).[19] The hieroglyph has a lotus blossom entwined around it and combines the image of the floral swathe with the specific symbolism of the lotus and the *ankh*.

Sexual allusions may enter into the life symbolism of the *ankh* hieroglyph – as may be seen in the form of the pubic triangle which is depicted at the top of the "leg" of a number of amulets made in the form of this sign (ill. 128).[20] Finally, although much rarer, solar symbolism may also appear as seen in the Amarna practice of sometimes writing the *ankh* hieroglyph as a simple T directly below the *aten* disk of the sun.[21] In these instances the solar disk replaces the loop of the *ankh* and not only forms an explicit monogram with the meaning of "the living Aten," but also shows us yet another aspect of the life-force behind the concept of *ankh*.

The flexibility seen in these aspects of the *ankh*'s expression reveals why the hieroglyphic forms could be such a rich source of symbolic imagery in Egyptian art, for as Erik Hornung has written, "... a symbol is essentially polysemic [having or being capable of several meanings] and complex; it stands for concepts and insights that individual words in a language can intimate but never fully capture."[22] Egyptian hieroglyphs thus transcended the boundaries of most written scripts in successfully blending symbolic representation and the written word to a degree that no other system of writing has surpassed.

Living Words
of the Gods

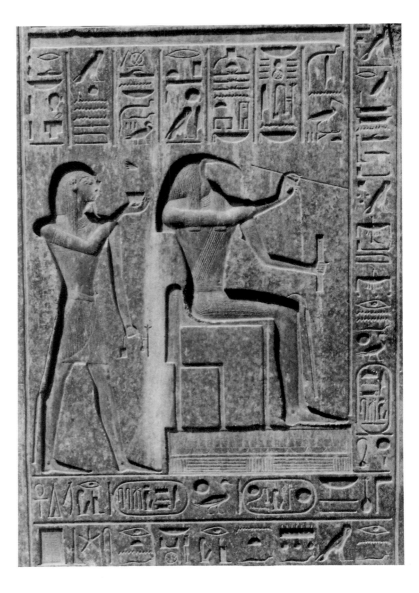

111 *The king with the god Thoth. Temple of
Ramesses II, Abydos, Dynasty 19.*

The ancient Egyptians considered their
system of writing to be of divine origin – the
gift of gods to humanity. The hieroglyphs
themselves were called "the god's words" and
they were above all associated with the god
Thoth – patron of scribes and the art of
writing. In the scene illustrated here, the god
himself prepares the inscription which
appears before him while the great king
Ramesses II stands in attendance, holding the
god's scribal water pot. Such representations
clearly show the great importance accorded
the Egyptians' system of writing in the
culture's religious sphere. A number of kings
and nobles were also depicted in their
statuary in the scribal guise, not only as a
means of conferring status in a largely non-
literate society, but also as a concrete way to
associate the human with the divine.

162 *Words as Magic, Words as Art*

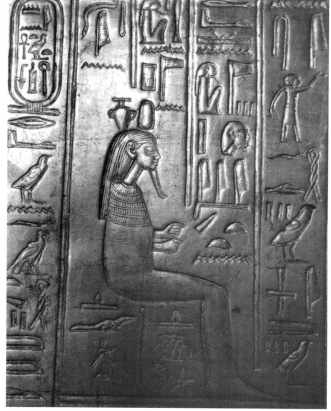

112 (Right) Deity representing offerings (shrine of Tutankhamun). Valley of the Kings, Dynasty 18. Egyptian Museum, Cairo.

Many Egyptian gods and goddesses were depicted wearing the hieroglyphic signs for their names upon their heads, and several deities – especially those who appear in groups without individual attributes – often cannot be distinguished by any other means. But the hieroglyphic signs can be more than mere identifying labels and often function independently in inscriptions and representations as manifestations of the gods themselves. The minor deity shown here seated on an invisible throne and wearing the hieroglyphic signs for bread and beer upon his head represents a personification of the offerings which would magically sustain the king throughout eternity. Here again, the relationship between divinity, written sign, and magical depiction is clear.

113 Hieroglyphs. Coffin of Princess Nubheteptikhered (after J. de Morgan).

The divine origin of the hieroglyphic script and the high degree of realism found in many of the signs depicting living things led to the hieroglyphs being regarded as possessing magical lives of their own. The magical forces associated with these "living" words were believed to be extremely potent, so that hieroglyphs representing dangerous creatures such as snakes were either incompletely drawn – as in the example seen here – or mutilated after being written, or the creatures were transfixed with knives or spears which were drawn through their heads or backs. Sometimes hieroglyphs of humans and other living creatures which were not hostile were also mutilated for magical reasons, perhaps to prevent them from consuming offerings intended for the deceased.

The Symbolism of Hieroglyphs 163

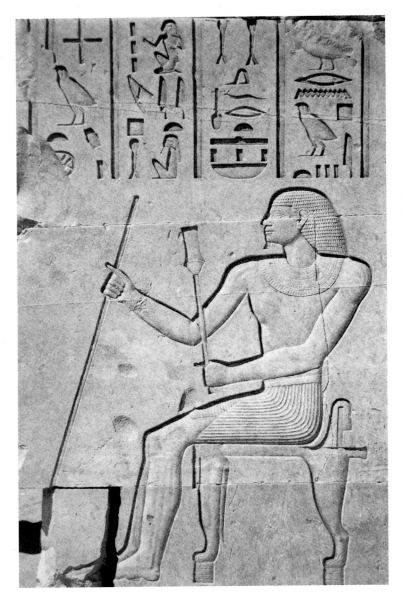

A Flexible Script: Different Ways to Convey Concepts

114 *The tomb owner as revered person. Tomb of Sa-renput I, Aswan, Dynasty 12.*

Ideographic representation: The simplest manner of incorporating the written hieroglyphs in Egyptian art, ideographic representation involves the depiction of a figure or object in the form of a hieroglyphic sign. This depiction may stand alone, suggesting a word or concept, or it may be linked to an associated text. Here the figure of the tomb owner is carved in the form of the hieroglyph used to signify a deceased person and functions in the inscription as the "person determinative" written at the end of an individual's name.

115 *Amenhotep III and the god Thoth in the form of a baboon. Statue of Kheruef (detail), Dynasty 18. (Now destroyed; after Erman).*

Rebus representation: This principle was used in Egyptian art to spell out personal names by incorporating hieroglyphic signs with syllabic values into the composition. In this example Amenhotep III is depicted as a seated god (one of the words for which can be *neb*) holding a *maat* feather and with a sun disk (*re*) upon his head, thus spelling out his throne name Neb-maat-re. The king is seated next to a baboon symbolizing the god Thoth upon a base in the shape of the sign *mer* connoting love. The whole statue thus reads "Nebmaatre beloved of Thoth" and/or "Thoth beloved of Nebmaatre."

116 *Bowl with feet. Predynastic Period. Metropolitan Museum of Art, New York.*

Visual analogy: This involves the use of hieroglyphic signs for other things which they resemble. In Egyptian art, objects are frequently made in the form of hieroglyphic signs which they resemble, such as a mirror case or a vase in the shape of an *ankh* sign. The ceramic bowl with feet shown here clearly represents the principle of visual analogy and is similar to a common hieroglyph which appeared later in Egyptian history depicting a bowl with two legs beneath it to suggest the idea of "to bring" or a thing "brought."

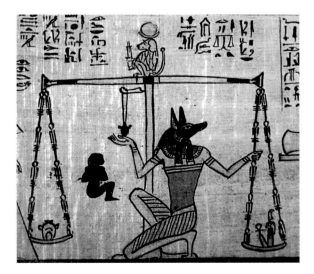

117 *(Left) Baboon on sacred scale. Papyrus of Nani, Dynasty 21. Metropolitan Museum of Art, New York.*

Visual metaphor: This subtle variety of hieroglyphic expression operates through the use of a sign to suggest something else by means of the extension of meaning. Thus one thing is used to suggest another with which it is somehow associated. At the most basic level, the baboon, which was associated with Thoth – the lunar god who functioned as the patron of writing and wisdom – could thus be represented to suggest activities or concepts related to Thoth such as writing, judgment, wisdom, knowledge, and excellence. Thoth's position here is significant because it was he who had to record the results of the "weighing of the heart" and report to Osiris whether or not the deceased was "true of voice."

Objects as Hieroglyphs and Hieroglyphs as Objects

118–123 *Constructed and visualized examples of the horizon hieroglyph.*

The forms of many hieroglyphs were "projected" by the Egyptians onto actual objects in two ways. On the one hand, hieroglyphic forms were used in the design and production of various objects, and on the other hand, natural objects were viewed and represented as though they were virtually identical with hieroglyphic signs which they resembled. In this group of illustrations, for example, the *akhet* hieroglyph — which represented the "horizon" where the sun rose and set — may be seen in the forms of a number of constructed and visualized objects onto which it was projected:

Constructed hieroglyphic forms may be found in small objects such as the headrest from the tomb of Tutankhamun (118) which mirrors the *akhet* in a rather complex way. The two lions reclining back to back suggest the shape of the hills at each side of the hieroglyph, while the curved headrest with the head which it supported resembled the form of the sun itself. The king's head thus rose and "set" like the sun from this "horizon." Temple pylons (119) were constructed in the form of the *akhet* hieroglyph in the same manner, and although it is not known for sure that the Great Sphinx at Giza (in the New Kingdom called Hor-em-akhet: "Horus in the Horizon") was designed to represent the horizon with its flanking pyramids, it is possible that it was originally constructed with this image in mind (120).

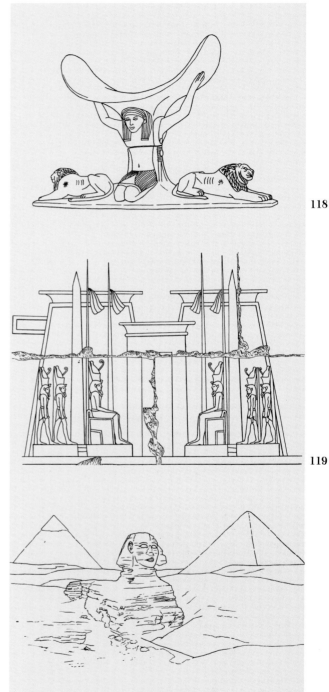

118

119

120

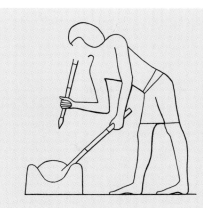

Visualized hieroglyphic forms may be seen in paintings of objects such as the representation of a man blowing onto a fire in a pit shaped exactly like the horizon hieroglyph (121), the representation of a tomb with the sun above it (122) which forms the same image, and even the way the western mountains of Thebes – called the western horizon, and behind which the sun actually set – were viewed by the Egyptians who constructed the great necropolises of their kings, queens and nobles in the slopes of this mountain range, across the river Nile from the main area of habitation (123). Similar, *akhet*-like cliffs have been noted on the east bank of the Nile at Amarna where Akhenaten founded his short-lived capital Akhetaten: "The horizon of the Aten."

The importance of hieroglyphic forms as symbolic images in Egyptian culture cannot be overestimated, and the projection of such forms onto natural and constructed objects is extremely frequent. Although only the educated elite of Egyptian society could properly read and write, and it is that portion of society for which most artworks were produced, nevertheless many people probably recognized at least some of the more common hieroglyphs. These signs entered the art and artifacts of the culture at a number of levels, ranging from the forms given to amulets and various everyday objects to the forms seen or imagined in local topographical and geographical shapes, and celebrated in popular myth and legend.

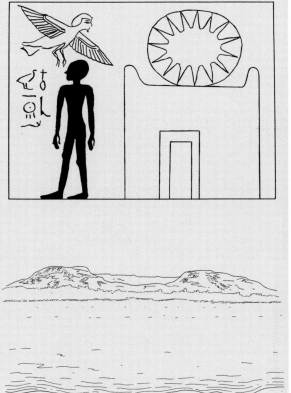

121

122

123

Flexible Symbols: the Multiple Meanings of Life

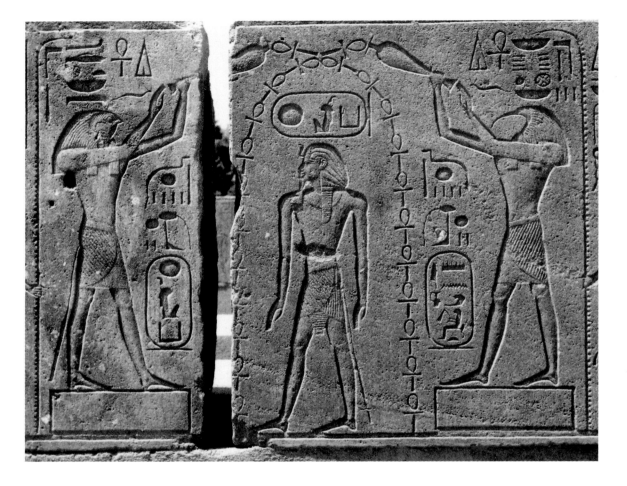

124 *Water and life: Inscribed block of Hatshepsut from Karnak. Dynasty 18.*

The ability of some hieroglyphic signs to represent a number of related concepts in representational works is well illustrated by the *ankh* or life sign (☥) which was used to symbolize not only life itself, but also by extension elements which sustained life. In this scene, Horus and Thoth pour streams of *ankh*s over Queen Hatshepsut from ritual libation jars – symbolizing the purification and life which the water connoted.

125 *(Left) Air and life: Statue of Amenhotep III and the god Sobek (detail). Sobek temple at Daharmsha (found near Thebes), Dynasty 18. Luxor Museum.*

The *ankh* was often used to signify the breath of life. Just as many Egyptian texts speak of the gods giving breath to the nose of the king, so many representational scenes depict a god or goddess holding an *ankh* sign to the nose of the king, or as in this case, where the god Sobek (out of the frame) offers the sign to Amenhotep III in a less explicit manner but with the same meaning.

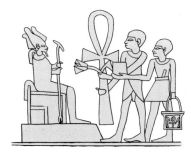

126 *(Left) Food and life: Tomb relief (detail), Dynasty 18. University College, London.*

The *ankh* could also be used to symbolize the life-giving power of food offerings (called *ankhu*), as in this drawing of an offering table loaded with loaves of bread in the shape of the *ankh* hieroglyph within a triangular enclosure drawn like the hieroglyph "to give" so that the group signifies the giving of offerings – and life – as in the common formula *di ankh*: "given life."

127 *(Above) Vegetation and Life: Funerary stela (detail), Dynasty 20. Egyptian Museum, Cairo.*

The *ankh* may be symbolized by bouquets and floral swathes (called *ankhu*) which represented both the general significance of verdant plant life and the specific symbolism associated with those plants which made up the floral bouquets. The lotus, for example, symbolized life through its connection with the concept of solar renewal, and the papyrus could have similar significance through its associations with the goddess Hathor.

128 *(Left) Sexuality and life:* Ankh *amulet. Dynasty 18. Egyptian Museum, Cairo.*

In some cases the decoration added to *ankh* amulets may suggest the concept of sexuality. While some *ankh* amulets display a small triangular pattern at the top of their "leg" which may be drawn to represent a lotus flower or papyrus umbel – both having associations with the idea of rebirth – sometimes the design seems to imitate the female pubic triangle, and thus fit neatly into the same concept through human sexuality.

169

SIGNIFICANT ACTIVITY
the symbolism of
ACTIONS

"It happened that barley was put on the threshing floor. It happened that male animals were brought to trample it. That means Horus avenging his father ..."
Mystery Play of the Succession, Part III

THE IMPORTANCE of religion for the ancient peoples of the Nile – at all levels of society – is one of the most salient aspects of Egyptian civilization, yet a surprising amount of the Egyptians' religious activity seems to have been performed by the king (or his priestly deputies) on behalf of the people as a whole. In fact, the official world view of the ancient Egyptians focused almost entirely on the ongoing interaction between the king and the gods, for in all periods the king functioned as an intermediary between the human and the divine, with the religious aspirations of the people resting upon his shoulders. This fact creates an interesting situation in regard to the rituals and other activities performed by the king in the course of fulfilling his role, for it underscores both the importance of the king's actions and their intensely symbolic nature. As a result, in this chapter we shall concern ourselves mainly with royal activities and their underlying ideology, though some of these actions also found expression in rituals involving private persons.

Real, Mythical, and Iconographic Actions

In order to understand the full significance of these symbolic actions we must examine a number of quite diverse activities which appear in Egyptian art – some actual and of an ongoing nature (or at least activities rooted in events and actions from early Egyptian history and which continued to be enacted symbolically); and others that were clearly mythical and had no actual relation to reality; and yet others which were purely propagandistic, and involved the "adjustment" of reality.

129 *Some activities such as this ritual of hoeing the ground were conducted by kings and commoners alike in different contexts.*

Many scenes depicting aspects of rituals associated with the transfer and continuation of power – the king's coronation, or his jubilee festival, for example – clearly represent activities which were actually performed during these important events. Representations of the so-called "race" run by the king in the *sed* or jubilee festival thus appear from even the earliest dynasties, and show the king running or striding around a prescribed course, perhaps, as is often said, to show his fitness for continued rule (ill. 132). Yet the underlying symbolism of the event is clear enough. The representations of this ritual and their accompanying texts show that as the king ran he carried in his hand a small scroll – the *imyet per* or "house document" which may be understood as something like "title of ownership" – a document which would seem to grant the king the right to the jubilee complex, or perhaps the palace, and by extension to the land as a whole. By carrying this document as he ran around the set course, the king affirmed his rulership over the land of Egypt. It has also been shown that the area crossed or encircled in the *heb-sed* "race" represented not only the extent of the king's earthly domain, but also his celestial realm, for the rule of the king was identified with the rule of the god Horus over heaven and earth. Thus the king would symbolically travel to the limits of his domain, re-establishing his authority over all that existed.[1]

Mythically significant as it may have been, representations of this action are clearly based on an actual event, described in contemporary texts. But other scenes depict activities which can only be purely imaginary or mythically based. Such is the case in depictions of the king learning to shoot the bow and arrow under the direct tutelage of one of the gods, usually a deity with martial associations such as Horus, Montu, or Seth. Ill. 133 shows an example of this in which the latter god instructs king Thutmose III in this activity. While most

The Symbolism of Actions 171

Egyptian kings clearly did learn to use the bow, along with other weapons, there is nothing particularly symbolic in this activity per se, and it is only inasmuch as the instruction is given personally by a god that the activity becomes symbolic of the king's divine tutelage and special theological position. Many other scenes, such as those showing the king receiving his crown from the hands of a deity, are of course directly parallel.

A third example shows that actual activities were sometimes subtly adjusted for the purposes of this kind of propagandistic representation, thus enabling the artist to produce what we might call "iconographic actions" based on real events yet not portrayed in a wholly realistic manner. Egyptian monarchs are often shown in battle shooting the bow from their chariots in a most unrealistic way, and several details of these scenes seem to be artificially adjusted (ill. 134).[2] For one thing, the king is invariably shown pulling the bow much further back than would be practical or possible, for even if the bow could be drawn as far as depicted, the bowstring must be kept ahead of the ear (a point of practice that the archer must observe to avoid being struck by the released string). More important, a bow actually cannot be aimed if fired in this manner since the archer's rear hand must be consistently anchored to the same point on the face (usually the chin, nose, or ear) in order to provide the rear element of the sighting radius – the equivalent of the rear sight of a rifle. If the length of the arrows in the chariot quiver is compared with that of the arrow being pulled on the king's overdrawn bow, the former will be seen to be only long enough to reach a realistic anchoring point. But the elongated span cannot merely be the result of a representational convention designed to avoid the placement of the bowstring before the king's face, because the draw is often much longer than would be necessary to do so. In fact, the ancient artists need only have omitted a small part of the bowstring had this been their intent, so the longer draw seems to have had a propagandistic purpose in portraying the king's superhuman strength and prowess.

This same factor may also be seen in another detail of these compositions, for the king is usually shown riding alone in his chariot, with the reins of his horses tied around his waist in order to free his hands for the purpose of shooting the bow. It has been pointed out, however, that this portrayal is probably unrealistic, too.[3] All the evidence would suggest that the Egyptian king was accompanied in his chariot – as all archers were – by a driver who held the reins while the king fought. The tying of the horse's reins to the king's waist is thus probably a representational device aimed at letting nothing detract from the king's glory – and actually augmenting it by once

again suggesting superhuman levels of power and skill. Other examples of this kind of representation include depictions of the king at an enlarged scale which enables him to grasp an enemy from the top of a fortress (ill. 37) or to carry a group of prisoners under one arm.

Representations of royal activity may thus show realistic, mythical, or iconographic action taking place, a range which may also be seen to some extent in non-royal Egyptian art, such as various funerary scenes in private tombs. These range from the representation of actual events of the burial such as the funerary procession and its associated rituals to mythical portrayals of the *ba* or "soul" of the deceased leaving the tomb and symbolic activities such as representations of the pilgrimage journey to religious sites such as Sais, or later, Abydos (see Location). During the New Kingdom, certain scenes such as that of the tomb owner hunting in the marshes with his wife – attired in party finery (the significance of which is discussed later in this chapter) – may also qualify as coming close to iconographic actions, though this type of action is more usually limited to the person of the king.

Conversely, the Egyptian king is relatively rarely depicted in realistic action in New Kingdom works, for most of his representations are set within the mythical or iconographic spheres. This is to say that his actions usually take on the significance of larger-than-life activities, even if this is merely sitting – ruling – upon his throne. In fact, virtually the only instances where a reigning king is represented in a totally passive role are in those scenes in private tombs which show the enthroned monarch receiving the tomb owner. Royal and sacral depictions of the king show him involved in events which may range from his birth (viewed as an active event initiated and supervised by the gods) through a wide variety of activities. Most of these actions fall into one of two complementary groups, however: the service of the gods and the maintenance of order. Examples from both of these groups enable us to see the interplay of the real, mythical, and iconographic spheres.

Service of the Gods

Because the king acted as an intermediary between the human and the divine, he was responsible for satisfying the gods in order to ensure the smooth functioning of the cosmos itself. Most of the work involved in this service was actually performed by the priests and temple personnel, of course, but it was nevertheless the king, in theory, who provided for the gods and supplied their physical needs in the various temple rituals. Thus, it is the representation of the king

that constantly appears in association with the figures of the gods on the walls of temples, and the priests are shown only occasionally – bearing the weight of the god's sacred barque or in other relatively minor roles.

The number of actions associated with the ministration of the gods was quite large, yet a few appear recurrently and are of special symbolic importance. From the very foundation of a temple, the king played the dominant role in its construction and functioning. Individual monarchs were responsible for building the successive pylons and courts added to Egypt's greatest temples and even complete structures in other cases. Representations show the king involved in a foundation ritual known as "stretching the cord" which probably took place before work began on the construction of a temple or of any addition (ill. 135). These depictions usually show the king performing the rite with the help of Seshat, the goddess of writing and measurement, a mythical aspect which reinforced the king's central and unique role in the temple construction. On the other hand, in scenes of purification where the king censed and sanctified the site of the new construction he is shown, realistically, alone.

Once built, the king's involvement in the temple's activities dominated the actions of everyone who might enter the shrines and other sanctified areas. His figure is often shown flanking the doors and entrances to the central areas of the temple; and the text which accompanies these representations of the king is a standard one commanding all who enter to "be purified four times." This either served as a reminder that those who entered must be ritually purified or, since they already certainly were, perhaps magically conferred purification upon all who passed.

Within the intimate quarters of the temple – the shrines and suites where the gods took up residence – the king was represented as directly fulfilling his duties. Not only is he shown holding up the ceilings above the shrines of the gods, which were often decorated on their upper surfaces with the form of the sky hieroglyph to signify the king's upholding of the heavens (a symbolic action par excellence), but he is also shown performing the many small rituals which were involved in the gods' care. These rituals included the daily bathing, dressing, anointing, and censing of the image of the deity, as well as the presenting of food and drink offerings and many other gifts ranging from small items such as jewelry and clothing to votive statues and even such massive items as obelisks and cargo ships. Clearly, some of these gifts could have been brought into the temple as shown in the representations, while others must have been

symbolically given with the object itself being ceremonially dedicated in another location – perhaps with an image of the god in attendance.

Some offerings were not physical, however, and involved the presentation of gifts of a symbolic or mythical nature, a situation which often leads to a combination of realistic and mythical representations. Foremost among such offerings was the presentation of Maat.[4] Many scenes depict the king offering a small figure of this goddess, who personified the qualities of truth, justice, and order, before the supreme deities of the land (ill. 136). Because this quality was regarded as one of the gods' supreme gifts to humanity, it was incumbent upon the king as shepherd and protector of the people to preserve and foster Maat, and to return her to the gods – or at least vouch for her continued existence – for the absence of Maat would result in chaos, evil, and unrest in the cosmos. Mythologically, Maat was held to be the daughter of the great sun god Re and the wife of Thoth, god of wisdom and judgment. Thus, in presenting the image of Maat, the king (or the priest who represented him) usually acted symbolically in the capacity of the god Thoth.[5] This fact places the representations simultaneously within two spheres, the real and the mythical, through the king's action in physically presenting an actual offering (the figure of the goddess) and the mythical role of the king functioning as Thoth within the cohort of the gods – although in both cases, the idea of the presentation of Maat is the same.

Sometimes more than one kind of significance was inherent in a single offering or other activity. Such is the case in the rite known as the consecration of the *"meret* chests." This interesting ritual is attested from the time of the Seventeenth Dynasty down to the Roman period and is represented quite frequently in temple reliefs, in several royal tombs of the New Kingdom and on a number of private sarcophagi of the Twenty-first Dynasty – showing a fairly wide range of symbolic applications and importance. Known as the rite of "consecrating the haulable *meret* chests four times" or simply "dragging the *meret* chests," the extant depictions show the king facing a deity (usually, though not always male) with the four chests, set on sledges, standing between them (ill. 137). The king stands in a rather unusual pose – he holds a scepter or club in his right hand which is raised as though he were about to deliver a blow – a somewhat different pose from that seen in most consecration scenes where the king simply stretches out a scepter before him. The chests themselves are distinctive in two ways, firstly in that they are shown surmounted by an ostrich plume at each of their four corners (the fact that only two feathers are shown in many representations being due

to the conventions of Egyptian art), and secondly the chests are shown enveloped in some kind of bandages or bands.

Accompanying texts show that the chests contained linen or clothing of four different colors: white, green, red, and blue. Several texts make it clear that the linen is to wrap the body of Osiris, though others simply stress the fact that the *meret* chests are associated with the four cardinal points and thus represent the earth and its peoples. A study of this ritual by Arno Egberts has shown that in this rite *ta-meret*, "the *meret* chest" is symbolically linked to *ta-meri* "the land of Egypt" and its people,[6] for the inscriptions include statements made by the king such as "I bring you Egypt," and the name of the rite *seta-mer(u)t* "hauling the *meret* chests" is sometimes actually replaced by the statement *seta ta-meri* "leading Egypt." The four chests, four feathers, and four colored linens clearly relate to the four cardinal points (see Numbers), and the bands which encircle the chests seem to symbolize the binding together of the Two Lands of Egypt as we see in statements such as: "Take Egypt which is unified, you have made the Two Lands into one whole."

Two levels or aspects of symbolism clearly apply to this rite then, that which pertains to the god Osiris and that which pertains to the monarchial binding of Egypt. The two ideas are not necessarily exclusive. Rather, they represent two aspects of the same mythic reality. The king not only functions implicitly as Horus, the son of Osiris, in rites such as this, thus binding the land as Horus did when he succeeded his father; but Osiris himself may be seen to symbolize Egypt. Mythologically, the parts of the god's body which were scattered through the land are brought back and bound together (a point alluded to in texts accompanying some depictions of the rite). The ritual thus symbolically expresses the political integration of Egypt by means of the Osiris myth.

Maintenance of Order

The Egyptian king not only represented humanity to the gods, but he also represented the gods to humanity. This other side of the king's symbolic role is reflected in a number of literary and representational motifs involving the use of his supernatural powers in the protection of the land and the preservation of *maat*. This aspect of the king's function has been aptly called "the containment of unrule"[7] and appears from the beginning of the dynastic period. It is present in the head-smiting scene on the Narmer Palette in which the king executes a captive enemy – who, though he probably represents an actual foe, is nevertheless symbolic of a much more basic threat to the cosmic

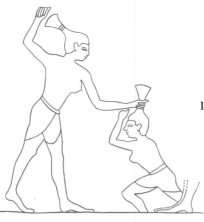

130 *Dancers with hair dressed to imitate the White Crown mime the royal smiting motif, detail from the Middle Kingdom tomb of Khnumhotep, Beni Hasan.*

order itself. Countless other expressions of this same motif were produced through thousands of years of Egyptian history (ill. 139).

There is certainly evidence that the action depicted in these representations was based upon real executions in the earliest stages of Egyptian history, and it has recently been suggested that this ceremonial slaying of enemies may have continued through New Kingdom times, although this suggestion has not met with general acceptance.[8] The evidence seems to confirm ceremonial execution of prisoners by the Fifth Dynasty King Sahure (2458–2446 BC) who was depicted smiting a Libyan chief in a scene copied exactly by Pepi I (2289–2255 BC) and Pepi II (2446–2152 BC) in the Sixth Dynasty, and over fifteen hundred years later by Pharaoh Taharqa (690–664 BC) in the Twenty-fifth Dynasty. But the fact that even the names of the individuals shown in Sahure's representation were copied over in these later examples would indicate that these depictions were substitutes for real actions no longer practiced, and that the action was simply being depicted again as a reaffirmation of its symbolic significance. In the New Kingdom the motif of the king shooting at enemies from his chariot in the course of battle became, like the head-smiting scene, an action with parallel if not identical significance.[9]

But the subjugation of human foes was not the only way in which the containment of unrule was expressed. One of the most important motifs in this regard is that of the capture or destruction of animals which were considered hostile and which therefore served as an allegory of the establishment of rule over disorder. Of the various animals which represented untamed life-force – and thus chaos – the hippopotamus was probably pre-eminent, and representations of royal hippopotamus hunts are found from very early times, down through the latest periods of pharaonic history.[10] The most ancient depictions extant may actually be those on cylinder seal impressions

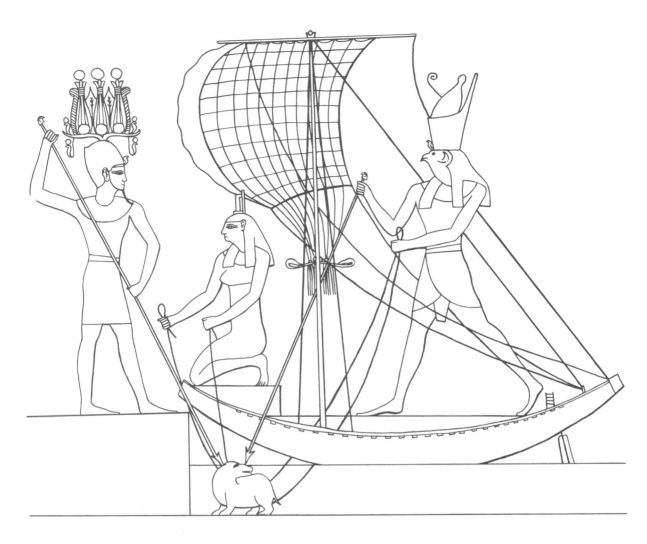

131
*The king destroys the
Sethian hippopotamus.
Reconstructed relief from
the Temple of Edfu.*

of the First Dynasty, but the motif clearly appears in reliefs from the funerary temples of Sahure and Pepi II, and in these Old Kingdom examples the hunt appears to be conducted as an established rite, which it may already have been for some time. At first, the hunt may have symbolized the containment of unrule in only general terms, but as time progressed the hippopotamus hunt took on specific Osirian overtones with the animal representing that archenemy of order, the god Seth, and the king representing Horus the avenger of his father Osiris. In its late form, as depicted on the walls of the Temple of Horus at Edfu (ill. 131), the mythically interpreted action of harpooning the hippopotamus was ritually acted out annually in the "Festival of Victory" performed at that temple. A cake in the form of

a hippopotamus was also cut up symbolizing the ultimate destruction of Seth: "Bring in the hippopotamus in the form of a cake into the presence of Him-with-the-Upraised-Arm . . . Be thou annihilated, O Seth, be thou annihilated! . . . This is Horus the protector of his father, Osiris, who prevails over the hippopotamus."[11]

The two statues found in the tomb of Tutankhamun which show the king holding a harpoon in his upraised hand, while standing in a small papyrus skiff seem to represent the king performing this same symbolic action (ill. 140). Because Egyptian sculpture in the round rarely portrays a king performing an action, however, it can only be the importance of this ritual which caused the normal convention to be transcended in the production of these works. The hippopotamus itself was probably not depicted with the harpooning figures of the king, lest the creature magically become a danger in the royal tomb.

The motif of hunting wild birds in the marshes – usually with a boomerang or throwing stick – is perhaps symbolically parallel to the hippopotamus hunting scenes just considered, though the action of bird hunting may involve other connotations as we shall see. Interestingly, although the duck hunting scene is one of the most popular motifs in Egyptian private tombs of the New Kingdom, it almost never occurs in royal tombs, perhaps for symbolic reasons or simply because it was used in those of commoners. The one exception is in the tomb of King Ay in the Western Valley of the Kings, but Ay was a commoner for most of his life and it may be that the choice of the motif in this king's tomb was based on his personal background. More directly associated with royal involvement is the action of netting wild fowl in clap nets – an activity depicted in several temples – which shows the king using such a net with the aid of various gods (ill. 141). At Edfu the symbolic meaning of this action is made clear because in the representation on the walls of that temple the net contains not only trapped birds but also the symbolic figures of bound human captives. The containment of unrule may be expressed in several ways, therefore, with matters of context and decorum doubtless playing important roles in the choice of the motif's specific expression.[12]

Ritual and Non-ritual Symbolic Actions

Just as a distinction was made at the beginning of this chapter between real, mythical, and what we have called iconographic actions, so another distinction must be made between ritual actions and non-ritual actions which are conducted with symbolic intent or meaning. In other words, although all ritual actions are symbolic,

some actions which take place in everyday life, outside of the context of formal ritual, may also take on symbolic meaning. While of the two, ritual actions are by far the most common in Egyptian art, both types of activity must be considered in order to fully understand the symbolism of action.

The importance of ritual cannot be overestimated, for from an anthropological perspective most religions consist of myth, supported by ritual, aimed at what has been called "transformation of state" – the manipulation of reality for human benefit, such as the curbing of evil or malevolent forces and the elicitation of positive forces and material blessings.[13] This definition could hardly be truer of ancient Egyptian religion which made use of myth and ritual – through symbol and magic – in exactly those ways. While Egyptian myths provided a descriptive model of how the creation of the world had come about and a pattern of how it should continue if all went properly, rituals were equally important in providing an affirmation of what was believed and a magical means of effecting the required "transformation of state." If myths portrayed the underlying nature of reality, ritual actions preserved and maintained that same underlying reality.[14] Many of the actions discussed above clearly fall into this category, but we shall consider a separate example – the ritual or complex of rituals called by the Egyptians the "opening of the mouth" – in order to more clearly define the type of symbolism inherent in ritual actions.

The "opening of the mouth" seems to have been performed on statues of gods (and probably those of kings also) from a relatively early time, and in the New Kingdom and later periods the rite was also applied to other statues, the mummy of the deceased (now also non-royals) before burial (ill. 142), and to various images intended for the purposes of healing or protection including the heart scarab placed upon the mummy. The central concept behind the rite seems to have been the same in all forms of its expression: to symbolically and magically animate the statue, image, or mummy (in the latter case perhaps to restore the *ka* to its body) and in all cases to allow the object to function as a living being or entity.

Variations could exist in the performance of the ceremony in different circumstances, but the major aspects of the rite are clearly seen in its application to a royal statue. First, the statue was placed, facing south, upon a mound or bed of clean sand – signifying a pure environment, but also symbolizing the primeval mound of creation[15] – and given a preliminary censing. Incense seems to have been offered to the statue at various times throughout the rite (see Materials). Next the statue was sprinkled with water from two sets of

vessels – each a set of four vessels representing the gods of the cardinal points. The statue was then presented with ten balls or pellets of natron, a naturally occurring salt, and five pellets of incense for the purification of its mouth. Following this a number of animals were sacrificed before the image. The formula calls for two oxen, two gazelles, and a duck or goose. The foreleg and heart of one of the oxen were presented directly to the image – apparently signifying the power and life of the sacrificed animal.

When these preparatory stages were complete the mouth of the statue was touched with various implements such as an adze and a chisel, clearly depicting the figurative "opening of the mouth." These implements were made with tips of either flint or iron – both substances being symbolic (see Materials) – and were supposed to open the eyes and ears of the statue as well as its mouth, and thus confer upon it the full faculties of a living being. The mouth of the statue was also smeared with milk, just as a newborn child would first receive this substance – though the actual symbolic meaning of this part of the ceremony may have held some other significance. Finally, the statue was clothed, anointed, and ornamented with items of jewelry and given various insignia of office or of royalty in the case of the statue of a king. A meal might then be offered to the statue and it would be considered completed not only as an image, but also as an animated entity invested with a life of its own or identified with the god who took life within it.

In this rather detailed description we see that a ritual may sometimes be performed only once and certainly does not necessitate repeated actions or activities. Central to the ritual activity, however, is the element of control, for virtually every circumstance of ritual actions is carefully dictated – the materials used, as well as the time, place, and manner in which the action is carried out are all prescribed, with each detail of a set sequence having its own symbolic significance. Although variations of the ritual may exist, each follows its own sequence of specific actions without departing from that sequence in any way.

By contrast, non-ritual actions do not consist of a set sequence of events. They may occur spontaneously and, theoretically at least, at any time. It is purely the symbolism of the action itself which is significant, and this is not dependent upon prescribed formulae for its effectiveness. Thus, as viewed by a number of scholars such as Wolfhart Westendorf and Philippe Derchain, representations of certain actions found in everyday life are coded through the use of subtle clues to indicate the presence of an underlying symbolic motif.[16] A number of examples may be found on the small gilded

shrine of Tutankhamun, the decorated panels of which show the king and his young wife Ankhesenamun engaged in a variety of activities. Ankhesenamun wears the headdress of Hathor and offers both Hathorian symbols such as the *menat* and *sistrum* to her husband as well as lotus flowers and mandrake fruit – all of which have quite definite sexual associations. In two of the scenes in particular, the significance of the king's actions may also reinforce this association. In one of the scenes Tutankhamun shoots with a bow at wild ducks, while in the other, he pours liquid into the queen's hand from a long cylindrical flask while holding lotuses and mandrakes (ill. 143). Because the actions of shooting with a bow and pouring out liquid may both be expressed by use of the same Egyptian word *seti* which was also used with the meaning of sexual ejaculation or impregnation, these actions have been thought to relate to the underlying theme of what seem, for the Egyptians, to have been the inextricable concepts of physical sexuality and the renewal of life.

It should be pointed out that not all Egyptologists agree with this interpretation,[17] though other scenes also lend themselves to such a symbolic understanding. Similar symbolism may be alluded to in private funerary works where the lotus flowers carried by men and women alike could well be symbols of rebirth, and the inedible mandrake fruits which are held or sniffed in these scenes may carry the same connotations on a more direct, physical level. Again, some scholars following Westendorf and Derchain believe that those representations which show the tomb owner hunting wildfowl or spearing fish (or occasionally hippopotami) in the marshes contain a number of symbolic elements relating to sex, fertility, and rebirth. The marsh setting itself is frequently associated with original creation, with verdant plant life and fecundity, and with Hathor, goddess of sexual love. Both the hunting of wild ducks or hippopotami (a symbol of afterlife triumph over chaotic forces) and the capturing of bulti fish (symbolic of the sun and rebirth) may fit into the overall theme of sexuality, birth, and rebirth, as Westendorf has pointed out, for the action of throwing the throwstick (Egyptian *qema* "to throw") forms a visual pun on the word *qema* "to create" or "to beget," just as the word *seti* used for the spearing of fish resembles the word *seti* "to impregnate."[18] In scenes such as these it is noteworthy, in fact, that the man is usually accompanied not only by his wife who is dressed in her wig (often a specific sexual symbol) and best-dress finery, but also by the couple's children who may also function as concrete expressions of the theme of sexual fertility, birth, and by extension rebirth. It is possible of course that these representations depict actual recreational activities without any kind of deeper symbolism,

yet this does not preclude the presence of additional layers of symbolic interpretation, as much of Egyptian art is designed to work on a number of levels, as Gay Robins has recently pointed out.[19]

Another activity with symbolic significance in the funerary sphere is that which depicts the deceased person playing the thirty square board game without an opponent. Recent studies have shown that this solitary game is meant to indicate a playing against the unseen powers of the afterlife and as such the action is a symbol of successful passage into that sphere.[20] Although the motif is primarily found in private funerary contexts of the New Kingdom, it is not without royal parallel and appears in a representation of Nefertari where the queen is shown engaged in this activity in her tomb in the Valley of the Queens.

While other non-ritual activities may be found depicted in funerary and also in domestic contexts, the symbolism of these actions is almost invariably that of sexuality, birth, and afterlife rebirth. Some of these actions come close to or might be classified as gestures, but true gestures represent an important sub-category of symbolic activity which we shall examine in the following chapter.

Real, Mythical, and Iconographic Actions

132 *(Right) King Djoser running the* heb-sed *"race." Step-Pyramid complex, Saqqara, Dynasty 3.*

Many representations which show the Egyptian king engaged in some kind of ritual activity depict real events in which the king actually participated. This scene, for example, shows the king's participation in his *sed* or jubilee festival in which he ran around a prescribed course carrying with him the *imiet-per*, a document which functioned as a title deed to the festival ground and by extension to the whole land of Egypt. The action thus symbolized a reaffirmation and renewal of the king's rule over his realm.

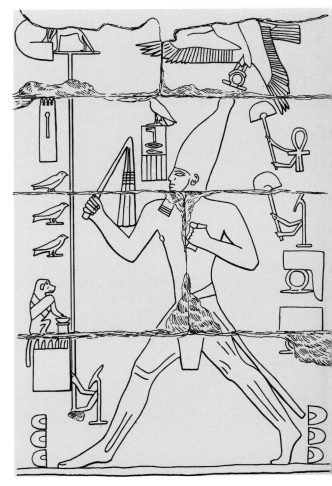

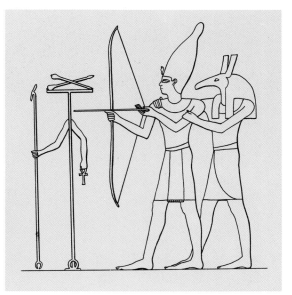

133 *(Left) Thutmose III and the god Seth. Temple of Amun, Karnak, Dynasty 18.*

Other representations show the king involved in mythical activities which may possibly have been acted out in some cases (as in certain temple rituals where costumed priests probably represented the various deities), but which often appear to be purely imaginary. In this instance, the god Seth is shown coaching the king in the use of the bow, and while most monarchs doubtless did receive training in the use of this weapon, the representational presence and direct assistance of the god is metaphorical for the divine guidance and support which the king was believed to enjoy.

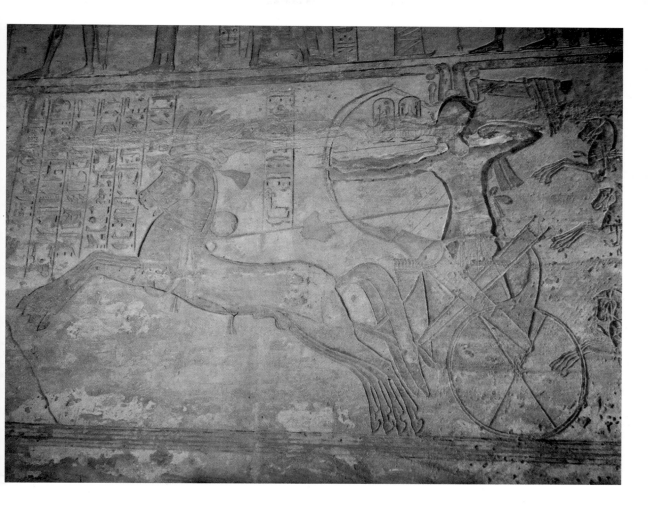

134 *Battle scene of Ramesses II. Great Temple, Abu Simbel, Dynasty 19.*

Sometimes the actions found in Egyptian art are of a realistic nature, but depicted in an exaggerated or unrealistic manner for symbolic or propagandistic purposes. This is seen in the way in which the king is here shown pulling the bow much further back than would be possible. Not only would a real arrow be too short to be pulled to this distance (in other scenes the unrealistic length of the arrow on the bow may be compared with the much shorter ones in the king's chariot quiver), but the bow cannot be aimed properly if fired in such a way, because the rear hand must always be anchored at some point on the face. The reason for this kind of depiction has sometimes been thought to be to avoid covering the king's face with the bowstring, but the ancient artists simply omitted part of the string when this might have occurred in their representations, and the overdraw is often far greater than necessary just to clear the archer's face. It is more likely that the exaggerated action is a "heroic overdraw" aimed at attributing superhuman strength and skill to the king. Another aspect of this same kind of unrealistic action is shown in the way the horse's reins are tied around the king's waist – it would be impossible to steer the chariot in this manner and the reins were in fact held by a chariot driver.

The Symbolism of Actions 185

The Service of the Gods

135 *(Left) The "stretching of the cord" ceremony. Temple of Amun and Re-Horakhty, Amada, Nubia, Dynasty 18.*

The king's involvement in the service of the gods began with the very foundation of a new temple. The king himself initiated new construction or the expansion of existing temples in the "stretching of the cord" ceremony whereby the site was oriented and the boundaries of the structure delineated. This representation shows the king accomplishing this action – the ceremonial equivalent of "groundbreaking" – mythically, with the help of the deity Seshat who was the patron goddess of writing and measurement.

136 *(Above) The king presenting an image of Maat. Temple of Seti I, Abydos, Dynasty 19.*

Of the many offerings which the king and his sacral deputies presented to the gods, some were purely symbolic. The "presentation of Maat" in which the king offered a small figure of the goddess of truth as a symbol of his maintenance of the order established by the gods is a common example. Although the king actually presented a small statuette of the goddess in this ritual, he acted in the role of the god Thoth, husband of Maat, and is shown in the company of the gods themselves, thus placing the action in two spheres – the real and the mythical.

137 *(Left) Hatshepsut presenting* meret-*chests. Decorated block from the Red Chapel, Karnak, Dynasty 18.*

Some of the king's actions related to different symbolic motifs at the same time. In the ritual known as the presentation of the "*meret* chests," four feather-decked and tightly bound containers containing linens of four different colors were brought before a god four times – each fourfold element symbolizing the four cardinal points and the union of the land at the political level. But at the religious level, the action also signified the bringing together of the dismembered and scattered parts of Osiris from the four quarters and the making whole of that god.

138 *Hatshepsut "removing the foot" before Amun. Decorated block from the Red Chapel, Karnak, Dynasty 18.*

The king's care of the god extended not only to the giving of offerings of food, drink, and clothing, as well as many other gifts, but also the protection and care of the god's earthly domain. At the close of the ritual activities performed before the god, the king or officiating priest would back out of the god's presence as he performed the "removing the foot" – sweeping away all footprints from before the shrine and thus restoring it to its original state, and symbolically to the primeval conditions of the original creation.

The Maintenance of Order

139 *The king smiting enemies. Temple of Amun hypostyle hall (north wall), Karnak, Dynasty 19.*

The most common expression of the motif of the king's maintenance of order in his kingdom – and symbolically in the cosmos itself – is the head-smiting scene that is known from the earliest dynasties. In these scenes the king grasps enemy captives (often ethnically differentiated to suggest all of Egypt's foes) by the hair and raises his arm to execute them with a club or mace. Although such executions are known to have actually occurred in the earlier period of Egyptian history and occasionally perhaps at least into the Old Kindom, most Egyptologists believe that later scenes are purely ceremonial – endless symbolic repetitions of an established representational genre deemed just as effective as the actual dispatching of real enemies.

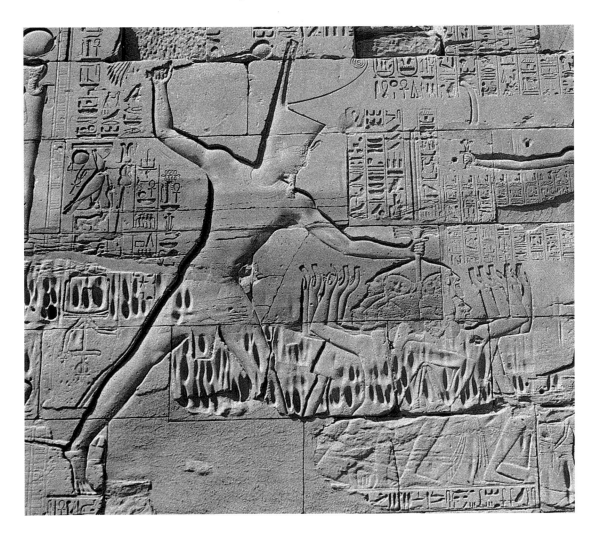

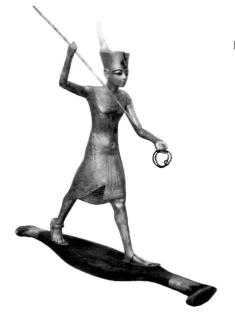

140 *(Left) The king hunting hippopotami. Tomb of Tutankhamun, Valley of the Kings, Thebes, Dynasty 18. Egyptian Museum, Cairo.*

Another example of the maintenance of order is found in the royal hunting of hostile creatures, especially the hippopotamus which was the most dangerous and disruptive creature found in ancient Egypt. Not only are many kings shown harpooning these animals in actual hunting scenes, but the hunt was acted out in an annual temple ritual, and the motif also occurs in symbolic settings such as this where Tutankhamun is shown standing in a light papyrus skiff with raised harpoon ready to strike the unseen creature. The hippopotamus itself was probably not shown in order to avoid its potentially dangerous presence in the king's tomb. Two such models were found in the tomb of Tutankhamun, possibly representing the king and his spirit double or *ka*.

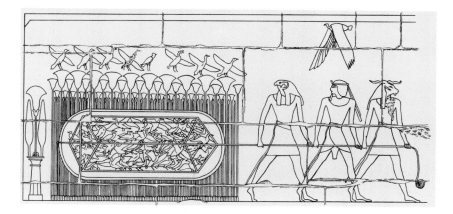

141 *(Above) The king netting wildfowl with the gods. Temple of Khnum hypostyle hall, Esna, Ptolemaic Period.*

A third example of this same motif of the maintenance of cosmic harmony and security occurs in certain scenes which show the king netting wildfowl – symbolic of the hostile spirits of the marshes, and thus of unrule and cosmic disharmony. Although a common motif in private tombs, this activity was not represented in royal burials but does appear in temple decorations where it is clearly symbolic. Not only is the king shown trapping the wildfowl in the company of the gods and thus acting in a mythical context, but also in one scene in the Ptolemaic Temple of Kom Ombo the net encloses the figures of bound human captives as well as animals and birds – showing the ultimately symbolic nature of the activity, the divine containment of disorder and unrule.

Ritual and Non-Ritual Symbolic Actions

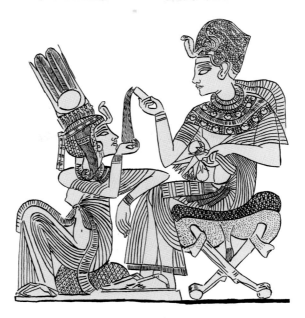

142 (Left) Ritual action: *The opening of the mouth ceremony. Tomb of Tutankhamun, Valley of the Kings, Thebes, Dynasty 18.*

The greater number of formal actions depicted in Egyptian art are of a ritual nature, which is to say that most aspects of the activity – the time, place, and manner in which it was carried out – were all carefully prescribed with each detail usually having specific symbolic significance. This may be seen in the opening of the mouth ceremony illustrated here which was part of a complex set of rituals aimed at magically bringing to life a non-living object such as a statue or image of a god or human, or restoring life to the mummy of the deceased.

The ritual was carried out at a certain time of day, in a specific setting, with detailed instructions being followed for its completion. The symbolic crux of the ceremony occurred when the mouth, ears, and eyes of the mummy or statue were touched – symbolically opened – with a number of ritual implements including a small adze with a tip of iron or flint (both symbolic materials). At this point the deceased was believed to gain life through identification with the surviving spirit, and the inanimate image was believed to receive the immanence of the god.

143 (Above) Non-ritual action: *The king pouring liquid into his wife's hand (small golden shrine of Tutankhamun). Valley of the Kings, Dynasty 18. Egyptian Museum, Cairo.*

Among the many symbolic action themes found in Egyptian art, some are of a non-ritual nature and may relate discretely to physical sexuality which was viewed as symbolic of birth and hence the rebirth of the afterlife. Although these themes are most commonly found in private tomb paintings of the New Kingdom, they also appear occasionally in the royal art of the Amarna Period and its immediate aftermath, when Egyptian kings were frequently represented in domestic settings with members of their families. Such is this scene from the funerary treasures of Tutankhamun depicting the king holding lotus blossoms and mandrakes which have been interpreted as symbols of sexuality, pouring liquid from a small cylindrical flask into his wife's cupped hand. Because the action of pouring was expressed by the same word used for sexual ejaculation, this action may be a subtly encoded conceit whereby sexual union is suggested as a symbolic metaphor for afterlife regeneration. A number of other actions such as shooting a bow, which is also represented on this shrine, were described by the same word as pouring and could have carried the same connotation.

The Symbolism of Actions 191

THE LANGUAGE OF THE BODY
the symbolism of
GESTURES

"My hands do 'come to me, come to me.' My body says,
my lips repeat."
Stela of Wahankh Intef II from Thebes

THE SYMBOLIC use of gestures is among the most fascinating and important aspects of the symbolism inherent in ancient Egyptian art. But it is also one of the most complex aspects and one which requires careful study. While the line between representations of symbolic *actions* – as discussed in the previous chapter – and symbolic *gestures* may seem at first to be a thin one, we can define gestures as specifically prescribed individual movements, stances, or poses which may be used as part of a larger activity or which may function independently.

To some extent, most human cultures make use of specific stances and gestures in the course of everyday life and even in quite formal contexts in order to express relationships or to communicate ideas, opinions, or emotions. Gestures may accompany, add to, or even replace the spoken word in many settings. This can be seen in almost any part of the modern world in activities which range from formal bowing, waving, and shaking hands to the sometimes comical yet effective gesturing which is the last resort of those who must communicate but do not speak the same language. But not all cultures purposely employ these gestures in their artistic representations, whereas Egyptian artists can be seen to have incorporated gesture symbolism into their compositions in a conscious manner from very early times.[1] In fact, a large part of formal Egyptian art was built up around this kind of representation, and a specific vocabulary of stances and gestures was utilized throughout the greater part of pharaonic history – to the degree that many of the most important motifs of Egyptian art may actually be classified by the gestures they depict.

Types of Gestures

When Egyptian art is analyzed from this perspective, certain types and groupings of gestures make themselves clear. One distinction which must be made from the outset is between what we might call *independent* and *sequential* gestures. A gesture which may be performed without reference to other gestures or actions before or after it may be termed as independent, and many of the figural "poses" seen in Egyptian art reflect this kind of gesture. For example, the crossed arms of many mummies and statues represent a gesture of this kind (ill. 146) – a specific pose or posture struck in order to convey a symbolic statement (usually regarding the association of the figure with the god Osiris) which is complete and independent of itself.

On the other hand, sequential gestures exist only as part of a larger complex of actions, gestures, or activities. The so-called *henu* gesture, for example, which was part of a ritual of praise known as the "Recitation of the Glorifications," is often shown in funerary settings from Old Kingdom times (ill. 147). Yet an examination of the extant representations shows that the usual depiction of this gesture is simply one part – perhaps the high point, or most characteristic part – of a complex series of movements and gestures.[2] The fact that the particular pose or stance normally depicted in representations of the *henu* ritual could be visually isolated and used to signify the whole sequence of activity illustrates precisely what is meant by a sequential gesture. Scenes such as those in the Eighteenth Dynasty tomb of Kheruef at Thebes showing dancers in various stages of movement provide another clear example of sequential gestures.

Gestures of either type might involve various kinds of specific movement, including the positioning or movement of the whole body, though usually only the head, arms, or hands are involved. As the *henu* ritual demonstrates, representations of gestures are typically "frozen" at their most characteristic point for the sake of recognition, and this too is true of both independent and sequential types. So Egyptian artists will usually depict a given gesture at the same point, rather than at any point or moment of its performance, though sometimes variants may be shown. Unfortunately, we do not always have enough evidence to clarify whether certain gestures stood alone or whether they were part of a sequential series and therefore directly linked to what appear to be different gestures. Thus when two or more gesturing figures are shown, it is not always possible to tell if the figures depict parallel or consecutive actions – that is, different gestures which *seem* to have a similar meaning, or simply parts of a series.

The "composite perspective," or "*aspektive*," nature of Egyptian two-dimensional representation also makes it difficult to reconstruct certain gestures and to know, for example, whether the left or right arm is being used or even if the arms are intended to be understood as being to the front or side of the individual performing the gesture.[3] These factors sometimes make the recovery of gesture patterns – and their interpretation – a difficult matter, but in many cases two- and three-dimensional representations and textual evidence can be compared and we can arrive at an understanding of how a gesture was delivered and what it meant.

When all of these factors are taken into account, a great many different gestures can be isolated, but the most important and frequently encountered fall into a limited number of distinct categories:[4] gestures of dominance, submission, protection, praise, invocation, offering, mourning, and rejoicing.

Dominance Although seldom seen in everyday life, gestures of dominance are encountered in formal scenes depicting the victory of kings or gods over enemies. The smiting scene discussed in the previous chapter which was doubtless originally based on the actual execution of prisoners seems to have come to be a purely representational device in which the king's raised mace became a gesture signifying the concept of the destruction of foes. Depictions of the king standing with his foot on the necks or backs of enemies represent a parallel gesture, as do examples of the "turned bow" which will be considered in detail below.

Submission These gestures include the basic bowing gesture of respect whereby an individual would often touch one or both hands to the knees and/or grasp one or both arms or shoulders with the opposite hands. These gestures might also be intensified by complete prostration. A different gesture of submission, often found in New Kingdom battle scenes where routed enemies are shown, involves the stretching out of an arm before the face, as though the defeated figures attempted to protect themselves from their victors or to plead for mercy.

Protection From Old Kingdom times a specifically protective gesture is found in representations showing figures extending one or two outstretched fingers toward dangerous creatures such as the hippopotamus or the crocodile (ill. 144). Amulets consisting of two fingers carved from stone, or made from some other material, carried the same apotropaic function as this gesture.

Praise The basic attitude of praise or supplication which is frequently seen in representations of Egyptians before their king or before the gods involves the holding up of one or both arms to about shoulder

144
Extending the finger in a gesture of protection from the crocodile which lurks below. Mastaba of Ptahhotep, Saqqara.

level with the palm facing outward toward the object of praise and the thumb shown below the hand (ill. 145). The kneeling form of the same gesture simply implies an intensification of the gesture's meaning.

Invocation The commonly depicted "invocation" or summoning gesture whereby a figure reaches out and beckons toward himself with one arm was used by the king to summon those before him, and by offerers who stood before offering tables as they called upon a god or the spirit of a deceased person to come forth to accept their offering with the words *(iw) en.i (iw) en.i* "(come) to me, (come) to me" (see opening quotation to this chapter). Thus, an inscription on the Late Period statue of Nebnetcheru in the Cairo Museum states "May the arm be bent at your tomb." Usually representations depict the arm stretched out somewhat further than in the gesture of praise with the hand held vertically so that the thumb is seen on top.

Offering The active, formal presentation of an object is usually signified by the object's being held on the outstretched, cupped hand – a gesture distinct from the last pose. The Egyptian term for generosity was *awet-a* "extension of the hand," and although any such pose would be understandable in most settings, representationally the gesture of "giving" is somewhat stylized and usually only appears in formal contexts.

Mourning The classic gesture of mourning most frequently seen in Egyptian art is one in which one or both arms are raised before the head as though to cover the face, or are placed above or on top of the head. Other very different gestures appear in the same context, however, as will be seen when these are discussed in detail.

Rejoicing In this gesture both hands, or sometimes only one, are held palm outward above shoulder level. The pose appears in various scenes of rejoicing such as the receipt of royal rewards or the celebration of victories.

We shall examine examples from most of these categories in actual contexts, for our analysis must include the examination of a number of specific gestures which have very different meanings while appearing virtually identical, and others which convey the same essential meanings although they are clearly different in appearance.

Similar Gestures with Different Meanings

Although some poses are represented more commonly in certain periods and changes may have occurred through time in the performance of some gestures, there is a remarkable consistency and continuation in the use and meaning of Egyptian gestures. This is true

to the extent that in some cases what appear at first sight to be identical gestures can be differentiated based upon relatively small differences in the way the hand or even the individual fingers are held. This was already noted in the difference between the invocation gesture where the hand is outstretched vertically with the thumb at the top, as opposed to the gesture of praise where the hand faces forward with the thumb at the side (usually appearing below the fingers). Other examples include the two outstretched fingers of the protective gesture, as against the anointing pose where a king or priest holds out his hand with only one finger extended – usually the smallest – which has been dipped in oil and is used to touch the statue or image being anointed. Clearly different contexts are involved in these examples, but other gestures are not so easily differentiated when representations stand alone with no distinctive context or in situations where a gesture may be susceptible to several different meanings.

Both of these situations may be seen in various types of the raised-arm gesture in which a divine or human figure raises one or both arms with the empty hand extended, palm forward. Under different circumstances, this pose may signify salutation, praise, adoration, entreaty, blessing, assistance, protection, surrender, rejoicing, resistance, or the giving of a signal or command.[5] Closer examination reveals slight differences in some of these poses or the contexts in which they appear, however, and these are the subtle clues for which we must hunt in attempting to define and understand such gestures.

One meaning of the raised-arm gesture may be seen in a group of related sculptural and two-dimensional representations showing figures in which the raised arm is held to the side of the body rather than to the front, and which exhibit the gesture at all times, even when they are the only figure represented. This last aspect is crucial, for it indicates that the gesture signifies something about the nature of the figure itself rather than merely a transitory action. A large number of such raised-arm figures were produced in the ancient Near East where we find that several deities and demigods or demons were represented in this way. Comparative study indicates that the raised arm in most of these figures is an apotropaic and protective device whereby the god's power is shown as manifest in the gesture itself, as though the deity were threatening to smite an enemy with its hand and thus holding that enemy at bay.

In Egypt, this same gesture is seen in representations of the god Min[6] as well as related deities such as Horus-Min and Min-Amun. It may also be found in certain representations of the god Bes and other apotropaic figures such as the leonine figure with upraised right

"arm" from the tomb of Tutankhamun (ill. 148), the protective nature of which is made clear by the large *sa* symbol of protection held beneath the beast's other paw. Details such as this reinforce our understanding of the apotropaic or protective nature of many raised-arm figures of this group, but the identification often rests largely on matters of context or, to be more precise, the lack of context in which these figures may display their raised-arm gesture.

Alternatively, a different group of raised-arm gestures may be found in representations where gods or humans raise their arms directly before other figures in clear and consistent contexts. A specific example can be found in the many representations of Isis, Nephthys, Horus, or Anubis standing before or behind the figure of the god Osiris with one or both arms raised so that the hand – palm outward – is directed toward the god (ill. 150). Whether the minor deities actually touch him or simply raise their arms in the presence of Osiris, this pose is often presumed to be a gesture of support for the mummiform god. It is more than probable, however, that two or perhaps even three separate gestures are actually involved in these scenes.

Those representations which show a figure actually touching Osiris with both hands do seem to indicate support, as is occasionally explained in associated texts and inscriptions. In these instances, however, both hands are usually depicted as being placed on the god, one hand on the shoulder, the other on the lower torso or arm. But in examples where one hand is placed on the figure of Osiris in support and the other is raised behind the god but not touching him, it would seem preferable to view the gesture as a combination of support and protection rather than purely one of support – as combinations of gestures are known for other gesture patterns, as we shall see. In other examples that appear at first to be similar but where neither hand actually touches the god, it would seem that support cannot be indicated. In these instances, the gesture is probably rather one of protection when the figure is in close proximity to the god – and especially behind him – and perhaps one of salutation or praise when the minor figures are further away. Protection is often directly implied in cases of close proximity – as when the god Amun announces "I placed your sisters behind you as guard,"[7] or indirectly with the *sa ha.ef* or "protection behind him" formula (see Location) – whereas human figures or deities at a distance and even separated from the god by others can hardly be protecting him and must therefore be offering gestures of salutation or praise. Praise before a deity is, in fact, routinely given with one or two hands in exactly this manner.

Many ostensibly similar poses or stances must be recognized, then, to represent very different gestures. These must be identified and understood according to the specific form of the pose itself as well as according to context, including the identity of the person performing a given gesture and the information given in associated inscriptions and texts. The interdependence of representations and texts works both ways. The specific gesture implied in an inscription such as that which records the words of the god Amun to Thutmose III, "The arms of my majesty are raised to repulse the enemy. I give protection to you my son ..."[8] cannot be determined without representational evidence.

Different Gestures with the Same Meaning

Another situation altogether exists with gestures which certainly appear to be disparate in form, yet which occur in the same contexts and must therefore be understood as variants functioning within the same range of symbolic meaning. To begin with, a certain amount of latitude exists in the form of the individual gestures themselves. Although a given gesture must conform to certain parameters in order to be recognized, and there may be key elements of the pose which remain unchanged, many individual gestures may exhibit a range of variants.

At the most basic level a given gesture might be performed standing or kneeling, and in some cases even lying down, and still maintain the same significance. The gestures found within the context of a subordinate appearing before a superior, for example (ill. 151), provide a clear example of this kind of variation in a given gesture type. Servants appearing before their masters, farmers waiting in line to appear before the scribes taking taxation accounts, and other scenes exhibiting the same kind of motif frequently depict the subordinate in a gesture stance of respect in which the figure bows somewhat with one hand touching the knee while grasping one shoulder with the opposite hand. The basic gesture may be seen to be varied, however, where both hands grasp the opposite shoulders, or one hand grasps the shoulder and the other the opposite forearm. In either case, this pose may be effected standing, sitting, or even prostrated upon the ground (often depending upon the proximity of the subordinate and the superior figure, as in the case of the peasant whose "turn" it is to go before the scribes). The degree of difference exhibited by the pose in these examples is not so great as to render it unrecognizable as a variant of the same basic gesture with the same meaning, but in other cases there is an even greater range of variety.

The wide range of gestures found in scenes of mourning for the dead (ills. 152–154) exhibits this variety. The classic gesture of mourning depicted from the earliest times shows the mourner with one or both hands raised before the face – as though covering it while weeping – though examples in some representations could be understood as depicting the mourners striking their heads or even in the act of throwing dust upon themselves as was sometimes done by bereaved individuals. This "standard" mourning pose is exhibited by mourners standing, sitting, or squatting on the ground, clearly with the same significance in each case. Other gestures involve very different poses, however, and are found in representations of actual human mourners and in scenes depicting Isis and Nephthys in their role as the *djerety* or "two kites," the mythical mourners who bewail Osiris and the deceased identified with him.[9] Although some of these scenes may be purely symbolic, the distinctive gestures performed by these goddesses are all found in scenes from actual burials. In both cases, the mourners may have their hands open and spread a little by their sides, crossed above or below the waist, or with one hand grasping the opposite arm anywhere between the wrist and the elbow. Some of these gesture forms seem to have recognizable mythic significance. For example, the pose in which the arms are crossed below waist level may imitate the enfolding of the deceased in the protective wings of the goddess. Other gestures of the same group may have similar mythic significance, but while the origin and significance of these different gestures is not always understood, they do all somehow relate to the concept of mourning, and functionally they must be seen as different poses of the same gesture complex with the same essential meaning.

This aspect of the unity of different gestures may also be seen in another aspect of gesture symbolism. It must be remembered that different gestures may be performed by the same figure at the same time – as when a kneeling captive raises one hand in a gesture of entreaty while grasping his knee in submission with the other hand. Similarly, mourners often hold one hand before their face in the classic gesture of mourning while also extending the other hand before them in what may be another gesture. Although two hands are frequently used together, almost all Egyptian hand gestures can in fact be performed with one hand when the other hand is engaged in carrying or holding something. Sometimes, the action of holding an object becomes itself a gesture of giving, as when the king presents an image of the goddess Maat with the words, "I give you Maat with my left hand, my right hand protecting her."[10] This ability to perform a normally two-handed gesture with one hand allows two different

gestures to be used simultaneously, but when two different gestures are used at the same time they necessarily fit into the same overall theme, or into themes which are compatible, such as submission and praise, or praise and rejoicing.

There is a considerable degree of flexibility, then, as to gesture forms which may carry the same symbolic meaning – a principle which must be balanced with that of subtle differences in pose sometimes having major differences in meaning.

The Turned Bow: A Shared Gesture

A final aspect of gesture symbolism to be considered here revolves around the rather fascinating fact that gestures could function as a kind of international language understandable to peoples of different cultures and languages. This is not to imply that a universal language of gestures exists, but rather that certain symbolic poses could spread among a number of cultures connected by trade, diplomacy, or even warfare – as Egypt was with various cultures of the ancient Near East – to the point where the gestures became widely understandable.

One of the more interesting groups of gestures shared by Egypt and her eastern neighbors is a complex of poses and stances involving the use of the bow. Because it was the most powerful weapon of the ancient world, the bow held an important place in the iconography of many ancient cultures, especially in Egypt where it was a symbol of monarchial power, and one which seems to have been used extensively in the vocabulary of dominance gestures, and as we will see, in gestures of submission.[11]

Many ancient Near Eastern representations show the bow being carried by the monarch, grasped with the body of the bow held outward, the bowstring toward the king. But important exceptions to this stance are found in Egyptian, Mesopotamian, and Iranian art, where a number of representations show kings in battle, holding audience, receiving tribute from subject peoples, or standing before servants while holding a bow backwards, with the bowstring outward. The bow is obviously useless when held in this manner, and the pose thus appears to represent a formalized gesture. While this stance has sometimes been thought to signify the accomplishment of hunting feats or military victories, it is found in many other contexts, and a number of years ago, I came to the conclusion that it is more likely that the "turned bow" represents a formal gesture of dominance.[12] Differentiation must be made between instances where the bow is shown carried casually in normal use, and situations where the bow appears to be presented to another person or group in

a formal emblematic gesture. But in all the extant examples of this formal type it may be noted that the bow is positioned with the string held toward the subordinate and away from the dominant subject – whether this is a deity or a king (ill. 155–159); and the pose seems to clearly represent a formal gesture of hierarchial dominance. Such use of the turned bow as a dominance gesture occurs in three contexts: where the bow is held by a deity before a mortal; by a king before a subject (especially a defeated enemy); and, at least in Egypt, by a non-royal person before an enemy or an inferior.

Although the bow was an attribute of a number of deities, it is not always shown in their representations. Indeed for some gods, including Neith, Waset, Astarte, and Reshef, it was a major attribute, but these deities are rarely shown before captives or other subordinate figures. In Egyptian art the turned bow as a dominance gesture is therefore found relatively infrequently in divine contexts (especially as the person usually appearing before a god is the king). Instances do occur, however, and a very clear example is found in a scene of Ptolemy VIII Euergetes II (170–163 BC and 145–116 BC), at Edfu (ill. 155), where the king is shown destroying a foreign enemy before a statue or figure of Horus-Behdet. Here the god lifts a mace in his right hand in the traditional striking pose, while in his left hand he holds a bow with its string toward the abject prisoner. The pose is identical to that found in Near Eastern examples where gods are also shown holding a turned bow before mortals.

The turned bow is more commonly found in Egyptian royal scenes in exactly those contexts where it might be expected – for example, where the king confronts enemies on the battlefield, and in the symbolic slaying of captives.[13] The motif may be seen in the Karnak relief of Ramesses II before prisoners carved on the south wall of the great Pillared Hall of the temple of Amun, and in another Karnak relief of Seti I attacking Libyans (ill. 159) which we shall discuss later. The stance also seems to be found in two specific circumstances in Egyptian representations of non-royal archers. In the first instance, representations of the archers' so-called "war-dance" sometimes show Egyptian soldiers holding their bows reversed – perhaps over the imagined body of an enemy – while striking a characteristic threat or victory pose;[14] and the crouching figure of the archer used as a determinative in the word *mesha* "army" and related words sometimes holds the bow turned as though proffered in this way. However, in no instance do we find an enemy holding a bow turned toward an Egyptian in this manner.

It also seems that the representation of the turned bow may have found a special use in the Egyptian funerary monument where

deceased Egyptian bowmen are frequently shown holding the turned bow toward the offering table and offerers who stand before them. On the First Intermediate Period stela of Nenu, for example, where the deceased is portrayed before his children in this way,[15] the positioning of his arms in holding the bow would seem to indicate a degree of formality which underlies the use of a formal symbolic gesture. Stelae showing a bowman holding the turned bow when he is represented alone on the monument or without other figures implied by an offering table do not seem to occur. Where the bowman is shown alone he seems always to be depicted grasping the bow naturally, as he would for use. In these instances then, the bowman's dominance in his capacity as a revered spirit or as a patriarchal figure in his family may well be what is being expressed.

To these uses of the turned bow as a dominance gesture another category can be added: the use of the turned bow as an expression of surrender by a bowman who holds his own turned bow above himself, thus symbolically placing himself under the victor's dominance.[16] While Egyptian battle scenes such as the Karnak representation of Seti I attacking Hittite chariotry appear at first to show the routed enemy in positions of random confusion, closer inspection reveals a definite pattern. The fleeing enemy figures often implore the king with an upraised arm in a clear gesture of capitulation, while with the other arm they hold their bows directly over their own heads as though deliberately to place themselves under the bowstring. This same posture is mirrored in many other scenes, and its use is clearly significant, for there would certainly be little point in holding up a weapon while surrendering unless the gesture represented in some way the act of surrender itself. The same gesture is clearly seen in a similar relief from the same location in which Seti is shown defeating Libyans (ill. 159). Here, a single large enemy "type" figure is shown holding his bow above himself in an identical pose, and it may be noticed that in this representation the Egyptian king is also shown snaring the enemy figure with his own bow turned in what may be an expression of the basic turned-bow gesture of dominance.

A strong indication that this pose does, in fact, reflect a conscious gesture is seen in those reliefs where it appears in settings not within the actual melee, yet where figures clearly implore the king in surrender. In the Karnak relief of Seti I's attack of Kadesh, the turned bow is held not only over the heads of enemies directly before the king's chariot but is also held in this same manner by the figure upon the walls of the city itself. A final example showing Ramesses II's defeat of a Syrian city from Beit el-Wali (ill. 37) demonstrates this clearly. There, the king is shown grasping an enlarged "type" figure

145
Partially personified serpents giving praise. Talatat block from a Temple of Amenhotep IV (Akhenaten), Thebes.

in the traditional smiting pose, but the enemy – shown above the ramparts of the city which he represents – holds his own broken bow above himself. In this instance the imagery is intensified by the use of the broken weapon, and the fact that it is held aloft shows the gesture to be clearly symbolic. While we would expect that a weapon would be thrown down in any act of capitulation, the only point in holding up the bow in this way would be to show that the defeated person was surrendering.

As might be expected, this motif of an enemy turning his bow over himself in surrender seems to coincide with Egyptian territorial expansion of the New Kingdom, and in Egyptian art the gesture disappears with the eventual fall of Egyptian military ascendancy in the Near East. That this pose entered the international vocabulary of commonly understood gestures – such as holding up one's hands to surrender in the modern world – may be seen in that the gesture is found in a slightly different, though directly parallel Mesopotamian scene on an obelisk of the eleventh century BC now in the British Museum where the god Ashur holds a turned bow over the heads of bound, vanquished enemies as they stand before an Assyrian king.[17]

So Egyptian iconography utilizes the motif of the turned bow in exactly those contexts in which the motif is found as a dominance gesture in the art of several ancient Near Eastern cultures. While deities, kings, and Egyptian archers are represented holding the turned bow toward enemies or inferiors, once the tradition is established, we do not find examples of kings turning the bow before gods, Egyptians before their kings, nor foreigners before Egyptians. Thus, the pattern existing in the instances of the gesture's appearance and non-appearance indicates that the turned bow was used as a potent gesture of dominance and of submission in Egyptian art. The turned bow gesture may even have originated in Egypt, though this is presently beyond proof – we simply do not have enough early examples of the motif to allow us to track its movement successfully from one culture to another – but that it was a diffused and shared gesture seems certain.

In these and the other examples discussed in this chapter we see that far from being merely a minor or abstruse aspect of Egyptian art, gesture symbolism was evidently a very real part of everyday life in ancient Egypt.[18] In Egyptian art it ranks alongside the aspects of form and hieroglyphic symbolism as one of the most important types of symbolic expression – one which played a major role in the communication of specific symbolic concepts, messages, and ideas.

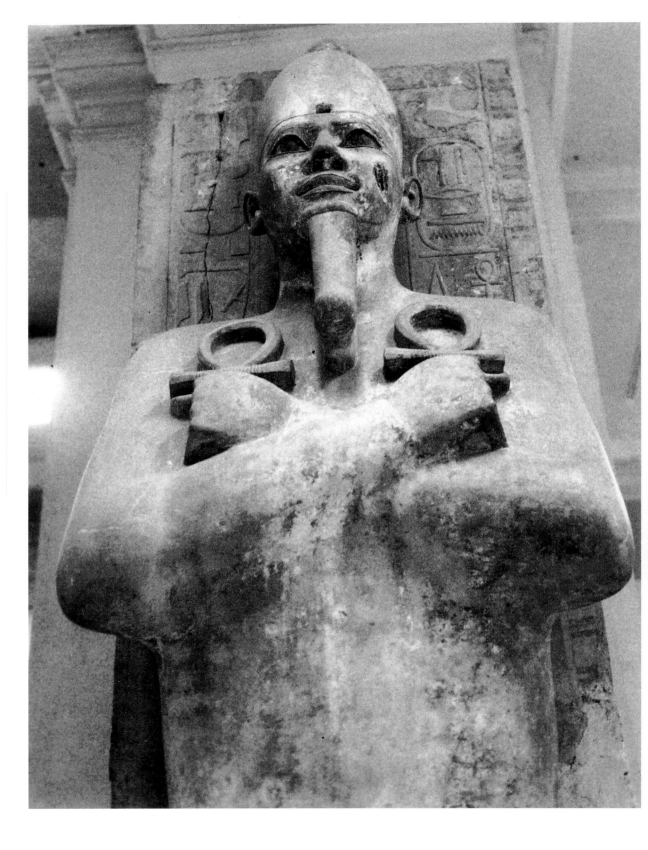

Independent and Sequential Gestures

Symbolic gestures may utilize the positioning or movement of the body, head, arms or hands, and are usually "frozen" at their most characteristic point in representations. Functionally, two types of gestures may be differentiated – "independent" and "sequential."

146 *(Left) Colossal statue of Sesostris I. Dynasty 12. Egyptian Museum, Cairo.*

Independent gestures such as that exhibited by the mummiform statue of Osiris in this illustration exist in isolation and have complete meaning in and of themselves without reference to any other gesture, action, or context. In this case the crossed arms of the king identify him with Osiris, the mummiform king of the netherworld. This Osiride gesture is frequently found in statues of deceased kings and in the poses of royal mummies of pharaohs of the New Kingdom, whereas the arms of mummies of private individuals of this period are usually placed to the side of the body. Mummies of royal women of the New Kingdom often exhibit yet another pose whereby one arm is positioned by the side and the other is folded across the chest – a gesture which may possibly have associated them with the goddess Hathor since female figures connected with this goddess in some way often exhibit this pose. Other independent gestures range from greeting and rejoicing to warding off evil and danger.

147 *(Above right) Ramesses III performing the* henu *ritual. Medinet Habu, Thebes, Dynasty 20.*

Sequential gestures exist where a certain pose or gesture occurs within a sequence of continuous action. An example may be seen in the *henu* gesture of praise frequently found in representations in certain contexts. This gesture usually depicts the king or some other figure crouching on one knee, with one clenched hand held above shoulder level while the other touches or beats the chest. The *henu* ritual, or "recitation of the

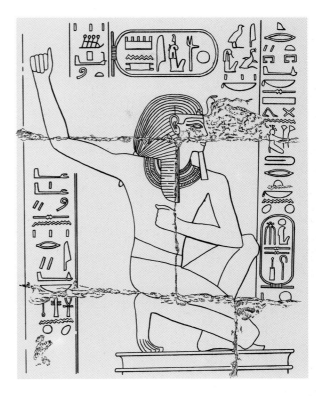

glorifications" as it was called, actually consisted of a complex series of actions and gestures performed in various stances. The specific gesture usually illustrated in Egyptian representations was perhaps chosen because it represented the most important or recognizable part of the *henu* ceremony, but it must be remembered that the gesture can only be understood in terms of the meaning of the larger ritual in which it was embedded. The distinction between the two types of gestures – independent and sequential – must be kept in mind in attempting to understand many of the symbolic poses found in Egyptian art which, although they may seem unrelated, may actually be part of a common gesture "complex." Other sequential gestures may be found in various contexts such as ritual funerary activities and formalized expressions of praise and offering.

The Symbolism of Gestures　205

Similar Gestures with Different Meanings

148 *(Left) Ivory lion figure. Tomb of Tutankhamun, Valley of the Kings, Thebes, Dynasty 18. Egyptian Museum, Cairo.*

A number of quite similar gestures occur in Egyptian art which actually represent different poses with different meanings. The raised arm poses illustrated here provide an example of these similar yet different forms. The ivory lion figure from the treasures of Tutankhamun stands on its rear legs anthropomorphically and raises one "arm" in a clearly symbolic gesture. The apotropaic or protective nature of this pose is heightened and "spelled out" by the hieroglyphic sign for "protection" upon which the lion rests its other paw. The fact that the arm is raised to the side of the body rather than the front, and that the pose is found in figures in isolation are important aspects of this gesture.

149 *(Right) Rejoicing men (relief). Tomb of Khai, Saqqara, Dynasty 18–19. Egyptian Museum, Cairo.*

In the gesture of rejoicing, both hands are usually raised high to the sides of the body. Sometimes one hand may be used to perform this gesture if the other is engaged in holding some object. In this case the gesture appears quite similar to that exhibited by protective deities like the leonine figure in ill. 148. A subtle difference between the two poses may be seen, however, in that in the gesture of rejoicing the palm of the hand is often depicted facing outward, away from the body, rather than to the front as in the apotropaic pose. Unlike the last gesture, this pose is rarely found in isolation and there is usually some aspect of context evident in which the rejoicing takes place.

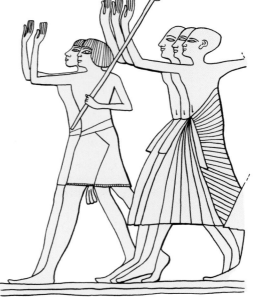

206　*The Language of the Body*

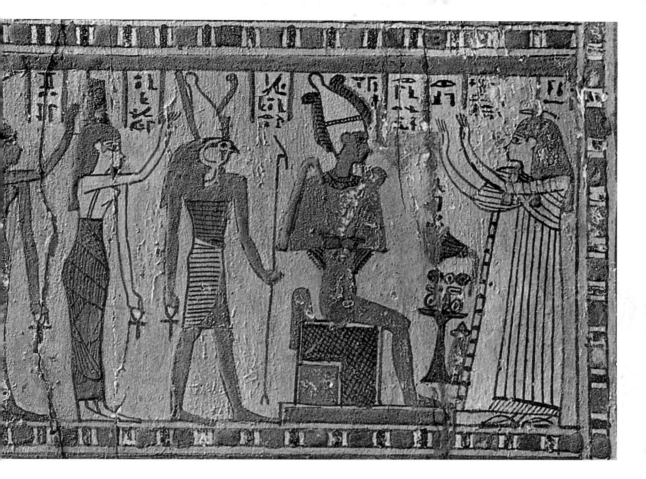

150 *Worshiper before Osiris and attendant deities. Stela of Tsentwot. Ptolemaic Period. Harer Collection, San Bernardino, California.*

The figures of the two goddesses who stand behind the god Osiris in this representation raise their arms in a pose which is somewhat similar to that of ills. 148 and 149. But in this gesture the arm is held to the front rather than to the side of the body. This gesture seems to have denoted support, protection, praise, or salutation depending on the specific context. Here the two goddesses seem to be protecting Osiris while the figure standing before the god raises both hands in praise and worship. Sometimes only inscriptions associated with a given representation can assure us of the exact significance of the gesture, though context will often make this reasonably clear. A human figure raising one or both arms in this pose before a god usually denotes the action of giving praise, while minor deities performing the same gesture with one hand in close proximity to a god are usually protective. If the minor deities are actually touching the god, however, the gesture may be one of support.

Different Gestures with Similar Meanings

151 *Peasants before scribes taking taxation accounts. Tomb of Ti, Saqqara, Dynasty 5.*

Apparently different gestures are sometimes related in that they are actually variants of the same essential pose. For example, peasant farmers appearing before scribes in the accounting of unpaid taxes often exhibit a wide range of variants of the basic gesture of submission and respect. In this pose the figures usually bow somewhat or prostrate themselves, often touching one or both hands to their knees. One or both hands may be used to grasp the opposite shoulder, however (as in this illustration), or one hand may grasp the opposite shoulder while the other grasps the opposite forearm or elbow. These all seem to be variants of the same essential pose of submission and respect.

152–154 *(Opposite) Mourning poses: (152) Tomb of Nebamun and Ipuky, Thebes, Dynasty 18. (153) The goddess Isis as mourner. (154) Tomb of Merymaat, Thebes, Dynasty 18.*

In some cases, truly different gestures may also function within the same range of meaning. It is difficult to know if these are different independent gestures, however, or if they are in fact sequential gestures representing different parts of a complex sequence. Poses exhibited by mourners in funerary contexts provide a good example of a range of different gestures apparently falling within the same general field of meaning.

The basic mourning pose depicts figures standing or kneeling with one or both hands raised before the head as though covering the face in weeping, or with the hand placed on top of the head (152). Other poses also found in the same context include (152) crossing the arms below the waist level with hands open; (153) – perhaps part of the same gesture complex – crossing the arms above the waist level, again with open hands; (154) holding

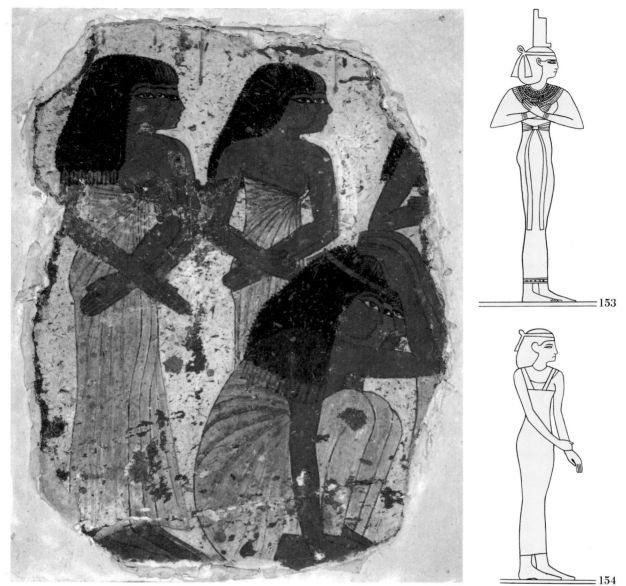

152

153

154

one arm by the side while grasping it with the opposite hand between the elbow and the wrist. These gestures and some others whose meanings are unclear are all found in representations of human mourners and of the goddesses Isis and Nephthys, known as the "two kites," in their association with the funerary rites. Each gesture doubtless had its own particular significance; for example, the crossing of the arms below waist level seen in ill. 152 may symbolically represent the enfolding arms of the goddess protecting the deceased as Osiris. While the significance of other gestures found in the context of mourning are not clear, all the poses seem to function within the same general range of mourning symbolism.

Shared Gestures: the Turned Bow

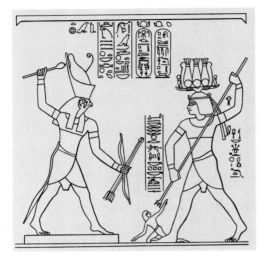

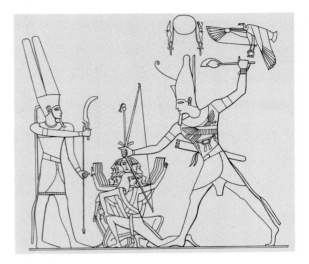

155 *(Above)·Ptolemy VIII Euergetes II destroys a prisoner before the god Horus-Behdet. Edfu, Ptolemaic Period.*

In formal contexts, the dominant individual in Egyptian representations usually holds the bow backwards with the string turned toward subordinate figures, as here, where the god Horus holds the turned bow toward the king and the prisoner before him.

156 *Ramesses II with prisoners of war. From the Temple of Amun, Karnak, Dynasty 19.*

The Egyptian king turns his bow away from himself and toward his captives in the "turned bow" gesture when no god is present. But standing before a god, as in this instance, the king does not turn his bow.

157 *(Left) The Assyrian king Ashurnasirpal II before servants. Nimrud, ninth century BC.*

The turned bow gesture may also be found in Mesopotamian art. The Assyrian king held his bow turned with the string pointing toward servants (as seen here), captives and enemies in the same manner and apparently with the same symbolic meaning of dominance.

158 *(Right) Ashurbanipal II of Assyria before an altar of the god Ashur. Kuyunjik, seventh century BC.*

When the Mesopotamian king stood before an altar or image of a god, however, he held the bow turned with the string toward himself and away from the dominant god in exactly the same manner as is found in Egyptian art.

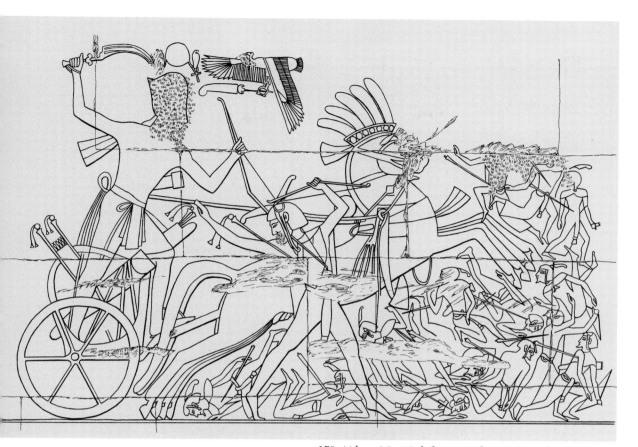

159 *(Above) Seti I defeating Libyans. Temple of Amun, Karnak, Dynasty 19.*

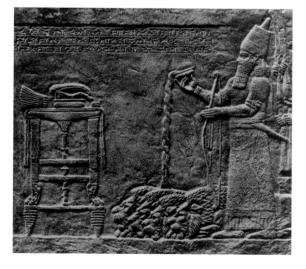

Another aspect of the symbolism of the turned bow is seen in many New Kingdom battle scenes. In these representations, surrendering enemy troops are often shown holding their own bows above their heads as if to place themselves under the turned bow and thus symbolically under the dominance of the conquering Egyptian king. In this instance, the victorious Seti snares a Libyan with his bow turned in the gesture of dominance (there would be no other reason to hold a bow backwards in the midst of pitched battle), while the large enemy figure – who functions as a type of the enemy in general – places himself under his own bow in abject capitulation. Such depictions in Egyptian and Near Eastern art intimate that this gesture of surrender was internationally understandable.

The Symbolism of Gestures 211

Glossary

MAJOR DEITIES

Amun The chief god of the Theban triad (with Mut and Khonsu), Amun rose to pre-eminence in New Kingdom times as something close to a state deity. He is usually shown anthropomorphically, wearing a tall feathered crown, but was also depicted as a ram or a goose.

Anubis An ancient mortuary deity, Anubis is represented as a black dog or jackal-like creature, or as a human with canine head. From New Kingdom times, Anubis is frequently depicted leading the deceased to the afterlife judgment.

Aten The physical disk of the sun appears to have been regarded as a variant form of the sun god in the early New Kingdom, but was briefly elevated during the Amarna period to the status of exclusive god by the heretic pharaoh Akhenaten.

Atum A primeval deity held to be the creator of the world, according to some branches of Egyptian theology. In later periods Atum was depicted as a ram, a ram-headed hawk, or an old, ram-headed man – all of which symbolized the setting sun in its evening manifestation.

Bes Usually portrayed as a dwarf with a large, ferocious-looking head (often crowned by feathers or with a lion-like mane), Bes in his various forms actually functioned as a friendly, protective deity associated with music, the household, and especially with childbirth.

Geb Primeval earth deity, viewed as one of the progenitors of the gods together with his wife Nut, goddess of the heavens. Although Geb was not an important god in the worship of the ancient Egyptians, he frequently appears in Egyptian art, usually in the form of a man with a goose atop his head.

Hathor Ancient mother goddess whose name means "House of Horus," relating to her protective maternal role. Conversely, as the "Eye of Re" she could manifest a violently destructive aspect. Hathor also became associated with the west and was thus an important deity in many scenes relating to the afterlife. Often portrayed as a cow or a cow-headed woman, Hathor merges with Isis in the later periods of Egyptian art.

Horus Originally a falcon god of the sky, Horus became associated with the role of the king early in Egyptian history. Later he was connected with Osiris as the son (by Isis) and avenger of that god, a mythological association which further strengthened his relation to the living king, just as Osiris was associated with the deceased king. Horus is usually depicted as a falcon or falcon-headed man, though in the later periods he may appear as a child.

Isis The wife of Osiris and mother of Horus, Isis is usually depicted as a woman with the hieroglyph for "throne" on her head, though she may appear in other forms and was closely associated with a number of goddesses such as Hathor. In Egyptian art Isis is often depicted mourning her deceased husband Osiris or nursing their son Horus. She is also shown protecting the sun god on his nightly journey through the underworld.

Khepri The name Khepri is related to the Egyptian word for "to come into being," and the god was regarded as the morning manifestation of the sun. Usually depicted as a scarab beetle, Khepri was also sometimes drawn as a human with scarab head.

Maat Goddess of Order, Truth, and Judgment, Maat is almost invariably depicted in Egyptian art as a woman with her symbol – a tall feather – on her head.

Neith A primeval (and sometimes androgynous) goddess worshiped from very early times, Neith became a goddess of war and also a protector of the dead. Along with Isis, Nephthys, and Selket, she is often depicted guarding New Kingdom burial chests, coffins, and sarcophagi.

Nephthys Recognized by a rectangular hieroglyph surmounted by another bowl-shaped sign worn on her head, Nephthys was the sister of Isis. With Isis, Neith, and Selket she protects the body of the deceased; and like Isis, she is also sometimes shown protecting the sun god Re.

Nut Goddess of the heavens, Nut was an ancient deity who daily gave birth to and reabsorbed the sun. She is portrayed as a woman arching over the body of her husband, the earth god Geb, and also on the underside of the lids of many sarcophagi, for she received the dead into herself just as she received the evening sun.

Osiris Supreme netherworld god, Osiris was also closely related to the institution of kingship. As the deity who died only to return to life, he represented not only the cycle of nature, but also all who had died, and especially the deceased king. Osiris is depicted anthropomorphically as a mummiform man with a crown and the crook and

flail of kingship. He was also associated with the *djed* pillar and was frequently shown in that form.

Ptah Worshiped at Memphis as an ancient creator god, Ptah was also the patron deity of craftsmen and in the Late Period became a member of the important composite deity Ptah-Sokar-Osiris. Represented as a mummiform man, Ptah usually holds a composite scepter before him that combines the *was* scepter and the *djed* pillar.

Re As the primary manifestation of the sun god, Re was worshiped at Heliopolis and soon rose to national significance. Thus, from the Fourth Dynasty the Egyptian king was regarded as the manifest son of this god. When Amun became the most important god in the Middle Kingdom, Re was fused with him as the composite Amun-Re. Re was usually depicted as a falcon-headed human, though he may also be represented by the disk of the sun itself.

Re-Horakhty A combined form of the gods Re and Horus of the Horizon worshiped at Heliopolis. This god was usually depicted as a hawk or hawk-headed god with a sun disk upon his head.

Selket Goddess of healing and protection whose symbol was a scorpion. Along with Isis, Nephthys, and Neith, Selket was one of the four goddesses who guarded the four Sons of Horus in funerary mythology and representations.

Seth God of violence and confusion, Seth personified the harsh desert lands as opposed to the fertile valley of the Nile represented by Osiris whom he killed. As the brother of Horus, Seth also represented the domain of Upper Egypt as opposed to the Lower, northern region of the land. The god was depicted in the form of a fabulous creature or as a human with the creature's long, curved head.

Sons of Horus These were four genii or minor deities connected with the cardinal points and which guarded the viscera of the deceased. Originally human-headed, after Dynasty Eighteen they were regularly portrayed with the heads of different creatures: Imsety, human-headed (south); Duamutef, jackal-headed (east); Hapy, ape-headed (north); Qebesenuef, falcon-headed (west).

Thoth God of the moon and of writing, wisdom, and learning, Thoth was depicted as an ibis-headed deity, or in the guise of an ibis or baboon. The god was frequently depicted in scenes showing the afterlife judgment of the deceased where Thoth recorded the verdict before the throne of Osiris.

MISCELLANEOUS TERMS

Afterlife The Egyptian concept of the afterlife was a complex one. While the body remained in its grave, other aspects of the person such as the *ba* moved within the realms of heaven and earth in an afterlife existence. This was not reincarnation, but a concept of the continued afterlife existence of separate aspects of the person.

Amduat See Book of That Which Is in the Underworld.

Amulet Small figures of gods or objects of special significance which were worn as protective charms or placed in the wrappings of the mummy, amulets were made in the hieroglyphic forms of deities, sacred animals, and parts of the human body, as well as religious and magical symbols.

Apotropaic Intended to ward off evil.

Architrave Rectangular stone block placed between the tops of columns and the roof of temples and other buildings. Sometimes, a decorated block above windows or doors.

Ba Usually depicted as a human-headed bird, the *ba* represented one aspect of the human being. It was free to leave the body after death, and to return at will.

Book of Gates Funerary work which appears in royal tombs late in the Eighteenth Dynasty. The name of the composition refers to the twelve gates which divide the hours of the night and which are carefully enumerated in this work.

Book of That Which Is in the Underworld New Kingdom royal funerary work detailing the twelve divisions of the underworld corresponding to the twelve hours of the night. The work's main focus is upon the journey of the sun through these netherworld regions and its resultant rebirth.

Book of the Dead A collection of spells, many derived from the Coffin Texts and Pyramid Texts, which were used by commoners (as well as by some kings) during the New Kingdom. Personally inscribed papyrus rolls contained one of the many versions of this collection of spells with the deceased's name inserted in the text at appropriate points.

Book of the Earth Religious composition originating in Dynasty 20 which describes the sun's nocturnal journey through the underworld.

Books of the Heavens Religious texts composed during the late New Kingdom which describe the sun's passage through the heavens. Three of the

more well-known are the *Book of the Day, Book of the Night*, and the *Book of the Celestial Cow*.

Coffin Texts A collection of magical spells, many of which were descended from the Pyramid Texts and which were inscribed on the coffins of nobles and commoners during the Middle Kingdom Period. These texts formed in turn the basis for many of the spells incorporated in the *Book of the Dead* in the New Kingdom.

Hypostasis The manifestation of a specific aspect or attribute of a deity such as the "soul," "splendor," or "perception" of a god or goddess.

Isocephaly The achievement of equality of size between two or more figures in a composition by adjusting scale or position in order to place the figures' heads at the same level.

Ka One form or aspect of the human "soul," the *ka* was viewed by the Egyptians as a spiritual double which continued to exist after death. Intimately related to the concepts of nourishment and strength, the *ka* received the offerings given to the deceased.

Litany of Re New Kingdom royal funerary composition originating in the Eighteenth Dynasty, *The Litany of the Sun*, as it is sometimes called, acclaims the sun god Re under 75 different forms and also praises the king in the form of different deities and especially as the sun god.

Mastaba A type of tomb common in the Old Kingdom, the mastaba (Arabic for "bench") is a flat, rectangular structure built above the actual burial, and often containing a small offering room or chapel.

Nome Provincial area of Egyptian administration, many of which were established in very early times. The nomes were frequently represented by anthropomorphic figures bearing the standards of their localities on their heads.

Primeval Hill/Mound This was the first earth which rose from the primeval waters at the time of creation and upon which, in turn, life appeared. Central to Egyptian mythological concepts of creation, the primeval hill was reflected in the design of some Egyptian temples and symbolically in funerary depictions of burial mounds.

Pyramid Texts The oldest body of religious writings in the world, these texts were inscribed on the inner passages and chambers of the royal pyramids of the kings of Dynasties 5 and 6, and include even older texts. The purpose of the texts was to ensure the successful passage of the deceased king into the afterlife, a theme which was later continued in the *Coffin Texts* and the *Book of the Dead*.

Sarcophagus Sometimes used synonymously with coffin, though usually in Egyptological literature the term refers to the outermost box (of wood or stone) in which a coffin or coffins were placed.

***Sed*-Festival** From very early times Egyptian kings held a jubilee festival after thirty years of reign. This event was then repeated at shorter intervals (often about every three years) thereafter. The *Sed*-festival involved a ritual recoronation and various other activities aimed at rejuvenating the king and re-establishing his rulership.

Stela An inscribed, upright stone used as a boundary marker, to celebrate victories, to honor gods, and for many other purposes. The most common type, however, was the funerary stela which often depicted the deceased in the presence of one or more deities, and which listed offerings and provisions which would provide sustenance in the afterlife.

Throne Name The chief title given to the Egyptian king at his accession as distinct from his birth name. Modern books usually refer to Egyptian kings by their birth names, for example Tutankhamun. The Egyptians themselves referred to their monarchs by means of the throne name – for Tutankhamum, "Nebkheperure" ("the Lordly manifestation of Re").

Underworld The ancient Egyptians imagined the underworld as an area directly beneath the earth which was in many respects a mirror image of the world of day. The sun entered this netherworld each night and followed a riverine course until it rose from the eastern horizon at dawn. The netherworld was peopled with both the dead and myriad divine beings.

Notes to the Text

Introduction

1 Wallace, 1966, p. 107. Baines, 1980, surveys the use of magic in ancient Egypt; and see Bourghouts, 1978, Ritner, 1993.
2 A number of studies of the underlying nature and psychology of Egyptian symbolism have been produced. A survey of the material and bibliography is given by Westendorf, 1986, c. 122–28.
3 The exclusivity was accomplished for purposes of decorum, social status, or even secrecy for effect – a desire for virtuosity which is paralleled in certain literary works. See Borghouts, 1976, p. 3.
4 Wilkinson, 1992, pp. 9–12.
5 Museum of Fine Arts, Boston, No. 25.659; published with commentary on the non-symbolic aspects by Freed, 1981; and Leprohon, 1985, pp. 112–15.
6 Kemp, 1989, pp. 4–5. An interesting parallel to this situation, brought to my attention by Arielle Kozloff and concerning a modern architectural work, may be seen in Rudolph Arnheim's "The Mind Adds the Meaning" (Arnheim, 1977), pp. 64–66.
7 Griffiths, 1970, p. 63.
8 Pyramid Text 1971. See Faulkner, 1969.
9 Pyramid Text 2042. See Faulkner, 1969.
10 Book of the Dead, chapter 17. See Faulkner, 1990.

Chapter 1 · The Symbolism of FORM

1 *Urkunden* IV, 506, p. 1565.
2 Hollis, 1990, p. 126.
3 See for example Desroches-Noblecourt, 1963, pp. 177, 186; Edwards, 1976, p. 133.
4 See Gamer-Wallert, 1970, pp. 124–31.
5 Reeves, 1990, p. 159. On Egyptian mirrors in general, see Lilyquist, 1979.

6 See for example Pinch, 1943; Montet, 1957; Bleeker, 1973; and for the *khener* dancers, Nord, 1981.
7 Kozloff and Bryan, 1992, pp. 331ff.
8 Kozloff and Bryan, 1992, pp. 336–37. Kozloff also sees a parallel between these aquatic birds and the form of the constellation Cygnus which lies between the two "arms" of the Milky Way at certain times of the year.
9 This meaning may be reflected in the name of the goddess Nut which seems to contain the Egyptian word for waters, *nu*, with the feminine suffix *t* giving a possible meaning of "She of the Waters." See for example Allen, 1988, pp. 4–5.
10 Kozloff and Bryan, 1992, pp. 348–49.
11 A number of writers propose specific species; for example Houlihan, 1986, pp. 122–23, but there is a wide range of variation in the ancient representations suggesting that various species may have been depicted.
12 See for example Carter, 1927, pp. 128–29.
13 I am indebted to Professor Earl Ertman who first drew my attention to this seemingly anomalous representation.
14 Brooklyn Museum, No. 39.119. On the symbolism of this form, Kozloff and Bryan, 1992, p. 130.
15 Pyramid texts 2054. On the symbolism of this phrase, see Griffiths, 1982, c. 623–24.
16 Pyramid Text 959. See Faulkner, 1969.
17 Kozloff and Bryan, 1992, pp. 132–33.
18 See for example Taylor, 1989, pp. 7–11 and Hayes, 1935, *passim*.
19 Stadelmann-Sourouzian, 1984, pp. 267–69; Brock, 1991, p. 32.
20 Excellent recent discussions are found in Reymond, 1969; Baines, 1976, pp. 10–15; and Hornung, 1992, pp. 115–29. On specific aspects of this symbolism, see also Saleh, 1969; and Brunner, 1970.
21 Hornung, 1992, p. 118.
22 Lichtheim, 1976, p. 44.

23 See Graefe, 1983, pp. 55–79
24 Lichtheim, 1976, p. 26.

Chapter 2 · The Symbolism of SIZE

1 Schäfer, 1974, p. 234.
2 Aldred, 1980, p. 204.
3 Simpson, 1982, p. 266.
4 Stela of Amenhotep III, Eyptian Museum, Cairo, No. JE34025; translated by Lichtheim, 1976, p. 45.
5 Simpson, 1982, p. 270.
6 Hornung, 1992, pp. 82–87.
7 Hawass, 1985.
8 Bell, 1985, p. 38.
9 Schaden, 1993.
10 Schäfer, 1974, p. 234.
11 Simpson, 1982, p. 268.
12 Personal communication from Professor Robins, January 1993. See also Robins, 1986, p. 21; and Robins, 1991, *passim*.
13 Wilkinson, 1987, p. 131.
14 Kozloff and Bryan, 1992, pp. 148–49, 461–75.
15 Robins, 1985, p. 102.
16 Museum of Fine Arts, Boston, No. 09.204.
17 Metropolitan Museum of Art, New York, No. 26.3.29; and Egyptian Museum, Cairo, No. JE36195.
18 Johnson, 1990, pp. 34–37.
19 Aldred, 1980, p. 182; and see also 1988, pp. 232–35.
20 See for example Martin, 1987, pp. 71–84.

Chapter 3 · The Symbolism of LOCATION

1 Sarcophagus, Metropolitan Museum of Art, New York, No. 14.7.16; lid, .166.
2 Book of the Dead, chapters 117–19. See Faulkner, 1990.
3 See Needham, 1973.
4 Hymn to Amun-Re: P. Bologna 1094.2 and P. Anastasi II.6. See M. Lichtheim, 1976, p. 111.
5 Fischer, 1984, pp. 187–91; Grieshammer, 1984, c. 191–93.
6 Žaba, 1953. Some scholars see very specific astronomical alignments in a number of Egyptian temples; see for example Wells, 1985.

7 This may be indicated by inscriptions appearing on certain statues; see for example Kozloff and Bryan, 1992, p. 151, n. 37.
8 So for example Martin, 1989 (commentary on scene 64); though contra Martin, see the review by Charles C. Van Siclen III, *VA* 6:3 (1990), 196.
9 Brunner, 1970.
10 Personal communication from Professor Ertman, August, 1992.
11 Baines, 1976, and 1985, *passim*. See also Winter, 1968.
12 Bell, 1983; 1986.
13 See, for example, Wilkinson 1993. A number of Eighteenth Dynasty private burials position representations of the deceased so as to adore the rising sun, and these tombs also exhibit absolute positioning of certain scenes. See for example Manniche, 1987, pp. 29ff.
14 Hornung, 1990, p. 94.
15 The protective and directional aspects of these deities also extended beyond the funerary context as may be seen in a representation of a temple *per ankh* or "house of life" (see Chapter 6, ill. 94) which shows four entrances oriented toward the four cardinal points and the names of Isis, Nephthys, Horus, and Thoth at the four corners.
16 This plan is not invariable, however. In the Theban tomb of Ay (WV-23), for example, the four sons of Horus appear seated together in one corner of the burial chamber, with the northern pair wearing the Red Crown and the southern pair wearing the White Crown.

Chapter 4 · The Symbolism of MATERIALS

1 For previous studies in this area, see Barta, 1980, and Raven, 1988.
2 The shining appearance which associated precious metals with the celestial bodies was a quality which may well have been seen as symbolic in other areas such as the high polish given to some stone statues and the varnish given

wooden objects. Raven, 1988, p. 238 has pointed out that this may also apply to faience, for which a form of the Egyptian term *tchehen* "dazzling," an epithet of the sun god, was used.
3 Raven, 1988, p. 241.
4 Van Rinsveld, 1993, p. 17.
5 For example, Petrie, 1914, pp. 25–26 and *passim*.
6 Lucas, 1962, pp. 155ff.
7 Ogdon, 1990, pp. 17–22.
8 Martin, 1986, pp. 873–75.
9 Hoffmeier, 1985, p. 223.
10 Lucas, 1962, pp. 429ff.
11 Book of the Dead, Chapter 109. See Faulkner, 1990.
12 Buhl, 1947, pp. 80–97.
13 Raven, 1988, p. 239.
14 Bourriau, 1984, pp. 362–66.
15 Frankfort, 1978, p. 132.
16 Hoffmeier, 1985, p. 170; Blackman, 1912, pp. 69–75.
17 Raven, 1988, pp. 239–40.
18 Parker, 1979, pp. 61–64.
19 Raven, 1988, p. 241; Manniche, 1982, p. 10.
20 Gessler-Lohr, 1983.

Chapter 5 · The Symbolism of COLOR

1 Erman and Grapow, 1926, p. 52; and see for example Kischkewitz, 1972, p. 21.
2 Kozloff and Bryan, 1992, p. 268.
3 Lucas, 1962, pp. 338–53; and Iversen, 1955.
4 Brunner-Traut, 1977a, c. 117–28; Kees, 1943; and Morenz, 1962, *passim*.
5 Ceccaldi, 1985, p. 254 – though the results of this study are not unambiguous. I am indebted to Dr Rita Freed for this reference.
6 Kees, 1943, pp. 431–34; Bianchi, 1989/90, p. 17.
7 Bell, 1985a, p. 41.
8 Pyramid Text, spell 567. See Faulkner, 1969.
9 Instructions of Merikare, line 64.
10 For the negative associations of black with death, see Hornung, 1992, p. 30. For the positive, regenerative aspects of the color, see Kozloff and Bryan, 1992, p. 142.
11 See Staehelin, 1990.

12 Hornung, 1990, p. 42.
13 Westendorf, 1986, c. 125.
14 Manniche, 1982, pp. 6, 11; Reeves, 1990, p. 154.
15 Hornung, 1990, p. 42.
16 British Museum, London, No. 826; the translation given is that of Lichtheim, 1976, p. 87.
17 Dolinska, 1990, pp. 3–7.
18 Van Siclen, 1990, pp. 169–76.
19 Edwards, 1976, pp. 127–28.
20 Fischer, 1976, pp. 39–50.

Chapter 6 · The Symbolism of NUMBERS

1 See for example Borchardt, 1922, and Stadelmann, 1991, who includes a chapter on "Pyramidenmystik" in the revised edition of his study of the pyramids.
2 Sethe, 1916, pp. 31–44. See also *inter alia* Goedicke, 1986, c. 128–29; Moftah, 1964; and Goff, 1979, pp. 135–45.
3 In poems, stories, and other *belles-lettres*, a number may be used purely for its phonetic similarity with another word, though in some cases clear symbolic significance is present. See for example Foster, 1993.
4 See Allen, 1988, p. 26; and Hornung, 1992, pp. 64–74.
5 Symbolic duality is not the sole reason for the juxtaposition of dual images in Egyptian art. It is possible that this convention is ultimately the result of the avoidance of frontal portrayals of the human figure, and the preference for profile views. Because the profile is inherently asymmetrical, its use may have led to the dual portrayal of the subject – see Robins, 1986, p. 15.
6 Westendorf, 1977, c. 705–7.
7 Kemp, 1989, pp. 31ff.
8 Compare Piankoff and Rambova, 1957, No. 5., scenes 3–50.
9 Coffin Texts, II, 39. See Faulkner, 1973.
10 Papyrus Leiden, I, 350.
11 See Redford, 1983, pp. 67ff.
12 See for example Derchain, 1976.
13 Pyramid Texts 1207. See Faulkner, 1969.

14 A mythological expression of this is seen in Pyramid Texts 152–60, though the list of deities given there is a variant one.
15 Derchain, 1965, pp. 139–43; and see Ritner, 1990, pp. 34–39 on this ritual and the symbolism of the number four in Egyptian magic.
16 Kurth, 1986, pp. 749–54.
17 Papyrus Chester Beatty I (see Lichtheim, 1976, II, p. 187).
18 Dawson, 1927, pp. 97–107.
19 Papyrus of Neskhonsu, Piankoff and Rambova, 1957, No. 4, scene 2.
20 Book of the Dead, 149. See Faulkner, 1990.
21 Plutarch, *Moralia* V, 382, 76. See Griffiths, 1970.
22 This principle should not be confused with what Erik Hornung has called "the extension of the existing" in relation to the increase in size of royal tombs and other monuments (Hornung, 1992, p. 84).

Chapter 7 · The Symbolism of HIEROGLYPHS

1 Ray, 1986, pp. 307–16.
2 Ray, 1986, discusses this idea, p. 311.
3 See *inter alia* Fischer, 1977, p. 1195; Baines, 1985, pp. 32–33.
4 Schenkel, 1976, p. 6.
5 Aldred, 1980, p. 17.
6 *Lettres à M. le duc de Blacas. Première lettre*, p. 10; cited by Kozloff and Bryan, 1992, p. 14.
7 Wilkinson, 1992, pp. 9–12.
8 Pyramid Text 1653. See Faulkner, 1969.
9 Faulkner, 1990, p. 116.
10 Schenkel, 1976, p. 6.
11 See Vernus, 1982, pp. 131–35. The categories given here differ somewhat from those of Vernus.
12 Metropolitan Museum of Art, New York, No. 10.176.113.
13 A distinction should be made between compositions which may

be literally "read" and those which suggest or connote verbal meanings.
14 Lehner, 1991.
15 Kendal, 1991, p. 46.
16 Metropolitan Museum of Art, New York, No. 19.2.16.
17 Baines, 1975, p. 22.
18 Schlögl, 1977, p. 17.
19 Egyptian Museum, Cairo, No. CG 34120.
20 I am indebted to Dr Emily Teeter for her corroborating comments on this observation; personal communication, December 1992.
21 Baines, 1975, p. 22.
22 Hornung, 1992, p. 31.

Chapter 8 · The Symbolism of ACTIONS

1 Spencer, 1978, p. 55, n. 22.
2 Wilkinson, 1991, pp. 83–99.
3 See Robins, 1990, p. 54; and the letters to the editor by Robins, *KMT* 3:2, 1992, p. 3; and Hansen, *KMT* 3:3, 1992, pp. 2–3.
4 Teeter, 1990.
5 Hornung, 1992, p. 132.
6 Egberts, 1988.
7 Kemp, 1989, pp. 46 ff. On the various forms of this motif, see also Hoffmeier, 1983.
8 Schulman, 1988; and contra Schulman's position on the reality of New Kingdom smiting scenes, see the reviews by W. Ward, *JNES* 51:2 (1992), 151–57; and S. Ahituv, *IEJ* 41:4 (1991), 301–5.
9 Romano, 1991, p. 90.
10 Säve-Söderbergh, 1953.
11 Fairman, 1974, pp. 114–15; and see also Griffiths, 1960.
12 Baines, 1976, *passim*.
13 Wallace, 1966, p. 107.
14 See for example Bleeker, 1967; and Kees, 1942.
15 Pyramid Text 199. See Faulkner, 1969. For this rite, see Otto, 1960.
16 Westendorf, 1967, pp. 139–50; Derchain, 1975, pp. 55–74; and

Derchain 1976, pp. 7–10. See also Manniche, 1987; and Robins, 1988.
17 So Krauss and Graefe, 1985, pp. 25–26.
18 Westendorf, 1967, p. 142.
19 Robins, 1990; and personal communication January 1993.
20 Piccione, 1990.

Chapter 9 · The Symbolism of GESTURES

1 Müller, 1937, p. 57ff. On the "frozen" aspect of gestures in Egyptian representational art, see Groenewegen-Frankfort, 1951, pp. 41–44.
2 Ogdon, 1979, pp. 71–76.
3 Schäfer, 1974, pp. 174–76.
4 Other categories are listed in Brunner-Traut, 1977b, c. 575ff; and cf. the works by Müller, 1937; and Grapow, 1939–42.
5 See Keel, 1974, 95–103; and Spalinger, 1978.
6 Ogdon, 1985/6; and Wilkinson, 1993.
7 Poetical Stela of Thutmose III, Egyptian Museum, Cairo, No. 34010 (see Lichtheim, 1976, II, p. 38).
8 Poetical Stela of Thutmose III (see note 7).
9 Fischer, 1976, pp. 39–50.
10 Teeter, 1990, pp. 65–66.
11 Hoffmeier, 1983; Wilkinson, 1991.
12 Wilkinson, 1988.
13 The earliest extant Egyptian example of the use of the bow as a symbol of royal dominance may occur in the Fifth Dynasty *Sed*-festival scenes of Niuserre. In Mesopotamia the motif may possibly occur earlier, but this is not certain. See Wilkinson, 1991.
14 See for example Wilkinson, 1988, p. 186.
15 Museum of Fine Arts, Boston, No. 03.1848.
16 Wilkinson, 1987.
17 Frankfort, 1970, p. 134.
18 Grapow, 1939–42.

Further Reading

Basic bibliography

Egyptian Art
There are many excellent books on Egyptian art but few which look at its symbolic nature in detail. An excellent general introduction which does include the symbolic aspects of a number of works is Cyril Aldred, *Egyptian Art in the Days of the Pharaohs 3100–320 BC* (London and New York, 1980). Erik Hornung, *Idea Into Image: Essays on Ancient Egyptian Thought* (New York, 1992) provides an examination of the relationship between Egyptian art and its underlying symbolic way of thought. Richard H. Wilkinson, *Reading Egyptian Art: A Hieroglyphic Guide to Ancient Egyptian Painting and Sculpture* (London and New York, 1992) looks at many of the individual symbolic images found in Egyptian art.

Symbol and Magic
In this area there are a great many background works which may be consulted. Erik Hornung, *Conceptions of God in Ancient Egypt: The One and the Many* (London, 1983) is an excellent study of Egyptian religion, and George Hart, *Dictionary of Egyptian Gods and Goddesses* (London, 1986) provides a fine introduction for those unfamiliar with the many Egyptian deities. The latter author's *Egyptian Myths: The Legendary Past* (London and Austin, 1990) also provides a clear introduction to the symbolism and magic found in Egyptian mythology. Specialized works on specific topics are listed below.

Specialized bibliography

The following abbreviations are used for journals and series which are frequently cited:

ÄA	*Ägyptologische Abhandlung*, Wiesbaden
ÄF	*Ägyptologische Forschungen*, Glückstadt, Hamburg, New York
BES	*Bulletin of the Egyptological Seminar*, New York
CdE	*Chronique d'Égypte*, Brussels
DE	*Discussions in Egyptology*
DHA	*Dossiers Histoire et Archeologie*, Paris
HÄB	*Hildesheimer Ägyptologische Beitrage*, Hildesheim
JANES	*Journal of the Ancient Near Eastern Society*, New York
JARCE	*Journal of the American Research Center in Egypt*, New York
JEA	*Journal of Egyptian Archaeology*, London
JNES	*Journal of Near Eastern Studies*, Chicago
JSSEA	*Journal of the Society for the Study of Egyptian Antiquities*, Toronto
KMT	*KMT: A Modern Journal of Ancient Egypt* (San Francisco)
LÄ	*Lexikon der Ägyptologie*. Wolfgang Helck, Eberhard Otto, and Wolfhart Westendorf, eds. Vol. I–VI (Wiesbaden, 1975–86)
MÄS	*Münchner Ägyptologische Studien*, Munich
MDAIK	*Mittelungen des Deutschen Archäologischen Instituts, Abteiling Kairo*, Cairo
NAWG	*Nachrichten der Akademie der Wissenschaften in Göttingen, Phil.-hist. klasse*, Göttingen
OLP	*Orientalia Lovaniensia Periodica*, Louven
PÄ	*Probleme der Ägyptologie*, Leiden
RAIN	*Royal Anthropological Institute News*, London
RdE	*Revue d'Egyptologie*, Cairo
SAK	*Studien zur Altägyptischen Kultur*, Hamburg
VA	*Varia Aegyptiaca*, San Antonio
ZÄS	*Zeitschrift fur Ägyptische Sprache und Altertumskunde*, Leipzig, Berlin

ALDRED, CYRIL. *Egyptian Art* (London and New York, 1980).

—— *Akhenaten: King of Egypt* (London and New York, 1988).

ALLEN, JAMES P. *Genesis in Egypt: The Philosophy of Ancient Egyptian Creation Accounts*. Yale Egyptological Studies 2 (New Haven, 1988).

ARNHEIM, RUDOLPH. *The Dynamics of Architectural Form* (Berkeley, Los Angeles, 1977).

ARNOLD, D. *Wandbild und Raumfunktion in ägyptischen Tempeln des Neuen Reiches* (Berlin, 1962).

BADAWY, ALEXANDER. *A History of Egyptian Architecture*. 3 vols. (1, private and 1990 reprint, London; 2 and 3, California, 1966, 1968).

BAINES, JOHN. "'Ankh-sign, belt and penis sheath," *SAK* 3 (1975), 1–24.

—— "Temple Symbolism," *RAIN* 15:3 (1976), 10–15.

—— *Fecundity Figures: Egyptian Personification and the Iconology of a Genre* (Warminster, 1985).

BARTA, WINFRIED. "Materialmagie und -symbolik," *LÄ* III (1980), c. 1233–37.

BELL, LANNY. "Luxor Update," *News and Notes of the Oriental Institute* 90 (1983), unnumbered.

—— "Aspects of the Cult of the Deified Tutankhamun," *Melanges Gamal Eddin Mokhtar*, vol. I (Cairo, 1985a), 31–59.

—— "Luxor Temple and the Cult of the Royal Ka," *JNES* 44:4 (1985b), 251–94.

—— "Les parcours processionnels," *DHA* 101 (1986), 29–30.

BIANCHI, R. "Ramesside Art as Reflected by a Dated Faience Statuette Identifying Ramesses II with Horus, the Falcon God," *BES* 10 (1989/90), 17–24.

BLACKMAN, A. M. "The Significance of Incense and Libations," *ZÄS* 50 (1912), 69–75.

BLEEKER, C. J. *Egyptian Festivals. Enactments of Religious Renewal.* Studies in the History of Religions, Supplements to *Numen* XIII (Leiden, 1967).

—— *Hathor and Thoth* (Leiden, 1973).

BORCHARDT, L. *Gegen die Zahlenmystik an der grossen Pyramide bei Gise* (Berlin, 1922).

BOURGHOUTS, J. F. *Ancient Egyptian Magical Texts* (Leiden, 1978).

—— "Magie," *LÄ* III (1980), c. 1137–51.

BOURRIAU, J.D. "Salbgefasse," *LÄ* V (1984), c. 362–66.

BREWER, D. J. and R. F. FRIEDMAN. *Fish and Fishing in Ancient Egypt* (Warminster, 1989).

BROCK, EDWIN C. "The Iconography of the 'Rishi' Coffin," *Programs and Abstracts of the Annual Meeting of the American Research Center in Egypt* 32 (Boston, 1991).

BRUNNER, H. "Die Sonnenbahn in ägyptischen Tempeln," in *Archäologie und Altes Testament, Festschrift für Kurt Galling* (Tübingen, 1970), 27–34.

BRUNNER-TRAUT, EMMA. "Farben symbolik," *LÄ* II (1977a), c. 117–28.

—— "Gesten," *LÄ* II (1977b), c. 573–85.

BUHL, M. L. "The Goddesses of the Egyptian Tree Cult," *JNES* 6 (1947), 80–97.

CAMINOS, RICARDO and HENRY G. FISCHER. *Ancient Egyptian Epigraphy and Palaeography* (New York, 1976).

CARTER, HOWARD. *Tomb of Tut-ankh-Amen*, vol. II (London, 1927).

CECCALDI, P. F. et al. "Les Cheveaux de Ramsès," in *La Momie de Ramsès II* (Paris, 1985).

DAWSON, W. R. "The Number 'Seven' in Egyptian Texts," *Aegyptus* 8 (1927), 97–107.

DERCHAIN, PHILIPPE. *Le Papyrus Salt 825 (B.M. 10051)*, 2 vols. (Brussels, 1965).

—— "La perruque et le cristal," *SAK* 2 (1975), 55–74.

—— "Symbols and Metaphors in Literature and Representations of Private Life," *RAIN* 15 (1976), 7–10.

DESROCHES-NOBLECOURT, CHRISTIANE. *Tutankhamen: Life and Death of a Pharaoh* (New York, 1963).

DOLINSKA, MONICA. "Red and Blue Figures of Amun," *VA* 6:1–2 (1990), 3–7.

EATON-KRAUSS, M. and E. GRAEFE. *The Small Golden Shrine from the Tomb of Tutankhamun* (Oxford, 1985).

EDWARDS, I. E. S. *Treasures of Tutankhamun* (New York, 1976).

EGBERTS, ARNO. "Consecrating the Meret-Chests: Some Reflections on an Egyptian Rite," *Akten des vierten Internationalen Ägyptologen Kongresses, München, 1985* (Hamburg, 1988), pp. 241–47.

ERMAN, ADOLF and HERMAN GRAPOW, eds. *Wörterbuch der ägyptischen Sprache*, vols. I–VI (Leipzig, 1926–50).

FAIRMAN, H. W. *The Triumph of Horus* (London, 1974).

FAULKNER. R. O. *The Ancient Egyptian Pyramid Texts*, 2 vols. (Oxford, 1969).

—— *The Ancient Egyptian Coffin Texts*, 3 vols. (Warminster, 1973, 1977, 1987).

—— *The Ancient Egyptian Book of the Dead* (Austin, 1990).

FISCHER, HENRY G. "Representations of *Dryt*-mourners in the Old Kingdom," *Egyptian Studies 1: Varia* (New York, 1976), 39–50.

—— "Hieroglyphen," *LÄ* II (1977), 1189–99.

—— "Rechts und Links," *LÄ* V (1984), 187–91.

FOSTER, JOHN L. *Thought Couplets in the Tale of Sinuhe* (Frankfurt, 1993).

FRANKFORT, HENRI. *The Art and Architecture of the Ancient Orient* (Harmondsworth, 1954/1970 ed.).

—— *Kingship and the Gods* (Chicago, 1978 ed.).

FREED, RITA E. "A Private Stela from Naga ed-Der and Relief Style of the Reign of Amenemhet I," in *Studies in Ancient Egypt, the Aegean, and the Sudan: Essays in Honor of Dows Dunham.* William K. Simpson and Whitney M. Davis, eds (Boston, 1981), pp. 68–76.

GAMER-WALLERT, I. *Fische und Fischkulte in*

alten Ägypten. ÄA 21 (1970), 109–13.

GARDINER, ALAN. "The Baptism of Pharaoh," *JEA* 36 (1950), 3–12.

GESSLER-LOHR, BEATIX. *Die heiligen Seen ägyptischer Tempel HÄB* 21 (1983).

GOEDICKE, HANS. "Symbolische Zahlen," *LÄ* VI (1986), c. 128–29.

GOFF, BEATRICE L. *Symbols of Ancient Egypt in the Late Period: The Twenty-first Dynasty* (The Hague, Paris, New York, 1979).

GRAEFE, E. "Der Sonnenaufgang zwischen den Pylontürmen," *OLP* 14 (1983), 55–79.

GRAPOW, HERMANN. "Wie die Alten Ägypter sich anredeten, wie sie sich grüssten und wie sie miteinander sprachen," *APAW* (1939 Nr.11, 1940 Nr.12, 1941 Nr.11, 1942 Nr.7).

GRIESHAMMER, REINHARD. "Rechts und Links (Symbolik)," *LÄ* V (1984), c. 191–93.

GRIFFITHS, JOHN G. *The Conflict of Horus and Seth from Egyptian and Classical Sources: A Study in Ancient Mythology* (Liverpool, 1960).

—— *Plutarch's De Iside et Osiride* (Cardiff, 1970).

—— "Osiris," *LÄ* IV (1982), c. 623–33.

GROENEWEGEN-FRANKFORT, H. A. *Arrest and Movement: An Essay on Space and Time in the Representational Art of the Ancient Near East* (Chicago, 1951).

HARPUR, YVONNE. *Decoration in Egyptian Tombs of the Old Kingdom* (London, 1987).

HAWASS, ZAHI. "The Khufu Statuette: Is It an Old Kingdom Sculpture?" in *Melanges Gamel Eddin Mokhtar*, vol. I (Cairo, 1985), pp. 367–94.

HAYES, W. C. *Royal Sarcophagi of the XVIII Dynasty* (Princeton, 1935).

HOFFMEIER, JAMES K. "Some Egyptian Motifs Related to Warfare and Enemies and their Old Testament Counterparts," in *Egyptological Miscellanies: A Tribute to Professor Ronald J. Williams*. J. K. Hoffmeier and E. S. Meltzer, eds (Toronto, 1983), pp. 53–70.

—— *Sacred in the Vocabulary of Ancient Egypt: The Term DSR, with Special Reference to Dynasties I–XX* (Gottingen, 1985).

HOLLIS, SUSAN TOWER. *The Ancient Egyptian "Tale of Two Brothers"* (Norman and London, 1990).

HORNUNG, ERIK. *The Valley of the Kings: Horizon of Eternity* (New York, 1990).

—— *Idea Into Image* (New York, 1992).

HOULIHAN, PATRICK F. *The Birds of Ancient Egypt* (Warminster, 1986).

IVERSON, ERIK. *Some Ancient Egyptian Paints and Pigments* (Copenhagen, 1955).

JOHNSON, W. RAYMOND. "Images of Amenhotep III in Thebes: Styles and Intentions," in *The Art of Amenhotep III: Art Historical Analysis*. L. M. Berman, ed. (Cleveland, 1990), pp. 26–46.

KEEL, OTHMAR. *Wirkmachtige Siegeszeichen im Alten Testament* (Freiburg, Göttingen, 1974).

KEES, H. *Bemerkungen zum Tieropfer der Ägypter und seiner Symbolik. NAWG* 2 (1942).

—— *Farbensymbolik in ägyptischen religiosen Texten. NAWG* 11 (1943).

KEMP, BARRY J. *Ancient Egypt: Anatomy of a Civilization* (London and New York, 1989).

KENDAL, TIMOTHY. "Gebel Barkal as Symbol," *Programs and Abstracts of the Annual Meeting of the American Research Center in Egypt* (Boston, 1991), p. 46.

KISCHKEWITZ, HANNELORE. *Egyptian Drawings* (London and New York, 1972).

KOEFED-PETERSEN, OTTO. *Catalogue des Sarcophages et Cercueils Égyptiens* (Copenhagen, 1951).

KOZLOFF, ARIELLE P. and BETSY M. BRYAN. *Egypt's Dazzling Sun: Amenhotep III and His World* (Cleveland, 1992).

KURTH, DIETER. "Treiben der 4 Kälber," *LÄ* VI (1986), c. 749–54.

LEHNER, MARK E. *Archaeology of an Image: The Great Sphinx at Giza* (Ph.D. dissertation, New Haven, 1991).

LEPROHON, R. *Stelae I: The Early Dynastic Period to the Late Middle Kingdom* (Mainz, 1985).

LICHTHEIM, MIRIAM. *Ancient Egyptian Literature*, 3 vols. (Berkeley and Los Angeles, 1973, 1976, 1980).

LILYQUIST, CHRISTINE. *Ancient Egyptian Mirrors: From the Earliest Times through the Middle Kingdom. MÄS* 27 (Berlin, 1979).

LUCAS, A. and J. R. HARRIS. *Ancient Egyptian Materials and Industries* (London, 4th ed., 1962).

MANNICHE, LISA. "The Body Colours of Gods and Men in Inlaid Jewellery and Related Objects from the Tomb of Tutankhamun," *Acta Orientalia* 43 (1982), 5–12.

—— *Sexual Life in Ancient Egypt* (London and New York, 1987).

MARTIN, GEOFFREY T. "Erotic Figurines: The Cairo Museum Material," *GM* 96 (1987), 71–84.

—— *The Memphite Tomb of Horemheb*, vol. I (London, 1989).

MARTIN, KARL. "Urhügel," *LÄ* VI (1986), c. 873–75.

MOFTAH, RAMSES. "Ara-Datierungen, Regierungsjahre und Zahlenwortspiele," *CdE*

39, Nr. 77 (1964), 44–54.

MONTET, P. "Hathor et le papyus," *Kemi* 14 (1957), 92–101.

MORENZ, S. "Von der Rolle der Farbe im alten Ägypten," *Palette* (Basel, 1962).

MÜLLER, H. "Darstellungen von Gebärden auf Denkmalern des Alten Reiches," *MDAIK* 7 (1937), 57–118.

NEEDHAM, RODNEY, ed. *Right and Left: Essays on Dual Symbolic Classification* (Chicago and London, 1973).

NORD, DEL. "The Term *ḫnr*: 'Harem' or 'Musical Performers'?," in *Studies in Ancient Egypt, the Aegean, and the Sudan: Essays in Honor of Dows Dunham*. William K. Simpson and Whitney M. Davis, eds (Boston, 1981), pp. 137–45.

OGDON, JORGE R. "Observations on a Ritual Gesture, After Some Old Kingdom Reliefs," *JSSEA* X.1 (1979), 71–76.

—— "Some Notes on the Iconography of Min," *BES* 7 (1985/6), 29–41.

—— "Some Reflections on the Meaning of 'Megalithic' Cultural Expression in Ancient Egypt (with Reference to the Symbolism of the Stone)," *VA* 6.1–2 (1990), 17–22.

OTTO, EBERHARD. *Das ägyptische Mundöffnungsritual*, *ÄA* 3 (Wiesbaden, 1960).

PARKER, RICHARD A. *The Edifice of Taharqa by the Sacred Lake of Karnak* (Providence and London, 1979).

PETRIE, W. M. F. *Amulets* (London, 1914).

PIANKOFF, A. and N. RAMBOVA. *Mythological Papyri*, 2 vols. (New York, 1957).

PICCIONE, PETER A. "Mehen, Mysteries, and Resurrection from the Coiled Serpent," *JARCE* XXVII (1990), 43–52.

PINCH, GERALDINE. *Votive Offerings to Hathor* (Warminster, 1993).

RAVEN, MAARTEN J. "Magical and Symbolic Aspects of Certain Materials in Ancient Egypt," *VA* 4.3 (1988), 237–42.

RAY, JOHN D. "The Emergence of Writing in Egypt," *World Archaeology* 17.3 (1986), 307–16.

REDFORD, DONALD B. "Notes on the History of Ancient Buto," *BES* 5 (1983), 67–101.

REEVES, NICHOLAS. *The Complete Tutankhamun* (London and New York, 1990).

REYMOND, E. A. E. *The Mythical Origin of the Egyptian Temple* (Manchester, 1969).

RITNER, ROBERT K. "O. Gardiner 363: A Spell Against Night Terrors," *JARCE* XXVII (1990), 25–42.

—— *The Mechanics of Ancient Egyptian Magical Practice* (Chicago, 1993).

ROBINS, GAY. "Standing Figures in the Grid System of the Twenty-sixth Dynasty," *SAK* 12 (1985), 101–16.

—— *Egyptian Painting and Relief* (Aylesbury, 1986).

—— "Ancient Egyptian Sexuality," *DE* 11 (1988), 61–72.

—— "Problems in Interpreting Egyptian Art," *DE* 17 (1990), 45–58.

—— "Composition and the Artist's Squared Grid," *JARCE* XXVIII (1991), 41–54.

ROMANO, JAMES F. "A Prince or a God at El Amarna," *Amarna Letters* 1 (1991), 86–93.

ROMER, JOHN. *Valley of the Kings* (New York and London, 1981).

SALEH, A. A. "The So-called 'Primeval Hill' and Other Related Elevations in Ancient Egyptian Mythology," *MDAIK* 25 (1969), 110–20.

SÄVE-SÖDERBERGH, T. *On Religious Representations of Hippopotamus Hunting as a Religious Motive* (Upsala, 1953).

SCHADEN, OTTO J. "Investigations in the Western Valley of the Kings" (forthcoming).

SCHÄFER, HEINRICH. *Principles of Egyptian Art*. Trans. John Baines (Oxford, 1974).

SCHENKEL, WOLFGANG. "The Structure of Hieroglyphic Script," *RAIN* 15 (1976), 4–7.

SCHLÖGL, H. *Der Sonnengot auf der Blüte* (Basel, 1977).

SCHULMAN, ALAN R. *Ceremonial Execution and Public Rewards. Some Historical Scenes on New Kingdom Private Stelae* (Freiburg and Gottingen, 1988).

SETHE, KURT. *Von Zahlen und Zahlworten bei den alten Aegyptern* (Strasburg, 1916).

SIMPSON, WILLIAM K. "Egyptian Sculpture and Two-Dimensional Representation as Propaganda," *JEA* 68 (1982), 266–77.

SPALINGER, ANTHONY. "A Canaanite Ritual in Egyptian Reliefs," *JSSEA* VIII.2 (1978), 47–60.

SPENCER, A. J. "Two Enigmatic Hieroglyphs and their Relation to the *Sed*-Festival," *JEA* 64 (1978), 54ff.

STADELMANN, RAINER. *Die ägyptischen Pyramiden: Vom Ziegelbau zum Weltwunder* (Mainz, 1991 ed).

STADELMANN-SOUROUZIAN, HOURIG. "Rischi-Sarg," *LÄ* V (1984), 267–69.

STAEHELIN, ELISABETH. "Zu den Farben der Hieroglyphen," in *Zwei Ramessidische Konigsgräber: Ramses IV und Ramses VII*. Erik Hornung (Mainz, 1990), 101–19.

TAYLOR, JOHN R. *Egyptian Coffins*, Shire Egyptology 11 (Aylesbury, 1989).

TEETER, EMILY. *The Presentation of Maat: The Iconography and Theology of an Ancient Egyptian Offering Ritual* (Chicago, 1990).

VAN RINSVELD, BERNARDO. "Monumental Hawk-Sculpture Redated in Brussels," *KMT* 4:1 (1993), 14–21.

VAN SICLEN, CHARLES C. "Additional Notes on the Blue Amun," *VA* 6:3 (1990), 169–76.

VASSILIKA, E. *Ptolemaic Philae* (Leuven, 1989).

VERNUS, PASCAL. "Les jeux d'écriture" and "Les graphies du nom d'Amon-Rê dans un papyrus funéraire," in *Naissance de l'écriture: cunéiformes et hiéroglyphes* (Paris, 1982), pp. 130–33, 134–35.

WALLACE, ANTHONY F. C. *Religion: An Anthropological View* (New York, 1966).

WELLS, RONALD. "Sothis and the Satet Temple on Elephantine: A Direct Connection," *SAK* 12 (1985), 255–302.

WESTENDORF, WOLFHART. "Bemerkungen zur 'Kammer der Wiedergeburt' im Tutanchamungrab," *ZÄS* 94 (1967), 139–50.

—— "Götterpaarbildung," *LÄ* II (1977), c. 705–7.

—— "Symbol, Symbolik," *LÄ* VI (1986), c. 122–28.

WILKINSON, RICHARD H. "The Turned Bow as a Gesture of Surrender in Egyptian Art," *JSSEA* XVII:3 (1987), 128–33.

—— "The Turned Bow in Egyptian Iconography," *VA* 4:2 (1988), 181–87.

—— "The Representation of the Bow in the Art of Ancient Egypt and the Near East," *JANES* 20 (1991), 83–99.

—— *Reading Egyptian Art: A Hieroglyphic Guide to Ancient Egyptian Painting and Sculpture* (London and New York, 1992).

—— "The Paths of Re: Symbolism in the Royal Tombs of Wadi Biban el Moluk," *KMT* 4.3 (1993), 42–51.

—— "Ancient Near Eastern Raised-Arm Figures and the Iconography of the Egyptian God Min," *BES* 11 (1994).

WILLEMS, HARCO. *Chests of Life* (Leiden, 1988).

WINTER, E. *Untersuchungen su den ägyptischen Tempelreliefs der griechisch-römischen Zeit* (Vienna, 1968).

ŽABA, Z. *L'Orientation Astronomique dans l'Ancienne Égypt, et la Précession de l'Axe du Monde* (Prague, 1953).

Index